THEATRE & STAGE PHOTOGRAPHY

Documenting theatrical and stage events under the often dramatic lighting designed for the production provides a number of specific photographic challenges, and is unlike most every other branch of photography. *Theatre & Stage Photography* provides an overview of basic photography as it applies to "available-light" situations, and will move both basic and experienced photographers through the process of accurately capturing both the production process and the resultant performance.

William C. Kenyon serves as head of the Lighting Design Program in the School of Theatre at Penn State University. An active professional designer, William has designed more than 150 plays, operas, and dances, along with over a dozen national and international tour seasons with several theatre and dance companies. William has been involved in Native American theatre and dance for more than 15 years, serving as resident lighting designer for the American Indian Dance Theatre, and was involved in the complete reimagining of *Unto These Hills*, a massive outdoor spectacle celebrating the history of the Cherokee. Prior to Penn State, William taught lighting and sound design at the University of Nebraska–Lincoln. William received his BFA from the University of Connecticut, and his MFA from Brandeis University in Massachusetts. William is very involved with OISTAT's Education Commission (Organisation Internationale des Scénographes, Techniciens et Architectes de Théâtre), after having served two terms as Commissioner for Education for USITT (United States Institute for Theatre Technology). He is also a member of USITT, OISTAT, IALD (International Association of Lighting Designers), IESNA (Illuminating Engineering Society of North America), and USAA (United Scenic Artists of America) Local #829 in the areas of lighting and sound design. When not on tour or in tech, William is working on climbing the highest point in each US state. He lives in Pennsylvania with his wife, Jenny, a costume and scenic designer and forensic artist, and his daughter, Delaney, who is a designer, martial artist, and world traveler.

THEATRE & STAGE PHOTOGRAPHY

A GUIDE TO CAPTURING IMAGES OF THEATRE, DANCE, OPERA, AND OTHER PERFORMANCE EVENTS

WILLIAM C. KENYON

Routledge
Taylor & Francis Group
NEW YORK AND LONDON

First published 2018
by Routledge
711 Third Avenue, New York, NY 10017

and by Routledge
2 Park Square, Milton Park, Abingdon, Oxon, OX14 4RN

Routledge is an imprint of the Taylor & Francis Group, an informa business

© 2018 William C. Kenyon

The right of William C. Kenyon to be identified as author of this work has been asserted by him in accordance with sections 77 and 78 of the Copyright, Designs and Patents Act 1988.

All rights reserved. No part of this book may be reprinted or reproduced or utilized in any form or by any electronic, mechanical, or other means, now known or hereafter invented, including photocopying and recording, or in any information storage or retrieval system, without permission in writing from the publishers.

Trademark notice: Product or corporate names may be trademarks or registered trademarks, and are used only for identification and explanation without intent to infringe.

Library of Congress Cataloging-in-Publication Data
A catalog record for this book has been requested

ISBN: 978-1-138-23627-1 (hbk)
ISBN: 978-1-138-23628-8 (pbk)
ISBN: 978-1-315-27118-7 (ebk)

Typeset in Univers by
Servis Filmsetting Ltd, Stockport, Cheshire

Visit the companion website: www.stagephoto.org

Printed and bound in India by Replika Press Pvt. Ltd.

To Jim Franklin and Bob Moody

Jim gave me a passion for theatre, lighting, and photography, and instilled in me a lifelong love of learning.

Bob taught me how to see light and color, and inspired me to take the risks I needed to take as an artist.

contents

List of Images and Tables		ix
Preface		xix
Acknowledgments		xxi
	Introduction	1
Chapter 1	an overview of basic photography	5
Chapter 2	camera focus and autofocus settings	13
Chapter 3	the camera meter and how a digital camera perceives light	21
Chapter 4	the primary settings	31
Chapter 5	aperture	39
Chapter 6	shutter speed	52
Chapter 7	film speed	71
Chapter 8	white balance	77
Chapter 9	framing your shots	95
Chapter 10	the secondary settings	111
Chapter 11	meter priority	114
Chapter 12	EV compensation	119
Chapter 13	auto-bracketing	126
Chapter 14	digital file formats	136
Chapter 15	practices for documenting process versus product	144
Chapter 16	practices for running a photo-call	168
Chapter 17	photography of other types of performances	179
Chapter 18	digital photo manipulation and presentation	187
Chapter 19	best practices for photographers	196
	glossary of terms	209
	appendix: list of print and internet reference materials	215
	about the author	217
	index	219

images and tables

Unless otherwise noted, all photographs and diagrams in this book were created by the author.

Introduction: Production shot from *Closer Than Ever*, Penn State Centre Stage, Summer 2005. [1] 2

Chapter 1: Production shot from *Unto These Hills*, Cherokee Historical Society, 2007. 6
Figure 1.1 – Cutaway view of the human eye. [2] 7
Figure 1.2 – Traditional SLR film camera – Nikon F2 with 35mm f/2 lens. 7
Figure 1.3 – Cutaway view of 35mm film camera. [2] 8
Figure 1.4 – Cutaway view of DSLR camera. [2] 8
Figure 1.5 – Olympus Stylus 790 SW point & shoot camera. 9
Figure 1.6 – Cutaway view of mirrorless camera. [2] 9
Figure 1.7 – Canon PowerShot SX10 IS with 20x optical zoom lens. 10
Figure 1.8 – The back of the Canon PowerShot with LCD screen deployed. 10
Figure 1.9 – Nikon D200 with 35mm f/1.8 lens. 11

Chapter 2: Production shot from *Singin' the Moon Up*, Penn State Centre Stage, Summer 2005. [1] 14
Figure 2.1 – Family selfie in Old Town Square, Prague, 2015. 15
Figure 2.2 – Autofocus light on Nikon D200. 15
Figure 2.3 – Sharp focus detail of scene from *Carousel*, Bucknell University, Oct. 2016. 16
Figure 2.4 – Sharp focus detail of pixel strip from passive autofocus system. 16
Figure 2.5 – Blurry focus detail of scene from *Carousel*, Bucknell University, Oct. 2016. 16
Figure 2.6 – Blurry focus detail of pixel strip from passive autofocus system. 16
Figure 2.7 – Typical manual/autofocus switch location. 17
Figure 2.8 – Autofocus area mode selector switch. 17
Figure 2.9 – Typical viewfinder in a DSLR camera. 18
Figure 2.10 – Lens flare from Eagle Dance, *Unto These Hills*, Cherokee Historical Society, 2006. 18
Figure 2.11 – DSLR camera and lens without hood. 19
Figure 2.12 – DSLR camera and lens with hood attached. 19
Figure 2.13 – Lens flare without hood. 19

Chapter 3: Jail scene, *Our Country's Good*, Brandeis University, 1994. 22
Figure 3.1 – Ansel Adams's Exposure Zone System. 23
Figure 3.2 – Exposure Zone System with camera set to optimally expose for Zone VIII. 23
Figure 3.3 – Exposure Zone System with camera set to optimally expose for Zone V. 24
Figure 3.4 – Typical light meter embedded in viewfinder. 24
Figure 3.5 – 18% grey card for meter balancing. 25
Figure 3.6 – Gossen Starlite 2 handheld photographic light meter. 26
Figure 3.7 – Metering mode selector on the D200, currently set to color matrix metering. 26
Figure 3.8 – Over-exposed shot caused by field metering. 27
Figure 3.9 – Properly exposed shot three stops under-exposed. 27
Figure 3.10 – Nikon D200 with built-in flash deployed. 27

list of images and tables

Figure 3.11 – Candid photograph of Mike Birardi and Katy Morgan without flash. 28
Figure 3.12 – Candid photograph of Mike Birardi and Katy Morgan with flash. 28
Figure 3.13 – Diagram of Inverse Square Law. 29

Chapter 4: Opening moment, *Proof*, Penn State Centre Stage, July 2007. 32
Figure 4.1 – Aperture readout inside the viewfinder display. 33
Figure 4.2 – Shutter speed readout inside the viewfinder display. 34
Figure 4.3 – Film speed readout inside the viewfinder display. 34
Figure 4.4 – The Exposure Triangle. [2] 35
Figure 4.5 – The Exposure Triangle with the camera set to ISO 400, f/5.6 @ 125th. [2] 35
Figure 4.6 – The Exposure Triangle with the camera set to ISO 400, f/4 @ 250th. [2] 36
Figure 4.7 – The Exposure Triangle with the camera set to ISO 800, f/5.6 @ 250th. [2] 36
Figure 4.8 – The MacBook Preview screen with the Inspector window. 38

Chapter 5: Student working at the light board, rehearsal of *Pentecost*, Penn State University, Sept. 2009. 40
Figure 5.1 – 35mm lens with aperture adjusted to an open setting. 41
Figure 5.2 – 35mm lens with aperture adjusted to a closed setting. 41
Figure 5.3 – Manual 35mm lens with maximum aperture of f/2. (Shown as 1:2.) 42
Figure 5.4 – Autofocus 35mm lens with maximum aperture of f/1.8. 42
Figure 5.5 – Canon PowerShot zoom lens 5mm–100mm with variable aperture of f/2.8–5.7. 42
Figure 5.6 – Olympus Stylus zoom lens 6.7mm–20.1mm with variable aperture of f/3.5–5. 42
Figure 5.7 – Motorola Droid Maxx with prime lens with maximum aperture of f/2.4. 43
Figure 5.8 – Manual 35mm lens with aperture set to f/5.6. 44
Figure 5.9 – Manual 35mm lens with aperture set to f/4. 44
Figure 5.10 – Manual 35mm lens with aperture set to f/11. 44
Figure 5.11 – Camera set to f/2.8, 7' from the table, with the focus on the moose. 45
Figure 5.12 – Camera set to f/2.8, 7' from the table, with the focus on the wolf. 45
Figure 5.13 – Camera set to f/2.8, 7' from the table, with the focus on the cheetah. 45
Figure 5.14 – Camera set to f/16, 7' from the table, with the focus on the moose. 46
Figure 5.15 – Camera set to f/16, 7' from the table, with the focus on the wolf. 46
Figure 5.16 – Camera set to f/16, 7' from the table, with the focus on the cheetah. 46
Figure 5.17 – Camera set to f/2.8, 21' from the table, with the focus on the moose. 47
Figure 5.18 – Camera set to f/2.8, 21' from the table, with the focus on the wolf. 47
Figure 5.19 – Camera set to f/2.8, 21' from the table, with the focus on the cheetah. 47
Figure 5.20 – Kitri from *Don Quixote*, Russian Ballet of Delaware, 1995. 48
Figure 5.21 – Nikon 80mm–200mm zoom lens with depth-of-field markings. 49

Chapter 6: Dream ballet from *Carousel*, Bucknell University, Oct. 2016. 53
Figure 6.1 – Manual shutter speed setting on Nikon SLR camera. 54
Figure 6.2 – Bouncing ball #1: Camera set to f/2.2 at 1/1600th. 55
Figure 6.3 – Bouncing ball #2: Camera set to f/7.1 at 1/200th. 55

Figure 6.4 – Bouncing ball #3: Camera set to f/13 at 1/60th. 55
Figure 6.5 – Bouncing ball #4: Camera set to f/22 at 1/8th. 55
Figure 6.6 – Basic tripod with baseplate. 56
Figure 6.7 – Threaded bolt and removable baseplate. 56
Figure 6.8 – Rubber tripod feet for smooth surfaces or delicate surfaces. 57
Figure 6.9 – Steel spikes for outdoor use. 57
Figure 6.10 – Traditional mechanical shutter release cable attached to Nikon SLR camera. 57
Figure 6.11 – Modern electronic wired shutter release cable and remote. 58
Figure 6.12 – DSLR mounted on tripod with shorter leg lashed to seats. [2] 58
Figure 6.13 – Detail of Paracord lashing on tripod. [2] 59
Figure 6.14 – Tripod set with two legs toward back of house and placed into the seating. [2] 59
Figure 6.15 – Tripod with legs lashed together to create a monopod. [2] 60
Figure 6.16 – Converted monopod in use. [2] 60
Figure 6.17 – Monopod/Walking stick in use. [2] 61
Figure 6.18 – Traditional shutter release button on Nikon SLR camera. 62
Figure 6.19 – Current shutter release button on Nikon DSLR camera. 62
Figure 6.20 – Step 1: Extend the strap and remove any twists or kinks. [2] 63
Figure 6.21 – Sketch of Step 1. [2] 63
Figure 6.22 – Step 2: Reach right hand up through the loop of the strap from below. [2] 64
Figure 6.23 – Sketch of Step 2. [2] 64
Figure 6.24 – Step 3: Settle the loop of the strap just above your elbow so your arm passes over the strap end on your right, and under the strap end on the left. [2] 65
Figure 6.25 – Sketch of Step 3. [2] 65
Figure 6.26 – Step 4: Now for the tricky part – reach around and under the right-side strap end and grip *t*he camera; your hand moves clockwise around the right-side strap to accomplish this. [2] 66
Figure 6.27 – Sketch of Step 4. [2] 66
Figure 6.28 – Step 5: Final arrangement of straps and adjusted for comfortable tension. [2] 67
Figure 6.29 – Sketch of Step 5. [2] 67
Figure 6.30 – Seated on back of chair in the house. [2] 67
Figure 6.31 – Side view of seated pose. [2] 68
Figure 6.32 – Front view of seated pose. [2] 68
Figure 6.33 – Side view of "Weaver" stance. [2] 69
Figure 6.34 – Side view of "bracing" stance. [2] 69

Chapter 7: *R.U.R.*, power-plant attack scene, Brandeis University, 1993. 72
Figure 7.1 – Manual ASA/ISO setting on Nikon SLR camera. 73
Figure 7.2 – ISO sensitivity setting on Nikon DSLR camera. ISO set to 800. 74
Figure 7.3 – Cheetah toy with film speed set to ISO 100, f/2.8 at 1/8th, no digital NR. 74
Figure 7.4 – Cheetah toy with film speed set to ISO 800, f/2.8 at 1/160th, low-level digital NR. 74
Figure 7.5 – Cheetah toy with film speed set to ISO 1600, f/2.8 at 1/125th, high-level digital NR. 75
Figure 7.6 – Cheetah toy with film speed set to ISO 3200, f/2.8 at 1/250th, high-level digital NR. 75
Figure 7.7 – Cheetah toy with film speed set to ISO 1600, f/2.8 at 1/40th, digital NR disabled. 75

Chapter 8: Cop song, *Urinetown*, Penn State University, Oct. 2006. [3] 78
Figure 8.1 – Visible spectrum of light. [2] 79
Figure 8.2 – Kelvin temperature scale. [2] 79
Figure 8.3 – Object lit with incandescent source, D200 set to 3200° Kelvin. 80
Figure 8.4 – Object lit with incandescent source, D200 set to 5600° Kelvin. 80

Figure 8.5 – Object lit with incandescent source, D200 set to 6300° Kelvin. 80
Figure 8.6 – Object lit with incandescent source, D200 set to 10,000° Kelvin. 80
Figure 8.7 – Object lit with white LED source, D200 set to 3200° Kelvin. 81
Figure 8.8 – Object lit with white LED source, D200 set to 5600° Kelvin. 81
Figure 8.9 – Object lit with white LED source, D200 set to 6300° Kelvin. 81
Figure 8.10 – Object lit with white LED source, D200 set to 10,000° Kelvin. 81
Figure 8.11 – Object lit with white arc source, D200 set to 3200° Kelvin. 82
Figure 8.12 – Object lit with white arc source, D200 set to 5600° Kelvin. 82
Figure 8.13 – Object lit with white arc source, D200 set to 6300° Kelvin. 82
Figure 8.14 – Object lit with white arc source, D200 set to 10,000° Kelvin. 82
Figure 8.15 – Object lit with incandescent source, shot with Droid Maxx camera phone. 83
Figure 8.16 – Object lit with white LED source, shot with Droid Maxx camera phone. 83
Figure 8.17 – Object lit with white arc source, shot with Droid Maxx camera phone. 83
Figure 8.18 – 52mm 80A filter for my film cameras. 84
Figure 8.19 – Roll of Kodak Ektachrome 320T color slide film. 84
Figure 8.20 – Setting the D200 to 3200° Kelvin. 85
Figure 8.21 – SPD of daylight at noon with a clear sky. [4] 86
Figure 8.22 – SPD of daylight at noon with a cloudy sky. [4] 86
Figure 8.23 – SPD of ETC Source Four Leko with incandescent HPL 575-watt lamp and no gel. [4] 86
Figure 8.24 – SPD of ETC Source Four Leko with Series 2 Lustr+ LED color engine, set to white. [4] 86
Figure 8.25 – SPD of Vari*Lite VL3000 with 1200-watt arc source, set to white. [4] 87
Figure 8.26 – SPD of cool white fluorescent tubes. [4] 87
Figure 8.27 – SPD of ETC Source Four Leko with incandescent HPL 575-watt lamp with Roscolux 26 gel. [4] 88
Figure 8.28 – SPD of ETC Source Four Leko with Series 2 Lustr+ LED color engine, set to emulate Roscolux 26 gel. [4] 88
Figure 8.29 – SPD of ETC Source Four Leko with incandescent HPL 575-watt lamp with Roscolux 68 gel. [4] 88
Figure 8.30 – SPD of ETC Source Four Leko with Series 2 Lustr+ LED color engine, set to emulate Roscolux 68 gel. [4] 88
Figure 8.31 – SPD of ETC Source Four Leko with incandescent HPL 575-watt lamp with Roscolux 90 gel. [4] 89
Figure 8.32 – SPD of ETC Source Four Leko with Series 2 Lustr+ LED color engine, set to emulate Roscolux 90 gel. [4] 89
Figure 8.33 – Ball, foam, rainbow cloth under clear incandescent Leko. 90
Figure 8.34 – Ball, foam, rainbow cloth under incandescent Leko with Roscolux 26. 90
Figure 8.35 – Ball, foam, rainbow cloth under incandescent Leko with Roscolux 68. 90
Figure 8.36 – Ball, foam, rainbow cloth under incandescent Leko with Roscolux 90. 90
Figure 8.37 – SPD of ETC Source Four Leko with incandescent HPL 575-watt lamp with Roscolux 44 gel. [4] 91
Figure 8.38 – SPD of ETC Source Four Leko with incandescent HPL 575-watt lamp with Roscolux 70 gel. [4] 91
Figure 8.39 – Lion and fabric under clear incandescent light, camera set to 3200° Kelvin. 91
Figure 8.40 – Lion and fabric under clear incandescent light, camera set to auto white balance. 91

Figure 8.41 – Lion and fabric under Roscolux 44 incandescent light, camera set to 3200° Kelvin. 92

Figure 8.42 – Lion and fabric under Roscolux 44 incandescent light, camera set to auto white balance. 92

Figure 8.43 – Lion and fabric under Roscolux 70 incandescent light, camera set to 3200° Kelvin. 92

Figure 8.44 – Lion and fabric under Roscolux 70 incandescent light, camera set to auto white balance. 93

Chapter 9: Stroke and sedation moment, *Wings*, University of Connecticut, March 1990. [5] 96

Figure 9.1 – Final moment from *La Voix Humaine*, long shot in landscape mode. 97

Figure 9.2 – Final moment from *La Voix Humaine*, closer shot in portrait mode. 98

Figure 9.3 – Rule of Thirds on a 3" x 3" square. 98

Figure 9.4 – Rule of Thirds with intersections highlighted. 98

Figure 9.5 – Rule of Thirds applied to *Carousel* production shot. 98

Figure 9.6 – 3:2 aspect ratio, *Luna Gale*, Allegheny College, Feb. 2017. [6] 99

Figure 9.7 – 4:3 aspect ratio, *Luna Gale*, Allegheny College, Feb. 2017. [6] 100

Figure 9.8 – 16:9 aspect ratio, *Luna Gale*, Allegheny College, Feb. 2017. [6] 101

Figure 9.9 – Image size adjustment window in Photoshop. 102

Figure 9.10 – Shot of a character's costume from *Twelfth Night*, Penn State University, Nov. 2016. 104

Figure 9.11 – Alternate shot of a character's costume from *Twelfth Night*, Penn State University, Nov. 2016. 104

Figure 9.12 – Scene from *Twelfth Night*, shot from downstage center seating section. 105

Figure 9.13 – Scene from *Twelfth Night*, shot from a lower row in the stage right seating section. 106

Figure 9.14 – Scene from *Twelfth Night*, shot from the highest row in the stage right seating section. 106

Figure 9.15 – Court scene from *Twelfth Night*, shot from the downstage center seating section. 107

Figure 9.16 – Court scene from *Twelfth Night*, shot from the lower rows in the center of the stage right seating section. 107

Figure 9.17 – Court scene from *Twelfth Night*, shot from the downstage right vomitory. 107

Figure 9.18 – Exterior scene from *Twelfth Night*, shot from the downstage center seating section. 108

Figure 9.19 – Exterior scene from *Twelfth Night*, shot from the downstage right vomitory. 109

Figure 9.20 – Production moment from *1776*, Penn State University. 109

Chapter 10: Battle of Horseshoe Bend, *Unto These Hills*, Cherokee Historical Society, 2007. 112

Chapter 11: Porch at night, *Singin' the Moon Up*, July 2005. [1] 115

Figure 11.1 – Nikon DSLR mode button and setting indicator. 116

Figure 11.2 – Canon PowerShot metering mode selector, standard settings. 116

Figure 11.3 – Canon PowerShot metering mode selector, presets. 117

Chapter 12: Night scene, *The Fantastiks*, Nutmeg Summer Stage, June 1992. 120

Figure 12.1 – EV compensation menu button. 120

Figure 12.2 – Once pressed, you can access and change the EV compensation. This is currently showing an EV compensation of –1 stop. 120

Figure 12.3 – "On the meter" exposure taken with an aperture set to f/2.8 and a shutter speed of 1/8000th. 121

Figure 12.4 – Same shot with –1 EV compensation. 121

Figure 12.5 – Same shot with +1 EV compensation. 121

Figure 12.6 – Test shot taken at an aperture of f/2.8, a shutter speed of 1/320th, and no EV compensation. This bracketed shot is under-exposed by 1 stop from being "on the meter." 122

Figure 12.7 – Test shot taken at an aperture of f/2.8, a shutter speed of 1/160th, and no EV compensation. This bracketed shot is "on the meter." 122

Figure 12.8 – Test shot taken at an aperture of f/2.8, a shutter speed of 1/80th, and no EV compensation. This bracketed shot is over-exposed by 1 stop from being "on the meter." 122

Figure 12.9 – Test shot taken at an aperture of f/2.8, a shutter speed of 1/640th, and an EV compensation of –1. This bracketed shot is under-exposed by 1 stop from being "on the meter," but in reality, is 2 stops under-exposed. 123

Figure 12.10 – Test shot taken at an aperture of f/2.8, a shutter speed of 1/320th, and an EV compensation of –1. This bracketed shot is "on the meter," but in reality, is 1 stop under-exposed. 123

Figure 12.11 – Test shot taken at an aperture of f/2.8, a shutter speed of 1/160th, and an EV compensation of -1. This bracketed shot is over-exposed by 1 stop from being "on the meter," but in reality, is "on the meter." 123

Figure 12.12 – Test shot taken at an aperture of f/2.8, a shutter speed of 1/2500th, and an EV compensation of -3. This bracketed shot is under-exposed by 1 stop from being "on the meter," but in reality, is 4 stops under-exposed. 124

Figure 12.13 – Test shot taken at an aperture of f/2.8, a shutter speed of 1/1250th, and an EV compensation of -3. This bracketed shot is "on the meter," but in reality, is 3 stops under-exposed. 124

Figure 12.14 – Test shot taken at an aperture of f/2.8, a shutter speed of 1/640th, and an EV compensation of -3. This bracketed shot is over-exposed by 1 stop from being "on the meter," but in reality, is 2 stops under-exposed. 124

Chapter 13: Trail of Tears, *Unto These Hills*, Cherokee Historical Society, 2007. 127

Figure 13.1 – This is the auto-bracket menu button on my camera, which gives you quick access to adjusting the number of shots and exposure offset. 128

Figure 13.2 – This is the auto-bracket menu on my camera, where you can see the exposure range and number of shots selected. These can be adjusted on the fly with the two dials embedded in the shooting grip. 129

Figure 13.3 – This shot was taken with an aperture of f/2.8 and a shutter speed of 1/160th. 130

Figure 13.4 – This shot was taken with an aperture of f/2.8 and a shutter speed of 1/100th. 130

Figure 13.5 – This shot was taken with an aperture of f/2.8 and a shutter speed of 1/60th. 131

Figure 13.6 – This shot was taken with an aperture of f/2.8 and a shutter speed of 1/40th. 131

Figure 13.7 – This shot was taken with an aperture of f/2.8 and a shutter speed of 1/25th. 132

Figure 13.8 – The bottom part of the large dial here is marked S, Cl, and Ch, which refer to the shooting mode. 133

Chapter 14: Extraordinary Girl, *American Idiot*, Penn State University, Feb. 2017. [7] 137

Table 14.1 – Image size options, pixel counts, and print size. 138

Table 14.2 – Image format options. 139

Figure 14.1 – File format and size setting in lower left corner, and remaining exposures counter in lower right corner. 139

Table 14.3 – Exposure count based on file types (Nikon D200 & 8GB CF card). 140

Figure 14.2 – Three memory cards for digital storage of photos. Clockwise from bottom, Compact Flash (CF) Card, Secure Digital (SD) Card, eXtreme Digital (xD) Card. 141

Figure 14.3 – MicroSD memory card with SD card adapter. 142

Chapter 15: Final moment, *1776*, Pavilion Theatre, July 2007. — 145

Figure 15.1 – Model for *Unto These Hills*, Cherokee Historical Society, 2006. [8] — 147

Figure 15.2 – Production shot, *Unto These Hills*, Cherokee Historical Society, 2007. — 147

Figure 15.3 – Pavilion Theatre, model for *1776*. [2] — 148

Figure 15.4 – Final moment with projections, *1776*, Pavilion Theatre, July 2007. — 149

Figure 15.5 – Projections moment, *American Idiot*, Penn State University, Feb. 2017. [7] — 150

Figure 15.6 – Projections moment, *Last Train to Nibroc*, University of Nebraska–Lincoln, March 2001. — 151

Figure 15.7 – Scenic design, *A View from the Bridge*, Brandeis University, 1993. Scenic design by Karl Eigsti, scenic art by Bob Moody. — 152

Figure 15.8 – Scenic design, *Carousel*, Bucknell University, Oct. 2016. Scenic design by Andy Nice, direction by Emily Martin-Moberly. — 153

Figure 15.9 – *Twelfth Night*, floor paint sample in paint shop. [9] — 154

Figure 15.10 – *Twelfth Night*, floor basecoat with painter's tape. [9] — 154

Figure 15.11 – *Twelfth Night*, floor painted before tape removed. [9] — 154

Figure 15.12 – *Twelfth Night*, floor after tape removed under work light. [9] — 154

Figure 15.13 – *Twelfth Night*, floor side view under show light. [9] — 155

Figure 15.14 – *Twelfth Night*, floor long view under show light. [9] — 155

Figure 15.15 – *Twelfth Night*, floor under show light with performers. — 155

Figure 15.16 – Moment from *La Voix Humaine*, Penn State School of Music, Oct. 2015. Shot at an aperture of f/2.8 and a shutter speed of 1/125th. — 156

Figure 15.17 – Moment from *La Voix Humaine*, Penn State School of Music, Oct. 2015. Shot at an aperture of f/2.8 and a shutter speed of 1/80th. — 156

Figure 15.18 – Moment from *La Voix Humaine*, Penn State School of Music, Oct. 2015. Shot at an aperture of f/2.8 and a shutter speed of 1/45th. — 156

Figure 15.19 – Base makeup completed. — 158

Figure 15.20 – Adding first layer of latex to forehead. — 158

Figure 15.21 – Adding layer of latex to cheek. — 158

Figure 15.22 – Stretching the latex as it sets. — 158

Figure 15.23 – Drying the latex to create the wrinkles. — 158

Figure 15.24 – Line work on the latex appliques. — 158

Figure 15.25 – Additional line work on the appliques. — 159

Figure 15.26 – Adding powder over the line work. — 159

Figure 15.27 – Applying the facial hair. — 159

Figure 15.28 – Final touches before the wig. — 159

Figure 15.29 – Final look with the wig. — 159

Figure 15.30 – Final look with costume suit coat. — 159

Figure 15.31 – Doublet and tutu for *The Nutcracker*, Eisenhower Auditorium, Dec. 2009. — 160

Figure 15.32 – Church wall build process Step 1 – Arch framing, *First Noel*, Dec. 2016. [10] — 160

Figure 15.33 – Church wall build process Step 2 – Arch frame installed, *First Noel*, Dec. 2016. [10] — 161

Figure 15.34 – Church wall build process Step 3 – Full frame of flat, *First Noel*, Dec. 2016. [10] — 161

Figure 15.35 – Church wall build process Step 4 – Front skin on flat, *First Noel*, Dec. 2016. [10] — 161

Figure 15.36 – Church wall build process Step 5 – Inset window backing installed, *First Noel*, Dec. 2016. [10] — 161

Figure 15.37 – Church wall build process Step 6 – Back of detail element, *First Noel*, Dec. 2016. [10] — 162

Figure 15.38 – Church wall build process Step 7 – Front of detail element, *First Noel*, Dec. 2016. [10] — 162

Figure 15.39 – Church wall build process Step 8 – Detail element and cross attached, *First Noel*, Dec. 2016. [10] — 162

Figure 15.40 – Church wall build process Step 9 – Full flat in paint shop, *First Noel*, Dec. 2016. [10] ... 162

Figure 15.41 – Church wall build process Step 10 – Finished flat, *First Noel*, Dec. 2016. [10] ... 163

Figure 15.42 – Church wall build process Step 11 – Flat installed in venue, *First Noel*, Dec. 2016. [10] ... 163

Figure 15.43 – Ring flash unit with adapter for mounting and amber ring lens installed. ... 163

Figure 15.44 – Ring flash unit installed on Nikon D200. ... 163

Figure 15.45 – Shot of statuette using only top-light. ... 164

Figure 15.46 – Shot of statuette using only built-in flash. ... 164

Figure 15.47 – Shot of statuette using top-light and ring flash manually held to right side. ... 164

Figure 15.48 – Shot of statuette using top-light and ring flash installed on front of lens. ... 164

Figure 15.49 – Stage left proscenium arch, house left lighting ladder, balcony rail, catwalk, and acoustical clouds, Gladys Mullenix Black Theatre, Allegheny College. [11] ... 166

Chapter 16: *Be More Chill* photo-call getting ready to start, Penn State University, Fall 2016. ... 169

Figure 16.1 – *Carousel* dance moment – Shot #1 in the auto-bracket series. ... 173

Figure 16.2 – *Carousel* dance moment – Shot #2 in the auto-bracket series. ... 174

Figure 16.3 – *Carousel* dance moment – Shot #3 in the auto-bracket series. ... 174

Figure 16.4 – Unexpected "cast member" in my shot from *Twelfth Night*, Penn State University, Nov. 2016. ... 176

Figure 16.5 – The usual equipment and supplies found in my "go" bag for photo-calls. ... 177

Figure 16.6 – Photo-call shot list for *Trouble in Tahiti*, prepared by Stage Manager Jojo Sugg. [12] ... 178

Chapter 17: *Penn State Spring Dance Concert*, Playhouse Theatre, 2006. [3] ... 180

Figure 17.1 – Prologue from *Trouble in Tahiti*, Oct. 2016. ... 181

Figure 17.2 – Production moment from *American Idiot*, Penn State School of Theatre, Feb. 2017. [7] ... 182

Figure 17.3 – Production moment from *Unto These Hills*, Cherokee Historical Society, 2007. ... 183

Figure 17.4 – Production moment from *For the Future – PSU Capital Campaign Closing Event*, April 2014. ... 184

Figure 17.5 – Production moment from *Spotlight on Musical Theatre*, WPSU-TV, 2006. [3] ... 185

Chapter 18: *Doubt*, Penn State Centre Stage, Aug. 2013. ... 188

Figure 18.1 – Mac monitor calibration window. ... 189

Figure 18.2 – Color Munki screen calibration device. ... 190

Figure 18.3 – Color Munki calibration tool installed and in position for calibration. ... 190

Figure 18.4 – Photo-call picture against a white background of Word files. ... 192

Figure 18.5 – Photo-call picture against a dark desktop background. ... 192

Figure 18.6 – Julie and female chorus from *Carousel*, Bucknell University, Nov. 2016. ... 193

Figure 18.7 – Cropped version of Julie and female chorus from *Carousel*, Bucknell University, Nov. 2016. ... 193

Figure 18.8 – Production moment from *Rimers of Eldritch*, Penn State University, Fall 2005. ... 194

Chapter 19: Crypt scene, *Romeo and Juliet*, University of Nebraska–Lincoln, Oct. 2003. ... 197

Figure 19.1 – Corrupted file. This was the JPEG version of the shot. ... 200

Figure 19.2 – Sorting photo files on a MacBook Pro. ... 201

Figure 19.3 – This is an example of what a release may look like. This is what I used to obtain permissions for the photos in this book. ... 202

Figure 19.4 – Note the watermarked photo credit in the lower left corner. *Twelfth Night*, Penn State University, Nov. 2016. ... 203

Figure 19.5 – Close-up of Photoshop – adding layer with text for photo credit. ... 203

list of images and tables xvii

Figure 19.6 – Nikon camera lens with UV filter and lens cap. Note that the UV filter has no effect on the color or sharpness of the fabric it sits on. 204

Glossary of Terms: Jail scene, *The Threepenny Opera*, University of Connecticut, 1993. 209

Image Credits
[1] Production photos by William Wellman.
[2] Photographs, sketches, and diagrams by Jenny Kenyon.
[3] Production photos by Zak Keller.
[4] Spectral Power Distribution graphs were generated with an Asensetek Lighting Passport handheld spectrometer.
[5] Production photo by James Franklin.
[6] The photographs of *Luna Gale* are from a production at Allegheny College, directed by Mark Cosdon, scenery by Michael Mehler, costumes by Miriam Patterson, and lighting by William Kenyon.
[7] Production photos by Zach Straeffer.
[8] Set model photo by unknown photographer.
[9] Process photos by Paige Eisenlohr.
[10] Process photos by Matthew Lewis, scenic design by Dan Robinson.
[11] Venue photo by Amanda Fallon.
[12] Photo call list by Jojo Sugg.
[13] Headshot photo provided by USITT (Richard Finkelstein).

There are dozens of fellow designers with whom I've worked over the years who contributed their vast talents and skills to create the scenery, costumes, props, and other visual elements in the various productions that I have photographed. To list everyone involved in all of these productions would require a supplementary guide to this book, so please forgive me if I haven't recognized you by name.

preface

As a very young entrant into the lighting design profession, I was often told during portfolio reviews that "stage lighting pictures are never right, so don't show them in your portfolio." This truism – that photography was somehow inherently incapable of faithfully representing theatre lighting design – seemed evidenced by the apparent absence of quality photographs of many otherwise skilled and talented designers' work, and it inspired me to learn what I needed to know so that I could claim, without hesitation, that the pictures in my portfolio were true and accurate representations of the design work. Along the way, I discovered a love for the photographic arts that parallels my passion for lighting and theatrical design, which I am pleased to be able to share with you in this book.

My interest in theatre and photography both began in high school, where I was exceptionally lucky to have access to a new theatre and a darkroom. I have always been fascinated by gadgets and equipment, so naturally I found the old cameras my father had were very interesting to experiment with. Additionally, my grandfather and uncle both worked for Kodak, so I had many resources to tap while I was learning my way around the camera. I began taking pictures with an entry-level Nikkormat film camera and whatever film I could get. After a few years of working on the lighting crew I also joined the yearbook staff and began to learn about developing and processing film and prints.

Upon graduation, I started at the University of Connecticut as a Bachelor of Fine Arts (BFA) lighting design student, and happily discovered that the darkrooms for the photography program were next door to the theatre design studios. Over the next four years, I took every lighting class available and a number of photography classes, which together gave me total access to both the theatre and the darkroom. I quickly realized that the difficulty of capturing accurate images in the theatre made it impossible to rely on other photographers to provide the photographs I would need to build a compelling portfolio. The cameras I started with had the most simplistic of light meters, and only allowed the user to set the **film speed**, **aperture**, and **shutter speed**. I had to learn quickly how these settings interacted with each other to maximize the light coming through the lens. The only reasons I became successful at this endeavor were the many opportunities to practice and some great guidance from several experienced photographers. I hope that this book will provide everything you need to get a great start down this path.

—William Kenyon,
State College, Pennsylvania, August 2017

acknowledgments

I would not be the lighting designer and photographer I am today without the inspiration, teaching, support, and guidance of quite a number of people. First, thanks to my parents, Dr. Bill and Judy Kenyon, who supported my efforts in the theatre without reservation, and gave me the integrity and work ethic I needed to be successful. Thanks also to my dad for letting me abscond with his collection of Nikon cameras, and to my sister Liz for sharing her camera lenses and unbounded artistic spirit.

Thank you to Rick Neidig, Dr. Bruce Chipman, Rosemary Crawford, Dan Welch, Helen Mason, and Barbara Springer, all of The Tatnall School, who gave me my start in theatre lighting and set me on the path to being an artist. Thanks to Brian Shannon, who introduced me to the darkroom, which helped me transition from picture taker to photographer.

In college and graduate school, I studied with many talented people, but none more so than Jim Franklin and Bob Moody. Thanks also to Brandeis professors Dennis Parichy, Elena Ivanova, and Karl Eigsti, who each influenced my work in special ways.

Thank you to Stacey Walker, senior editor at Focal Press for taking a chance on this book, which had no precedent, and her editorial assistant, Meredith Darnell, who walked me through the process of writing my first book. Thank you also to Justin Halverson, for being a great sounding board, and being willing to analyze and guide my early writings.

Thank you to my students (former, current, and future), for it is only because you work hard and ask good questions that I am inspired to continue teaching and to write things like this.

I count so many of my former students as valued friends and colleagues, but I want to give a specific shout out to Nick Gonsman, John Jacobsen, Adam Mendelson, and Travis Walker. The four of you challenged me to be better at what I do then, and continue to do so now.

Finally, thanks to my family – my wife, Jenny, and daughter, Delaney – who have supported my career and been called upon to make many sacrifices in the name of theatre art.

introduction

introduction

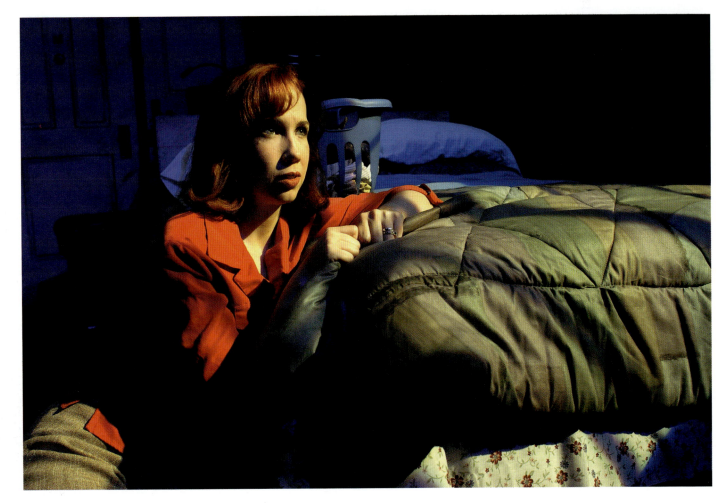

Production Shot from *Closer Than Ever*, Penn State Centre Stage, Summer 2005.

One of the most difficult things to do in the world of photography is to capture the energy of live performance in a still image. Photography has many inherent challenges to begin with, and when you add the complicating factors of working in low light, with very limited time, and with a complex assembly of people, scenery, costumes, and lighting, it becomes quite a daunting task.

Theatrical photography, often referred to as **available-light photography**, is a rare subset of modern photographic practice. As such, most photography classes and tutorials do not cover its challenges, strategies, and pitfalls. This leaves many practitioners to stumble, quite literally, in the dark as they gain experience.

In the following pages, I will share with you the results of my experience documenting live performances over the past 30 years. It is my hope that this book will prove to be useful to novices, journeymen, and expert photographers as appropriate, and that it might also prove useful to anyone who endeavors to capture that singular moment of excitement created by the many types of live performance that are to be found across the world. More than anything, however, this book is primarily for the student who is getting ready to transition into the professional world and needs to show a portfolio of their work. The old adage "a picture is worth a thousand words" is still quite true with any portfolio presentation, whether it is a "hard" portfolio presented in person, or a digital version of the candidate's work. To take that a bit further, however, a bad image speaks "a thousand wrong words" and leaves a very different impression than what you may want. I have seen far too many pictures in which one flaw effectively obscures the original intent of the designer's work — and such flaws exist in every aspect of the process. Improper framing, blurry focus, poor exposure, and perhaps worst of all, inaccurate color, have driven far too many students to begin their presentation by excusing the poor quality of the pictures. I hope that after reading through this book and putting these lessons into practice, you will gain the needed experience, and never have to apologize for anything.

If you are a novice photographer, I urge you to read all the way through, and to try all the suggested exercises until you feel you have each concept down solid. If you are a journeyman photographer, I still urge you to think as a novice when it comes to the specific aspects that are unique to theatrical photography, as there are some things that might surprise you. If you are an expert, you are most likely familiar with all of the trade-offs and challenges, but may not have shot within the structure of a photo-call before. If that's the case, you might want to skim the first few chapters, but don't skip them altogether, if only to better inform the careful choices you must make while taking pictures on stage. No matter what your level, there should be some insights here that will help to improve your work, or at least help you think about things a bit differently.

In the interest of brevity, when I refer to theatre or stage photography, I also mean dance, opera, performance art, touring musical acts, or video — basically anything "live" and produced for an audience. When I say designer, I am generally referring to all the various artists, technicians, and craftspeople who come together to create a performance. This includes, but isn't limited to, designers of lighting, scenery, costumes, sound, projections, wigs and makeup, and millinery, along with scenic artists, stage managers, props artisans, fabric dyers, riggers, technical directors, carpenters, welders, special-effects wizards, and possibly many others. Finally, when I say portfolio, I mean a hard portfolio, digital presentation, website, printed mailer, one-sheet, mailing portfolio, DVD, or any other print or digital media you might employ to share your work.

We will begin with an investigation into how cameras see and react to light, and the close, interdependent relationships of the major settings that affect exposure. Later chapters will delve into the myriad of settings that will simplify your workflow or automate certain steps of the process of photography. I will spend a great deal of time discussing how to run a successful photo-call, and then we will discuss how to handle the images that you've generated through the process.

On this book's companion website can be found biographies of other professional theatre photographers and some of their work (or links to their websites). Much like with any group of artists, you may find that we each have different ways of doing things, and perhaps even different goals informing our choices. Mine is certainly not the last word on this subject, and I hope that hearing from different perspectives and seeing other experts' work will continue to add to your experience and help you when you get behind the viewfinder. My hope is that you gain a thorough working knowledge of your camera so that you can make the right choices to show your work to its best effect (namely, promoting your work and getting hired!).

If you find contradictions, it doesn't necessarily mean that one of us is wrong, but instead that we have different goals in mind for the end product. The way I shoot now has developed through a great deal of practice and investigation over the past three decades, and much of what I do may help you, while other aspects may not apply quite the same way for every situation. In the end, when you share your work with others, whether it is for a job, in a design meeting, or just to share with family and friends, I want you to be proud of your work and confident that you have captured the essence of your efforts. If you feel good about the photos, and thus feel good about your work and yourself, the portfolio review will go much more smoothly. That said, don't ever show a picture you feel you have to apologize for or excuse some aspect of. If you try the exercises found in this book, and practice as much as you can, there should be no need.

I hope that this book helps you capture the best rendition of your work so that you can communicate your abilities and creativity. I created the companion website as a resource for advice, recommendations, and discussion. Come visit and join in. I look forward to sharing more of my work, seeing some of yours, and talking with you about your successes with the camera.

> I'll say it again. Try the exercises and get to know your camera! This practice is as important as any other aspect of what you have learned or are learning. Take the time to get to know your equipment and how it works. Take the time to try out the various features I have mentioned and see what the results are. I don't want anyone to be surprised by something not working the same way for you as it does for me when you are in the middle of a photo-call and the clock is ticking. Since you are working with a digital camera, practice is cheap compared to the days of film.

WWW.STAGEPHOTO.ORG

chapter one

an overview of basic photography

an overview of basic photography

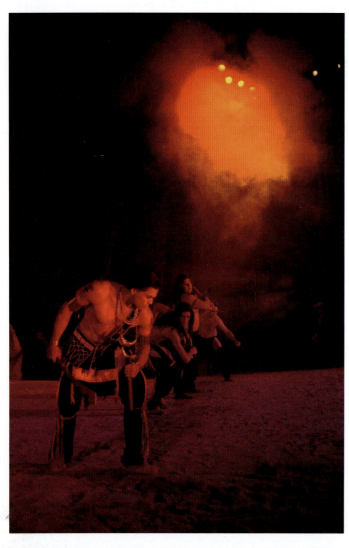

Production Shot from *Unto These Hills*, Cherokee Historical Society, 2007.

Overview of Photography

In its simplest form, a camera is a device for capturing light and transmitting it to a medium that allows us to fix an image of a moment in time. The first day of my basic photography class in college found me making a rough "pinhole" camera from a simple, "light-proof" container with a very small hole and something to cover the hole with. I used an empty, round cardboard oatmeal container and several layers of masking tape to seal it up. Inside, I placed an undeveloped sheet of photo paper (not even film), and took this contraption outside. Once in place, I uncovered the pinhole for a few seconds, while holding the camera still. Then I covered the hole back up and took my oats-can camera to the darkroom, where I removed and developed the sheet of paper, revealing a simple landscape scene from outside the Drama-Music Building.

The image was a simple black-and-white landscape, neither well framed nor optimally exposed, but my experience with this experiment demonstrates how ultimately simple the process of fixing an image can be. Beyond this, all the other things that your camera can do are merely ways to alter the resulting outcome. What is crucial to the success of your work is the full understanding of how each of the settings on your camera affects the outcome, and what the limitations of each setting are. Even the most advanced camera available today is still not nearly as capable as the human eye at perceiving light, and as such, everything done with the camera must be with the understanding that we are working to fix an image that is as close as possible to what the audience saw when they were in the theatre.

The human eye is a truly amazing organ and the result of some very interesting twists and turns in the history of evolution. Some animals have a sharper vision than we do, and some see beyond the human's visible spectrum, but regardless, the ability of our eye to perceive light, capture an image, and transmit that image to our brain is astounding. Much of how a camera works mimics this process, but currently it is merely an attempt to be as capable. Perhaps within our

lifetime, we will finally invent enough camera technologies to allow us to duplicate the quality of the sharpest-eyed human vision, which will make many of the points in this book less relevant. Until that time, however, it is important to know the differences and use the camera to its best abilities, which we will discuss in the next few chapters. Sometimes, the constraints of the camera can even be used to our benefit, if we know how to take advantage of them.

The eye has a number of very delicate structures that help to record an image. The lens and iris, which work together, regulate the amount of light penetrating the eye while focusing that image on the retina. The retina itself records the image, translates it into nerve impulses, and sends the image on to the brain. The rest of the structures exist to help focus the lens, dilate the pupil, move the eye around, and maintain the structure of the eye.

The eye works a bit more like a movie camera than a still camera in that it is constantly recording and updating the image that your brain perceives, but you can also generally recall a still image in your mind's eye.

A traditional SLR (single-lens-reflex) film camera has a few basic parts, including a lens with an aperture, a mirror, a prism, a viewfinder, and a shutter curtain, and film in a transport mechanism. The light enters the front of the lens, and is

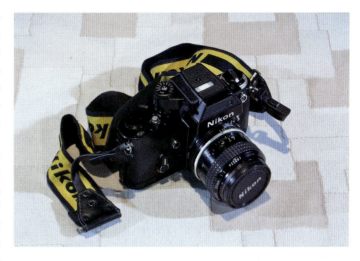

Figure 1.2: Traditional SLR film camera – Nikon F2 with 35mm f/2 lens.

affected by two parts of the lens: the aperture mechanism and the glass elements that form the optics of the lens. This focusing ability of the lens mimics the ability of the human eye in that the manipulation of the spatial relationship of the lens's various glass elements can focus the incoming light image onto the surface of the film, much like the human eye's lens does with the light it focuses on the retina. Wearing glasses or contact lenses simply helps the natural lenses of a person's eyes to focus incoming light precisely onto the surface of the retina, not in front of nor behind it. Additionally, the lens has an aperture, which controls the amount of light entering the camera, much as the iris of a human eye limits the amount of light that ultimately falls on the retina. In the dark, tiny muscles open the iris wide to allow as much light as possible to enter the lens; whereas in bright daylight, other muscles constrict the iris so that less light gets through. This constant adjustment of the iris maintains the correct "exposure" of the light on your retina.

One unique feature of certain camera lenses is their ability to zoom in and out. The human eye can't zoom. To get a larger image of an object, or in other words, a closer look,

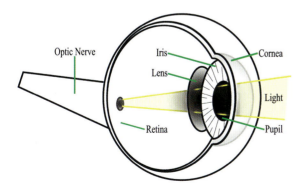

Figure 1.1: Cutaway view of the human eye.

an overview of basic photography

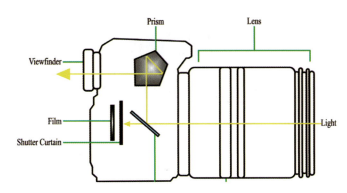

Figure 1.3: Cutaway view of 35mm film camera.

the eye must be moved closer to it. As with most features of a camera, a complementary relationship exists between the benefits obtained by using the zoom and the trade-offs that must be sacrificed to get them. We will discuss these later on.

Once the light has passed through a lens, and the lens is adjusted for proper focus and exposure with the focus ring and aperture, the light is directed upwards through a mirror and into a prism, and then onto the viewfinder and the photographer's eye. This mirror–prism arrangement allows the photographer to see the image through the actual lens, as opposed to other types of cameras where the image is viewed through a secondary lens. When the **shutter release** button is pressed, the mirror flips up and out of the way, and the shutter curtain retracts for a set amount of time, exposing the film behind the shutter to the light. If all done correctly, a properly framed, focused, and exposed image has been captured. Film cameras are also generally equipped with a light meter, calibrated to the film used in the camera, which helps to set the exposure. Beyond that, there are many settings and features that adjust varied aspects of this basic premise.

A **DSLR (digital-single-lens-reflex)** camera essentially replaces the film and film transport mechanism with an image-sensing array that captures and records the image as a digital file. Everything else about the process is essentially the same,

except that now there are many more features and options that can be added to the mix. Still, all of the aspects of DSLR photography revolve around the proper framing, focus, and exposure of the image sensor to the image you want to capture.

There are other cameras that you might find useful in some circumstances, including **mirrorless cameras**, point & shoot cameras, and smartphone cameras. Even though we will focus mainly on the use of other DSLR cameras, it is important to be aware of the other types of cameras available, their capabilities, and rough ideas of costs. The modern point & shoot camera is a variation on the older rangefinder or viewfinder camera, where you looked through a secondary lens at the object you wished to photograph, rather than directly through the lens as with an SLR camera. Some point & shoot cameras have this same system, allowing a user to look through a small viewport with a simple lens, usually up high near a corner of the camera.

More recently, point & shoot cameras have moved to display the image on a liquid crystal display (LCD) screen on the back of the camera, allowing the user to hold the camera up and further away from the face. Instead of looking at a secondary version of the image through an additional optical path, you are seeing a live digital preview of the image you are about to capture. Many prefer this, since they can continue to interact with the subjects in the shot rather than be stuck behind the

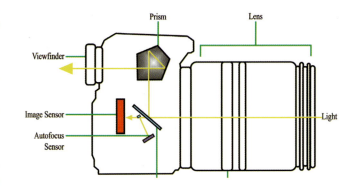

Figure 1.4: Cutaway view of DSLR camera.

an overview of basic photography 9

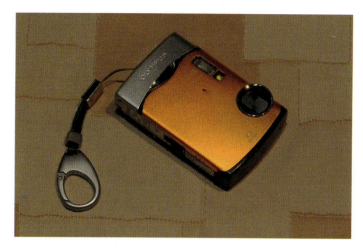

Figure 1.5: Olympus Stylus 790 SW point & shoot camera.

camera body, and they are able to better frame up the shot. This is fine for casual photos, when the camera is functioning according to settings determined by the manufacturer with the intention of providing any user with an acceptable final image.

Point & shoot cameras are a useful resource for process shots, shots in the shops, or perhaps while out doing research. Inexpensive, compact, and easy to carry, they are great to have around when traveling or when portability is a concern. The Olympus camera in Figure 1.5 is also waterproof and shockproof, and will function at temperatures well below freezing. The downsides, however, are significant when it comes to its ability to capture high-quality images. It doesn't have a high-quality image sensor, it has a limited set of features, and the lens isn't very fast. It performs as designed, but it is being quickly replaced with smartphone cameras.

The camera in my current smartphone (a 2010 Motorola Droid Maxx) is as good as the Olympus point & shoot, if not better in certain circumstances. The lens on my phone isn't very fast, so the camera's low-light capabilities are limited, but in terms of image quality, it serves me very well for process shots, research shots, or taking pictures in various shops. Still, it's not going to cut it when it comes to portfolio-grade photographs due to its limited functionality. It is even lighter than the Olympus, and it is always charged and handy, so I don't have extra gear to carry around. For travel and family events, it is quite sufficient, and I've gotten some great pictures from it. Some of the newest smartphones can record in 4K Ultra High Definition (4K ultraHD), and it is inevitable that this level of camera resolution will become more readily available in coming years. Resolution isn't the only major feature that you need to be aware of, and I feel like it will still be a while yet before smartphones can compete with true DSLR cameras. There is a limitation on smartphones due to the size of the lens that you are able to get. Some aftermarket manufacturers even make lens add-ons that allow for additional levels of quality. These are definitely interesting, but I don't think they will replace the DSLR for our situation, especially since DSLRs will also continue to evolve in quality and resolution.

Mirrorless cameras are a very interesting alternative to DSLRs, and may very well corner a major market share. These cameras eliminate the mirror and prism needed to allow the user to see through the lens. The mirrorless camera allows the light to pass straight through to the image sensor, and provides the user with a second, smaller viewport to use for framing up the shot. Mirrorless cameras are lighter, less expensive, and more compact than DSLRs. The downsides compared to DSLRs are a smaller selection of available lenses, fewer

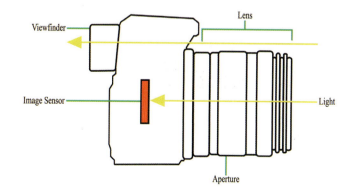

Figure 1.6: Cutaway view of mirrorless camera.

features, and reduced utility in lower-light situations. Still, in the next few years, they may own the market and may have minimized these concerns.

There are two levels of DSLR, the first of which bridges the gap between point & shoot cameras and full DSLR cameras, in both features and price point. The camera in Figure 1.7 is a Canon PowerShot, which has the form factor of a miniaturized DSLR, along with a somewhat richer feature set than most point & shoot cameras. As with most budget-minded designs, most of the features are accessed via menus on the rear LCD screen, and take a bit of time to set up. It has its uses in our world and may be a good choice for designers who need something for process shots as well as final product shots. This particular camera was $400 when new, about one-fifth of the cost of my go-to Nikon DSLR.

The lens in Figure 1.7 is the equivalent of a 28mm–560mm zoom lens on a regular 35mm film camera, which is an incredible range of focal length for a camera at this price. There are some drawbacks to the one-zoom-fits-all idea, however, especially when it comes to the camera's light-gathering ability when zoomed. This camera has the ability to capture audio and

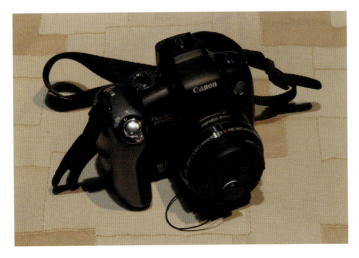

Figure 1.7: Canon PowerShot SX10 IS with 20x optical zoom lens.

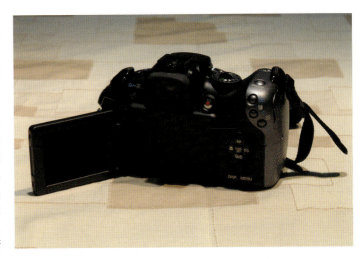

Figure 1.8: The back of the Canon PowerShot with LCD screen deployed.

video as well, which may be very useful for process shots of objects in motion, such as a piece of automated scenery. The LCD screen on the back can flip around and change angles, which is very useful in shooting video.

It is important to note that this book is not meant as a guide to how your specific camera works. There are way too many brands and models for me to be able to know where every button and dial is on them all. I will talk about how cameras work in a more general way, covering photographic theory based on what most cameras can do. Visit the companion website for more up-to-date information on new models, costs, and user reviews.

As a way to show specific examples, I will demonstrate most all the features I will be talking about using my trusty Nikon D200 DSLR, which I bought in May 2007. When I purchased this DLSR, it was at the top of the "**prosumer**" range of DSLR camera bodies available. This means it's situated between the entry-level cameras found at the big-box stores, and the high-end professional-grade cameras used primarily by professional photographers. This range of cameras comes with many (but not all) of the features found on professional-grade cameras, but unfortunately comes with a price tag that

is commensurate with its increased feature set. With a Sigma-branded zoom lens, the price for the camera and lens kit came to about $2,000.

There were three reasons I went with this level of camera, aside from the (hopefully) obvious fact that I am really excited by photography as an art form as well as a method of documentation. The first reason was due to some pretty significant brand loyalty. I've owned and used Nikons for most everything I've done, and they've held up well under adverse circumstances. The second reason was that I already owned a collection of older manual-focus Nikon lenses, and the new cameras are designed to be able to use the older lenses as well. The final reason I chose to go this route centers on color sensitivity. At the time, most entry-level models contained a red, green and blue (RGB) color-sensing matrix in the camera's meter that was fairly small, while the prosumer models used the much larger RGB color-sensing chip from the professional-grade cameras. Since accurate color is critical to what we do, I felt that this was a strong reason to move up to this range of cameras. This model also provided much more control over white balance and had advanced auto-bracketing features, which are very useful in our world, and I will delve into those topics in individual chapters later on.

My advice, if you don't already own a good camera, is to read through this entire book before settling on a new purchase. Most of the digital pictures in this book were taken with this camera, shown in Figure 1.9, and one of several Nikon lenses. It isn't my intention for this book to read as a lengthy commercial for Nikon products, as there are many other worthy brands available. I have only included specific brand and model information so that you may make accurate comparisons with other equipment when you are purchasing your own gear.

I know that this level of camera may be beyond the means of many young designers, however, and offer the following suggestions. If you can, borrow or rent a quality camera for a few shoots and see what you like or don't like. There are some resources in the back of this book that list places to rent

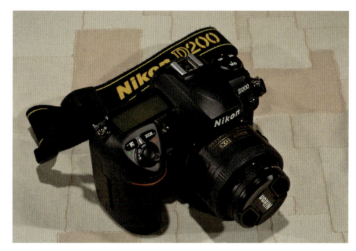

Figure 1.9: Nikon D200 with 35mm f/1.8 lens.

lenses, and you may be able to rent lenses or bodies from local camera stores near you. If you are still a student, many schools have an office where you can borrow equipment for short periods, as long as you are using the equipment in conjunction with a class. You may even have a friend, fellow designer, professional contact, or professor with this type of equipment who might be willing to lend it out. If you do any of these things, get the gear a day or two before and *practice with it*. You do not want to be surprised with a setting you can't locate or a dead battery 10 minutes before your photo-call begins.

Find what's best for your uses and your wallet, and go for it. Canon has also committed to maintaining continuity between bodies and lenses, so that fact has a lot to do with many people I know staying "in the family" of whatever brand they started with. The owner's manual that comes with your camera should be considered an indispensable sibling to this book. The owner's manual will tell you how to find the various controls, dials, and menus on your specific camera, and this book will tell you when and why to use the myriad of options available to you.

The best gear, without knowledge of how to employ it, won't always give you the best pictures, and great

photographers with an understanding of the photographic process can get really great shots with basic gear. The explosion of smartphones with cameras has led many students to try to rely on them for their documentation, without a clear understanding of what they risk giving up by not using a full DSLR.

Generally speaking, the more money you spend on a camera, the more features it will have. Additionally, you will most likely have more control over each feature, allowing for greater precision with your work. Much like buying a car or a computer, there are many specifications to look at, not just horsepower or the speed of the processor. With a digital camera, much of the focus may be on the **megapixel** count, which defines the quality of the image-capturing sensor. While this is certainly important, it isn't the last word on determining if one camera is better than another. When you look at buying a camera, just like buying a car, the fastest and most expensive one won't necessarily do the job you need it to. Just the other day I saw a Lamborghini sports car in the parking lot of a Lowe's hardware store, and remarked to my wife that the owner couldn't be doing anything more than buying a few nuts and bolts. Compared to our Honda van, which can handle bulk 2x4s and sheets of plywood, it didn't have nearly the hauling capacity. In the car owner's case, the Lamborghini may not have been the best tool for the job. With cameras, price and megapixel count are important, but they are not the only specifications to be concerned with. By the end of this book, I hope that you will be confident in your ability to find a camera that serves your purposes and that you enjoy using. If you already own a camera that you plan on using, I hope that this book serves to help you take advantage of all the options available to you with your particular model.

chapter two

camera focus and autofocus settings

14 camera focus and autofocus settings

Production shot from *Singin' the Moon Up,* Penn State Centre Stage, Summer 2005.

Before we get into all of the settings and concerns regarding exposure, we should talk about focus. Most cameras today have an autofocus setting, which may be easily relied upon for most everything that the average user needs. Most smartphone cameras or point & shoot cameras are used for taking pictures of friends and family, selfies, or travel destinations.

While not framed particularly well, this shot captures a moment in time on our family travels, and can be forgiven for being a bit grainy and out of balance. Despite the various challenges, though, the autofocus function has effectively done its job. Our faces are in focus, as are the architectural features in the background. Modern DSLR cameras and lenses are usually equipped with an autofocus mode or modes, and the ability to focus manually. Autofocus is further divided into active and passive systems, each of which has some limitations in the theatre. Active autofocus relies on a beam of light to establish the distance to the subject, while passive autofocus uses a special sensor to determine the visual contrast between items to

camera focus and autofocus settings

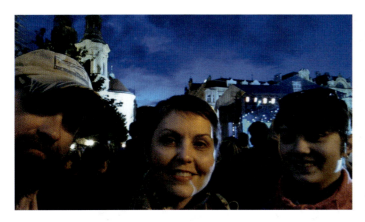

Figure 2.1: Family selfie in Old Town Square, Prague, 2015.

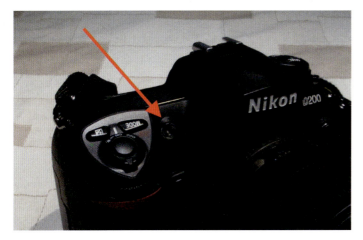

Figure 2.2: Autofocus light on Nikon D200.

determine the focal distance. The focal distance is the distance from the camera to the subject that, at a given point on the focus ring on the lens, will render the subject in focus.

When using the active autofocus system in your camera, there is a special light separate from the flash unit, often found on the right side of the camera near the base of the lens and the viewfinder. It may be coupled with other features such as red-eye reduction, but those don't really come into play at the distances we are generally shooting from in the theatre. In fact, the active autofocus light isn't really of use at those distances either. The concept is that your camera sends out a beam of light, and measures that beam upon its return to the camera, enabling the camera to derive the distance to the subject. Often, your camera may require you to be using a certain metering mode as well, which we will discuss in Chapter 3. Once it knows the physical distance to the object, the camera can adjust the focus of the lens based on the chosen aperture. The active autofocus may help when you are shooting close-ups, but is usually only useful at distances of a few feet to your subject. The active autofocus system is also hampered in low-light situations, and may result in the failure of your camera to accurately focus on the stage. I have often found this to be the case with my camera when photographing dark scenes, and often find myself switching to manual focus when the camera can't figure it out.

The passive autofocus system relies on an extra focus sensor strip that runs horizontally inside the camera when the camera is held in "landscape" mode. The camera uses this focus strip to detect a small portion of the image you are focusing on. It then optimizes the focus to create as high a contrast as possible between the various pixels on the strip. If the image is blurry, then there is more of a gradient from light to dark, whereas if the image is sharp, there will be a major shift in contrast from one pixel to the next. The camera knows what kind of lens you have, and with that knowledge, and the knowledge of what aperture setting you have selected, the camera can automatically dial in the correct focus for the object you are designating as your main point of interest in the shot. This system works particularly well if there are vertical, high-contrast elements in the shot, such as the contrast seen in Figure 2.3 between the character of Billy Bigelow, on the right, and the blue cyclorama behind him. If, however, you are in a low-light situation, or your camera can't find high-contrast verticals, you may be out of luck and need to switch to manual focus again.

When you look through the viewfinder and line up your shot, you then usually depress the shutter release button only halfway,

Figure 2.3: Sharp focus detail of scene from *Carousel,* Bucknell University, Oct. 2016.

Figure 2.5: Blurry focus detail of scene from *Carousel,* Bucknell University, Oct. 2016.

Figure 2.4: Sharp focus detail of pixel strip from passive autofocus system.

Figure 2.6: Blurry focus detail of pixel strip from passive autofocus system.

which triggers the camera to use its autofocus modes, as appropriate, to derive the proper focal distance. Once your camera has settled on a distance and has adjusted the focus, you can then continue to squeeze the shutter release and take the picture. Be sure to give your camera enough time to adjust the focus before taking the picture so that you assure yourself a crisp image.

Your camera may appear to run the focus in and out if it can't find the right distance, and may possibly default to one end of the range or the other, most likely leaving you with nothing even remotely in focus. Many cameras have the ability to hold focus once you've pressed the shutter button part of the way. If yours does, then you can take advantage of this trick by focusing the camera on an object that may not necessarily be at the center of your frame and then reframe your shot while continuing to hold the shutter button partially depressed. Once you've settled on the proper composition you can press the shutter button the rest of the way and take your shot.

If you happen to be using an older lens on a newer DSLR, you may not have the option for all of these autofocus settings, or you may even be using a lens that was made prior to all of these possibilities, in which case you will need to be sure to set the focus yourself. Most older lenses have a split focus

camera focus and autofocus settings

Figure 2.7: Typical manual/autofocus switch location.

field in the middle, in which the image is sliced in half and thrown slightly out of alignment unless the lens is focused to the proper focal length. It's best to locate a vertical line (the edge of a set piece, for example) to use as a guide for making sure the right focal length is set. Getting the pictures in focus is fairly easy and is certainly improved with much practice. However, don't discount the fact that your eyes may get tired over the course of a fast-and-furious photo-call. I find that if I'm not thinking about it, I end up squinting fairly hard through the viewfinder while taking pictures, and I have to take a moment to relax my eyes.

A camera may have several different autofocus modes. Mine has four that are representative of the most common options available. They are selected with the switch shown in Figure 2.8. From top to bottom, they are:

- Dynamic Area – Closest Subject: Camera focuses on the object(s) closest to the camera in focus, disregarding the rest of the shot. This mode is not useful for long shots.
- Group Dynamic: Camera focuses on the center of an area in the shot, which is selected by the user with the round rocker pad (see Figure 2.8). This mode allows a user to

Figure 2.8: Autofocus area mode selector switch.

focus on a very important subject that may not be in the middle of the frame.
- Dynamic Area: Camera focuses on the center of an area in the shot selected by the user, but also factors in focal information from other parts of the frame. This is useful for keeping a moving object in focus. If, for example, you are trying to focus on a dancer in motion, this feature will help predict the proper focal length for that dancer as they move through the frame. Some cameras have a feature related to this, which is called predictive focus tracking, where the camera is focusing on where the object will be when the shutter is pressed, as opposed to where it is now, based on the current movement of the object.
- Single Area: Allows the user to focus on one part of the frame, and is best for static compositions.

You may have the same or very similar options in your camera, but with different names. Check out the descriptions in the user manual; then experiment with each of your camera's specific autofocus modes to see what works for you. I tend to use the single area mode, since I want to make sure I'm focused on the characters that I am usually framing near the center of the shot, and I usually don't have to worry about people in motion.

In Figure 2.9, you can see nine small rectangular boxes, which are possible focus points that you can have the camera focus on if you choose one of the dynamic settings. Your camera may have a different layout, but most higher-end cameras have a feature similar to this. Many cameras also have a feature that supplements (or replaces) this feature, using sophisticated digital facial recognition algorithms to automatically find all the faces in the shot, highlighting them in your viewfinder, and trying to focus on them. This facial recognition feature may not work at a distance as well as you might like, so again, experiment.

Often, when shooting in the theatre, we run into situations where the lights themselves are in the shot, due either to the angle of the shot you are trying to take, or to the overall architecture of the venue. One of our most used venues at Penn State is a black box with a 16' grid height, so almost all shots inevitably have some of the lighting grid in view. A single bright-light source in an otherwise low-light setting can often lead to lens flare. Lens flare is the reflection or glare of lights directly shining on the surface of your camera lens. While this can create a very dramatic look, like in this shot from *Unto These Hills*, it is usually more of an issue to be avoided or mitigated than something you might want to capture in all your shots. I am usually trying to capture the moment as the audience experienced it, and their eyes wouldn't have reacted to the stage lights in the same way.

Many lenses come with an accessory called a lens hood. It attaches to the front rim of the lens (just like the lens cap), and is a simple tube that extends out from the front of the

Figure 2.9: Typical viewfinder in a DSLR camera.

Figure 2.10: Lens flare from Eagle Dance, *Unto These Hills*, Cherokee Historical Society, 2006.

camera focus and autofocus settings

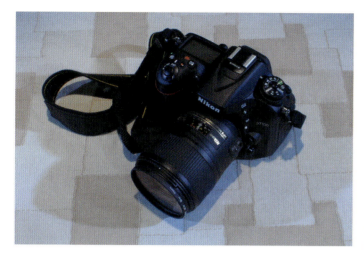

Figure 2.11: DSLR camera and lens without hood.

Figure 2.12: DSLR camera and lens with hood attached.

lens to shield the surface of the lens from lights shining on it from oblique angles. (Such hoods may also be purchased as aftermarket accessories if your lens did not come supplied with one.)

The hood adds some length to the lens casing, but so little weight that I almost never notice its presence. For longer-throw lenses, the hood may be a fully intact tube like the one pictured, but for wider-throw lenses, the hood may have some scallops cut out to prevent the edges of the hood from getting into the shot. As such, it is important to get the appropriate hood for the lens that you are using, otherwise you may experience some **vignetting**, or darkening, at the corners of your shot. If you see this, then you need to replace the hood with one more suited to the focal length of your lens. My wife took the shot in Figure 2.13 for a later chapter. I was using the camera that has the hood on it, and we discovered her camera was being subjected to the lens flare you see in the photograph. Since we couldn't put the hood on her camera, the solution was to change angles a bit, which you will see the result of in Figure 6.32.

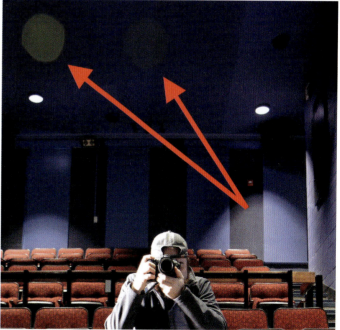

Figure 2.13: Lens flare without hood.

Camera Focus and Autofocus Settings Practice Session

This is the first set of suggested Practice Sessions that will be found in this book. Try out all the features in your camera to become familiar with them, and if you are already very familiar, you might still want to at least try the exercises that push your camera to its limits when working just with available light. Today's digital cameras often provide a preview screen on the back that gives us an immediate look at the shot we just took. The practice of taking a shot and immediately checking the results is somewhat humorously referred to as "chimping." While this is fine if you want some basic info about framing or major exposure questions, you should avoid relying on the small preview screen when it comes to details. It will be difficult to tell if you are truly in the sharpest focus possible, and the details in the highlights and shadows at the edges of your exposure window may be difficult to see.

The first step in reviewing your successes should be to load the pictures into your computer and view them on a quality monitor that has been calibrated. For some exercises, though, you may need to go a step further and print out some of the test shots that you take to see the final quality, since print quality is more demanding than laptop screen quality. Many of the exercises can be easily downloaded and viewed on screen – such as the shutter speed ones. You will be able to see what you need to see on the screen without printing the pictures. Other exercises may require you to print out your pictures in order to see the difference in color or resolution. Just because it looks great on screen doesn't always mean it will translate well to the final print. If, however, you are living in a totally digital world and aren't planning on printing things, then you won't have to be concerned with this aspect of things.

Read your camera manual and check out the focus settings page(s).

1. Do you have active or passive autofocus?
2. What settings need to be activated for your active autofocus to function properly?
3. What settings need to be activated for your passive autofocus to function properly?
4. How many focus zones do you have, and how do you switch between them?
5. How many autofocus modes do you have?
 5.1. How easy is it to switch between them?
 5.2. In the modes that depend on the user to select the focal point, how do you accomplish that?
6. Set up a shot with three different people in it, positioning one close to the camera, one at mid-range, and one far away.
 6.1. With the lights on brightly, experiment with your autofocus options.
 6.2. Experiment with switching to manual and getting a sharp focus on the various people in the shot.
 6.3. Then, with the lights turned low, try to use the autofocus features. If they still work, try turning the lights down even lower.
 6.4. With the lights still at a low level, switch back to manual and see if you can get a crisp shot with the amount of light present.
 6.5. Often, manual focus cameras will have a center circle that is bisected horizontally or on a diagonal. When the image is in focus, everything will look fine, but when it isn't, things won't line up in the circle where the line cuts through the image. Find a vertical line, either a person against a backdrop, as in Figure 2.3, or the edge of a scenery element. The proscenium arch may work as well, but I often find they are too dark to use for this. Work in the dark to see how easy or difficult it is to manipulate the focus in these conditions.

chapter three

the camera meter and how a digital camera perceives light

22 camera meter and light

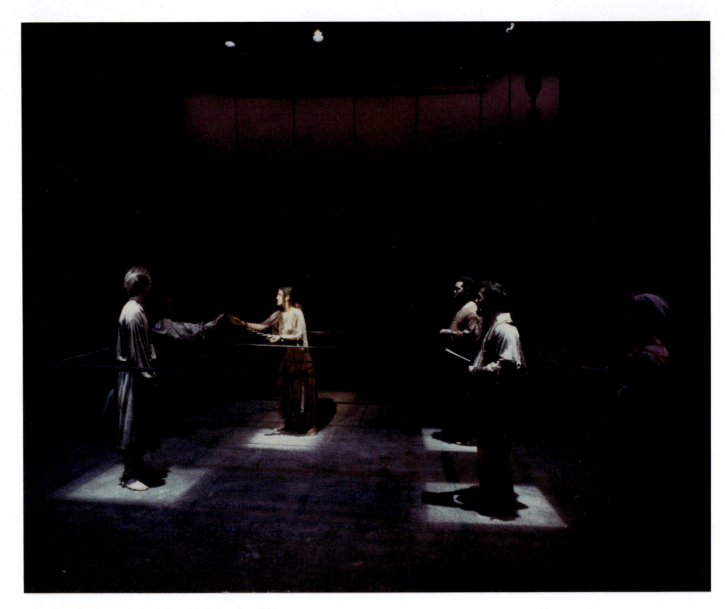

Jail scene, *Our Country's Good*, Brandeis University, 1994.

One of the most important things that you will be interacting with is your camera's light meter. Photography is all about capturing the light that bounces off of various surfaces, and makes its way through your camera lens to the image-capture device in the back of your camera. Along the way, the amount of light that is captured and fixed as an image is influenced by several parts of the camera that you have control over. Light, however, is ethereal. I can't give you a box of light, nor can I hand you five **foot-candles** of light.

Light can be measured in many ways, each of which is usually a quantification of the visible electromagnetic energy being transmitted by a source or reflected by an object. The most common unit that you may have heard of is a foot-candle. This is a measurement of light defined as the amount of light cast by a standard candle on a surface one foot away. There are many other metrics for measuring quantities of light, but we don't need them when it comes to metering light for photography. In photography, we are concerned with "**stops**" of light. A "stop" of light is not an absolute measurement, but is instead a measure of intensity relative to another lighting situation. A stop of light is, simply put, either twice or half as much light as in another lighting situation. Put another way, I can't hand you a stop of light, but I can increase or decrease the brightness of a given light by one stop. This would be done by either turning the light up twice as bright or dimming it down to half as bright as it was before. Almost everything we will talk about in terms of photographic exposure will revolve around this concept.

We also need to know about the Exposure Zone System. This was created by Ansel Adams, one of America's most famous photographers. He created the scale shown in Figure 3.1, which quantifies all the possible exposures available between pure black and pure white.

The zones are numbered zero (0) through ten (X), with Zone five (V) being considered middle grey. Our eyes, which are still far more capable of perceiving light than any camera made, are often able to discern detail in almost all of these exposure zones simultaneously. Most cameras can only accurately capture detail in any five adjacent zones. When you are choosing your exposure for a certain shot, you need to consider which of the five zones you want to see. Usually anything outside of the five zones that you are exposing for will fall off either end of the Zone System scale. If you set your exposure up so that you can actually capture items in the shots that are in Zones VI–X, then what you are doing is exposing for Zone VIII. Anything that has the equivalent brightness of Zone VIII will appear just fine, as well as any slightly brighter or darker items. However, anything that is much darker than Zone VI will just appear black. You will lose detail in the shadows for all those zones. If you don't have anything in the shot that would be as bright as Zone IX or Zone X, then you can expose for the middle of the range, and will get more detail visible in the lower zones...although Zones 0 and I may meld together.

The so-called falloff at the edges of the five zones that are properly exposed for will probably not be quite as drastic as this strip makes it seem, but it's fairly close to this concept. Certainly, once you are down to Zone II, I, and 0, those three will most likely all appear the same. Now, if we move our exposure so that it centers on Zone V, we will see something more like Figure 3.3. We will still experience some over-exposure and under-exposure at the extremes, but there may be a bit of perceptible detail that wasn't there before.

Remember that depending on what is in your shot, you may or may not have elements that fall within all of these zones to begin with. A perfect example of the extremes that

Figure 3.1: Ansel Adams's Exposure Zone System.

Figure 3.2: Exposure Zone System with camera set to optimally expose for Zone VIII.

Figure 3.3: Exposure Zone System with camera set to optimally expose for Zone V.

you might run into would be a scene with the characters in traditional American wedding attire. The men would be in black tuxedos, and the bride in pure white. The bridesmaids and the flowers may fall somewhere in between. The tuxedos might be considered to be in Zone 0 or Zone I, whereas the wedding gown might be in Zone IX or Zone X. This picture is said to have a high-contrast ratio. In other words, there are objects in the frame that are reflecting light at an intensity commensurate with most, if not all, of the 11 zones. If you set your camera to expose for the overall scene, you will find that there won't be much visible detail in the blacks of the tuxedo fabric, while the wedding dress will appear as a white blob, or possibly even too over-exposed to identify. You have to decide where you want the details to show. Almost without fail, I will choose to under-expose the subject so that I see good detail in the brighter parts of the shot. If there are over-exposed subjects, then the detail will be blown out and lost, whereas under-exposed subjects can sometimes be rescued in your digital image editing software and selectively brightened to reveal some detail.

If you look back at the cover photo for this chapter, you will see a perfect example of a shot that has elements through almost the entire zone range. I wanted to catch detail in the light tan costume piece worn by the female character, but she was being hit by a very tight and very bright beam of light from directly overhead, so while her costume is a tiny bit over-exposed at the shoulder, if I had under-exposed this shot any more, I would have lost many of the details in the shadows, possibly even the minor characters looking on from the edges of the shot. This shot was taken with Ektachrome 320T film, and is a digital scan of the resultant slide. Today's digital cameras are able to reproduce this shot easily, and may even have more ability to perceive details in the shadows than my film did at the time.

Let's talk about reading your camera's meter. Look at this viewfinder example again and note the meter bars at the bottom of the frame.

Usually at the center of the meter scale, you will see a 0, which represents optimum exposure. When your camera is adjusted to the settings that the internal light meter thinks are the best ones possible for capturing the shot you want, it will just have a lit bar below the 0. I also refer to this as the camera being "on the meter." You will also notice a scale centered on the 0 with marks at +1, –1, +2, and –2. There are also some intermediate marks between the numbers representing fractional stops of light. If your settings will result in the camera over-exposing the shot by 1 stop, then the meter will light up the bars all the way over to the +1, indicating that you need to adjust the camera to reduce the amount of light coming in by half. The intermediate marks indicate 1/3 or 2/3 of a stop (or in the digital readout, it is usually noted as 0.3 or 0.7 stops). In a perfect world, we would always be adjusting

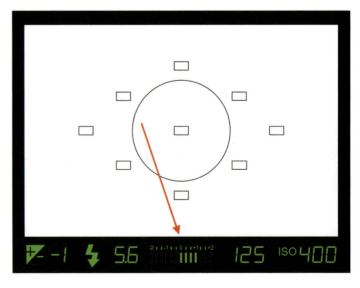

Figure 3.4: Typical light meter embedded in viewfinder.

the camera to set for that optimal exposure indicated by the meter reading simply 0. However, many factors influence what the meter sees, and you need to be aware of those issues in order to work with the meter to get the exposure you really need, as opposed to the one the camera thinks you need. In addition to working hard to gain the proper exposure for a shot, in Chapter 13 you will also learn about the practice of bracketing, which will give you more exposure versions of each shot to choose from later on.

Before you delve into more of these meter settings, you need to ensure that your meter is calibrated. One easy and relatively inexpensive way to do this is with an 18% grey card.

The 18% grey is the same grey found in Adams's Zone V, so it is also sometimes called middle grey. Your camera is calibrated to this value, and it can be used to check your meter.

1. Set your camera's meter to spot metering mode, and your camera's focus mode to a single area. Make sure both of these points are the same, and in the middle of your frame in the viewfinder.
2. Have someone hold the grey card in the light that you will be shooting under, and then allow your camera to meter off the grey of the card, as opposed to the colors of the set or costumes. This will ensure that the colors and values of all the various parts of the scene don't trick your meter into over- or under-exposing your shot.
3. Set your camera's metering options to manual, and adjust the aperture or shutter speed until only the middle bar is lit below the 0 on the meter scale. Now you are "on the meter," and you know that the camera will consider the grey card as the middle value for exposure.
4. You no longer need the grey card in the shot, and you now have an idea of how your camera is sensing the light in your scene. Take a picture using the settings that the meter saw while the grey card was in the shot, and look at the resultant exposure. Does it appear correct?
5. Now look again at the shot without the grey card, and see if your meter wants the shot to be over- or under-exposed. We don't have the time to do this for every scene, and as soon as the lights change, the settings you derive from this experiment must likewise be changed, but at least you will have a feeling for what your camera's meter thinks it sees versus what the audience sees.

In addition to using the built-in meter, some photographers go the extra step and employ a handheld light meter, such as the one shown in Figure 3.6.

While these can be an expensive addition to your kit, you may find them useful depending on what sorts of situations you are shooting in, and how much shooting you do in a year.

Figure 3.5: 18% grey card for meter balancing.

Figure 3.6: Gossen Starlite 2 handheld photographic light meter.

Figure 3.7: Metering mode selector on the D200, currently set to color matrix metering.

There are three major types of meters: reflected-light meters, spot meters, and incident-light meters. A reflected-light meter is found inside your camera already, but this type is also manufactured in a stand-alone handheld form. They measure the amount of light reflecting off of your subject(s), and will confirm which camera settings are best for the scene. A handheld spot meter is a more focused type of reflected-light meter, in that it only measures a very narrow spot within the scene. This is very useful if you want to meter off of that wedding gown in the fictional scene I described earlier. You should get a reading for just the gown, not influenced by anything else around. Keep in mind that if you are just metering the gown, the exposure readings you will get will try to render that white wedding gown as middle grey…perhaps not what you want. The incident-light meter measures the amount of ambient light falling on an object, and must be held just in front of the object, as opposed to being held by the photographer out in the house. It is impractical and time consuming to have to keep running up on stage to take a measurement for every shot.

Now that you are familiar with light meters and metering concerns, I'll tell you that I never use my handheld meter, and my camera is almost always set to field-metering mode. Why? Partly because I trained to shoot before all these options existed, and partly because I'm used to thinking about what the camera will see, and I'd rather not fight its tendency to expose for middle grey when in anything other than a field-metering situation.

From top to bottom, the three options on my camera are center-weighted metering, color matrix metering, and spot metering. Spot metering concentrates on a very small portion of the overall frame, much like a handheld spot meter. Center-weighted metering gives the priority to the center 20 percent of the frame, while color matrix metering essentially meters the entire field of the shot. If I ever experimented beyond the

Figure 3.8: Over-exposed shot caused by field metering.

Figure 3.9: Properly exposed shot three stops under-exposed.

color matrix, I might go with the center-weighted option, but your experience may lead you down a different path.

The following set of shots replicates one of the most difficult setups we might encounter: a lightly colored object surrounded entirely by black. Figure 3.8 shows what happens when the camera uses the field-metering setting and is trying to expose for middle grey. If you look closely at the surface the wolf toy is sitting on, it appears grey, but is actually black velour. Figure 3.9 shows the proper exposure for this shot, with the wolf toy being rendered properly, and the black velour appearing much darker. This shot is three stops under-exposed, and could go even a bit more if you wanted the cloth to appear realistically black in our final image. The next shot, a full stop further under-exposed from this one, made the toy appear too dark, so perhaps we only need another 1/3 or 2/3 of a stop instead.

Your best bet is to shoot as much as you can, to become familiar with your particular camera's metering tendencies. Does it consistently read low or high? If so, you can work with

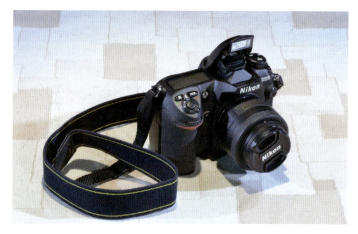

Figure 3.10: Nikon D200 with built-in flash deployed.

the EV compensation discussed in Chapter 12. How does your meter respond to truly low-light situations? High-contrast situations? Which metering option solves the problems best for you? Professional photographers usually employ light meters

Figure 3.11: Candid photograph of Mike Birardi and Katy Morgan without flash.

Figure 3.12: Candid photograph of Mike Birardi and Katy Morgan with flash.

and concern themselves with many of these metrics, but theatre designers often don't have time to deal with such issues in the midst of a photo-call. I have been very successful using my eye, my accumulated experience, the meter in my camera, the practice of bracketing, and some good luck over the years to get quality shots for my portfolio. I don't mean in any way to discount the value of handheld meters, but you will be well served at this point to spend your money on a good camera body and lens first, and spend some quality time with them.

Since we are talking about light and camera meters, let's discuss the use of a flash in stage photography. Flash units are very useful in many other situations, such as the pair of photographs seen here. These were taken with my Droid Maxx smartphone's camera, at the house left side of the seating at Radio City Music Hall. In Figure 3.11, you can see that the camera was exposing for the bulk of the shot, which included a brightly lit set of seats behind the subjects. As such, there isn't enough light on their faces to properly see them, and the contrast between foreground and background is too unbalanced and is the reverse of what it should be for a good shot. To solve this in a candid situation, it was easy to just turn the flash on and take another shot, which yielded Figure 3.12. My students are now clearly visible, and the foreground–background contrast is fine. You may also notice that the colors are a bit brighter and more vibrant in Figure 3.12.

Now, this is still a smartphone candid, so I'm not terribly concerned about some of the other aspects of these shots – it does what I needed it to do. However, I think you can see quite easily how much of an effect a single flash can have on a shot. There are some situations when you might need to employ a flash to capture a process shot or some other detail, but when it comes to taking pictures in a photo-call, I would avoid it at all costs.

Theatre photographers especially do not use flash during a photo-call for three connected reasons:

1. A flash introduces light to the scene that was not part of the lighting designer's original intent. If you are in a small space, the flash might actually affect the look of the resulting picture by flattening the image out. This effectively ruins the work of the lighting designer, especially when it comes to the careful, three-dimensional sculpting that they may have done in building the cues for the scene. You can also see this flattening effect when you look at Figures 3.11 and 3.12.

2. A flash is also possibly the wrong color temperature for the scene, and will skew the colors of the scene. This

affects everyone who has contributed colors to the scene, including the lighting designer, the scene designer, the costume designer, the scenic artist, the props designer, and even the makeup designer. Again, this is common if the venue is small, but won't really matter if the venue is large, due to our third concern. This is also very evident if you look at the color of the seats in Figure 3.11 versus Figure 3.12.

3. The **Inverse Square Law** tells us that the intensity of light over distance decreases according to the following formula: $\Delta I = 1/\Delta D^2$.

 Translated, the formula means that the Change in Intensity = 1/Change in Distance2.

 This means that for a given intensity of light at 10 feet, the corresponding intensity of the light at 20 feet will be 25 percent of the original measurement. If you start with 100 foot-candles at 10 feet, you will have 25 foot-candles (one-fourth) at 20 feet, and 11.12 foot-candles (one-ninth) at 30 feet.

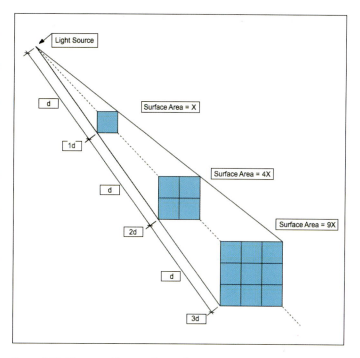

Figure 3.13: Diagram of Inverse Square Law.

The result of all this math is that, in a typical proscenium house, the amount of usable light from the camera's flash that reflects back off of the subject and makes it back to the camera is essentially non-existent. Your eye can still perceive the light, but the camera won't get any benefit from it illuminating the shot. We don't really want this anyway, due to the distorting effects I mention previously, and for another important reason. When you set your camera up to use a flash, it is expecting that extra light to be returning to the camera after bouncing off the subject, and sets up the aperture and shutter speed with this assumption in mind. If you have ever been to a rock concert, and seen people all over the venue taking flash pictures, then you are witnessing the Inverse Square Law doing its worst.

Instead of 20 or 30 feet from the stage, often the audience might be 100 feet or more. If we do the math (Relative Intensity = $1/10^2$), then we realize that if you were starting with 100 foot-candles of light, only 1 foot-candle is making it to the stage. *And that poor, lonely, single foot-candle of light still has to travel all the way back to your camera.* There is a corresponding benefit to moving either your eye or a camera further away from the image you are capturing. The further away you are, the smaller the area on your retina that the image will be focused. So, as you move back, the light intensity drops, but as it drops, the lens focuses that light on a smaller surface area, which keeps the intensity in balance. If this weren't to happen, things would appear to dim or brighten as you move further away or closer to them. Regardless, this isn't sufficient to overcome the fact that the camera has already lost most of the useful intensity of light from the flash. Most of the time that people use flash, they set their camera to one of the automatic program modes, and often there is a specific one just for flash use. Either way, the camera is assuming a certain amount of light will be added in to the image when you press the shutter

release button, and since that light isn't making it back to your camera, your shot will turn out very under-exposed.

Depending on your camera brand and type, there will be an optimal flash setting, which is often indicated with a lightning bolt symbol on the camera. This is known as the flash-sync setting. If you are using a flash for something specific, you need to figure out the optimal sync speed setting, which is listed in your owner's manual. If you don't use the correct speed, the flash may fire too soon or too late, ruining your shot with either poor exposure or black bars across the frame of each shot. If you see a black bar, the shutter hadn't fully opened yet, or had already started to close again when the flash fired. The shutter blocked a portion of the image sensor from capturing the light coming in through the lens.

I have seen some photographers set up a pair of independent flash units just outside of the view of the camera, in order to provide some fill light into eyes and faces. Alternately, I've seen two soft fill lights placed just outside of the camera's view instead, which removes the concern about having to remotely trigger the flash multiple times. This gives the photographer more of the quality of light that would be found at a traditional photo shoot for a magazine. While this remote placement of flash units eliminates the concerns about light loss over distance due to the Inverse Square Law, it doesn't eliminate the concerns I raised about color temperature or depth-of-field. More often this is a technique used by publicity photographers looking to get some good close-ups for the arts section of the newspaper. Perfectly valid for their purposes, but perhaps not as accurate as we would prefer to be for a portfolio shot due to color inaccuracy.

Once you are truly comfortable with your camera and its meter, you will find that you rarely have to continue to refer to it. This is a bit ironic, but is also a good gauge for you to use to see how well you are aligning your eye and the camera meter.

The Camera Meter Practice Session

1. In order to see what your meter is trying to accomplish, set your camera to automatic exposure, and take a picture of something that is exclusively bright white. Your camera's meter will try to expose that shot so that you end up with a grey field instead of white.
2. Also, try the same thing with a picture of something exclusively black. Again, your meter will go for a fairly long exposure, trying to expose the all-black field long enough that it ends up as middle grey. These are both things we hope to avoid, namely the camera's tendency to assume that the largest part of the picture you are taking should be middle grey.
3. Investigate the various metering options that your camera has. Take pictures of a bright, evenly lit scene with each of the various metering options, and see which one seems most accurate for your purposes.
4. Now take pictures with each metering option of a very dark scene, where everything is of varying levels of dark across the shot.
5. Take pictures of a scene with an artificially high contrast ratio, including black-and-white objects in several locations through the scene. Which meter options work best here?
6. Taking pictures where you are exposing for a small, well-lit object or group that is then framed by a very dark or almost black frame is usually going to fool your meter if you have it set for field metering. Set up a scenario similar to the shots with the wolf toy on a black field. Try center-weighted metering or spot metering instead, and also try spot metering a grey card in front of the object(s). See which one yields more accurate results.

chapter four

the primary settings

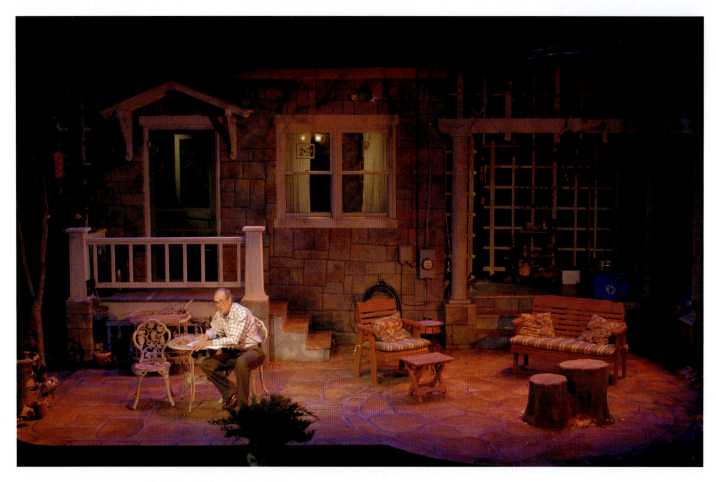

Opening moment, *Proof*, Penn State Centre Stage, July 2007.

Even the most basic camera generally has what I refer to as the Primary Settings (although the price you paid for your camera will have a great deal to do with how much control you have over these).

- Aperture or f-stop
- Shutter speed
- Film speed or **ASA/ISO**
- White balance

These can even be "found" when you consider my oatmeal container camera. Aperture is the size of the opening in the camera that allows light to pass through to whatever medium you are using to capture it, be it film or computer chip. In my case, it was the size of the pinhole I made in the side of the container. Shutter speed controls the duration of time that the **capture medium** is exposed to light. In my case, it was how long I left the hole open before covering it again with tape. Lastly, film speed and white balance are influenced by the type

and sensitivity of the particular film stock I chose to place in the camera. Film speed refers to the sensitivity of the capture medium, and white balance refers to the capture medium's ability to accurately render colors given a particular quality of light. My first, very basic 35mm SLR-type film camera gave me access to more precise control of these four settings. Now that we live in the digital era, we can enjoy far greater precision still.

No matter how much money you spend, however, keep in mind that current cameras are not quite as capable as the human eye at detecting and processing light. We must work hard as photographers to capture the best possible representative image of what our eye sees easily, and to be successful, we must understand the limitations of and trade-offs required by these Primary Settings. The first three – aperture, shutter speed, and film speed – work in direct concert with each other to affect the exposure of each shot, so their interplay and concurrent effects on the final image must be considered. We will delve into those concerns in subsequent chapters, but for now it is crucial to understand how these settings relate to each other.

Aperture

The aperture setting is also known as the f-stop of the lens. This number is found by dividing the focal length of the lens by the diameter of the lens opening. A lens is usually specified with two numbers: the focal length and the maximum aperture. A 50mm f/1.4 lens thus has a focal length of 50mm and a maximum aperture of f/1.4. Focal length will be discussed more in depth in Chapter 9, but we will focus on aperture for now. Aperture is controlled by a mechanical set of leaves inside the lens that overlap each other and allow the photographer to increase or decrease the diameter of the opening through which light passes as the lens focuses it on the capture medium. On a digital camera, this setting may be manipulated with a dial or other control, with the result showing up on a readout inside the viewfinder. They are often noted without the "f," as seen in Figure 4.1.

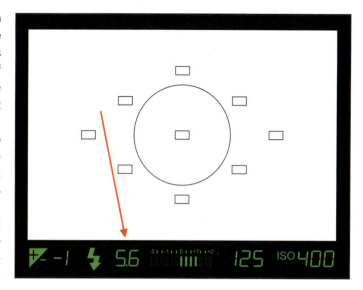

Figure 4.1: Aperture readout inside the viewfinder display.

Changing the aperture controls *how much* of the light reflected by the subject is allowed to pass through the lens and register on the capture medium. What the aperture can do is change the amount of light passing through the lens by opening or closing. Each step up in f-stop will double the amount of light passing through the lens; each step down halves it. As you may recall, this is equivalent to a change of plus or minus one stop of light.

Shutter Speed

Shutter speed refers to the length of time that the shutter curtain at the back of the camera is open, exposing the capture medium to the light passing through the lens and its aperture. Usually this is measured in fractions of a second, and expressed by the fraction's denominator. For example, setting the shutter speed to 125 (which might also be referred to as a 125th) means that the shutter will open for 1/125th of a second. This setting usually appears as a whole number in the viewfinder, as shown in Figure 4.2.

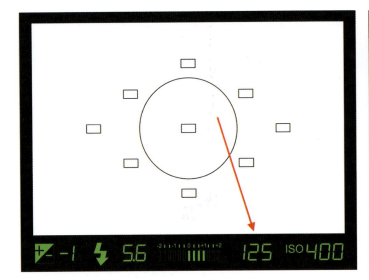

Figure 4.2: Shutter speed readout inside the viewfinder display.

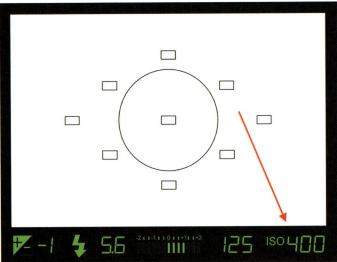

Figure 4.3: Film speed readout inside the viewfinder display.

The shutter curtain in the camera opens and closes to control *how long* the capture medium is exposed to light. As with the aperture, it doesn't change the amount of light reflecting off the subject, but rather controls how long that reflected light is allowed to pass through to the capture medium. Each change in shutter speed results in the shutter remaining open for twice (or half) as long as the prior step. This is again equivalent to a change of plus or minus one stop of light.

Film Speed

Film speed, which in film terms denotes the film's sensitivity to light, and in digital terms refers to the camera chip's sensitivity to light, is also referred to as the American Standards Association (ASA) or International Standards Organization (ISO). Simply put, this is a rating of how sensitive the capture medium is to the light passing through the lens-aperture-shutter mechanisms. This number is usually expressed as a whole number, such as ISO 400. If this information shows in your viewfinder, it might appear along with a small ISO indicator, as shown in Figure 4.3.

The sensitivity of the camera sensor mimics the changes in the sensitivity of film, and also follows the same numbering scheme. A shift from one setting to the next represents a change that makes the chip either twice or half as sensitive, meaning that you need either twice as much light or half as much light to fix the image with the correct exposure, which again is equivalent to a change of plus or minus one stop of light.

Once you get past all the numbers and acronyms, all three of these settings have essentially the same effect on the exposure of the image. There are a number of other considerations that we need to take into account when choosing between all these settings, but before we get into that, it is crucial that we look at the relationship of these three, which may be seen in Figure 4.4. This might be the most important image in this entire book, so grab a Post-it note and bookmark this page, as you may want to refer to it again.

For now, pay close attention to each side of the triangle, and you will see how the changes in each setting affect the

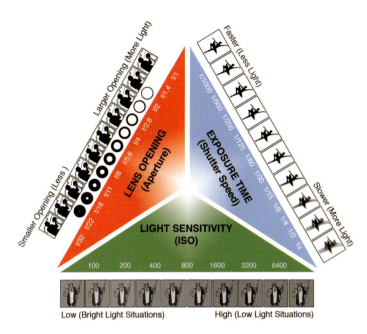

Figure 4.4: The Exposure Triangle.

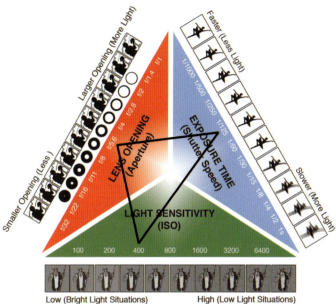

Figure 4.5: The Exposure Triangle with the camera set to ISO 400, f/5.6 @ 125th.

amount of light that is ultimately captured within the camera. Each range of settings accounts for more or less light, and each change from one setting to another results in a change that captures either twice (or half) as much light as before. It is important to remember that these changes are relative to a previous configuration of settings, and not absolute measurements. A particular group of settings may produce the perfect exposure for one shot, but as soon as the amount of light reflecting off the subject(s) changes, the settings will probably need to be adjusted as well. There isn't a golden setting that always works for theatre photography. To better understand these links, let's pretend that we have our camera set up for a shot, and we are "on the meter" with the following settings in place:

- Film speed set to ISO 400.
- Aperture set to f-stop of f/5.6.
- Shutter speed set to 1/125th of a second.

This relationship can be expressed as shown in Figure 4.5 with the lines connecting up the three settings.

Now, perhaps we want to change the shutter speed because we are taking pictures of a dancer who is moving, and we want the shutter speed quickened to capture her without any motion blur. We could increase our shutter speed to 250 (1/250th of a second), which is twice as fast as 1/125th. This means that the capture medium will only be exposed to the light coming through the lens for *half as long* as it was before, which will result in a shot that is one stop *under-exposed*. The solution to bring the shot back to proper exposure would be to open up the aperture to f/4, resulting in *twice as much* light passing through the lens. After doubling our shutter speed *and* the diameter of the aperture, twice as much light passes through the aperture but for only half as long, which means that, ultimately, the same amount of light is captured by the sensor as before.

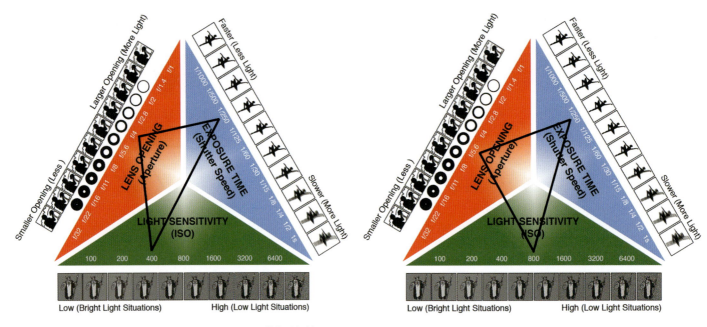

Figure 4.6: The Exposure Triangle with the camera set to ISO 400, f/4 @ 250th.

Figure 4.7: The Exposure Triangle with the camera set to ISO 800, f/5.6 @ 250th.

A third option, if we wanted to increase our shutter speed to 1/250th, but didn't want to change our aperture to compensate would be to change our film speed. This would be done if we wanted to maintain a certain depth-of-field, which we will discuss in the next chapter. If we move from ISO 400 to ISO 800, we are making the camera's light sensor *twice as sensitive* as before. Because the f-stop (aperture) remains the same, in this case the light reaches the sensor for half as long, but the chip is twice as sensitive during that interval, so again we end up with a properly exposed shot.

These three settings all affect proper exposure, and the concepts apply equally to color or black-and-white photography. We are dealing with lights and darks, or the "values" of each item in the shot, but not the "hues," which are dealt with next. All three of these settings work in concert with each other, and it is wonderfully useful that, despite all the different terms, they each represent the same amount of change in exposure. This symbiotic relationship is at the core of understanding proper exposure and all of the variations that are available to you.

White Balance

White balance, which deals with the color sensitivity of the film or chip, affects the hues, or colors, of the final image. White-balance settings help your camera understand what "white" is, and thus, how to accurately interpret all the other colors in the shot. Significantly, theatre lights produce a different color of white light than natural daylight or indoor fluorescent light. Since most people use their cameras in these two situations, camera chips are calibrated to accurately render color under those cooler white lights, and not the warmer quality of theatre light. If we don't adjust for our unique situation, then we will

find that our pictures are not color-accurate, and may in fact be so skewed as to be unusable. While white balance doesn't really have much bearing on exposure, it is just as important as f-stop, shutter speed, and film speed, because of our fairly unique situation with color.

It is a very good practice to decide upon your ASA/ISO and your white-balance settings at the start of each photo-call or session, so that you have a common exposure through-line for the session. If you see, however, from what you are getting on your preview screen that things are way off, feel free to change these settings as well. All of this data concerning the settings in the camera is usually embedded in the **metadata** of the photo file, so you can refer to it if needed to remind yourself of your choices. What you want to avoid is bouncing all over the place with these two settings during a call, as you will end up with a widely diverse set of shots, and this will burn time you can't afford to lose. As you gain more experience and knowledge, you will become confident in your settings choices in advance, giving you more time to focus on proper focus, framing, and exposure.

Much of what we do in modern photography is a direct result of how photography developed in the "film" age. The form factor of modern DSLR cameras steals directly from the look and shape of the old film SLRs, although that too is now evolving. The concepts of aperture and shutter speed still apply in the very same way they always did, but the concepts of film speed and white balance have moved from being a result of the type of film you chose to settings that live in the camera. Beyond that, they actually function the same way as far as their effect on the end result.

Another amazing feature of digital photography is the fact that the metadata about each shot you take is embedded within the image file, allowing you to pull up a great deal of info after the shoot is over. This means that you don't have to recall what your settings were for a specific shot anymore, and can call up that information as needed later on.

Most image-manipulation programs can read and report this data, but you can even find it on some of the more basic image viewers. Figure 4.8 shows the inspector window for the image seen at left, and amongst all the other data there, you can see things like the ISO, f-stop, and shutter speed. This display doesn't show the actual color temperature (as determined by the white-balance setting), but at least I know it wasn't on automatic. You can even see the details on the lens I was using. The remaining tabs reveal additional information about the camera used and other settings. When opening the **RAW** version of the file in Photoshop, I can see an approximation of the color temperature setting, based on what the camera saw.

The next four chapters delve deeper into these four Primary Settings, and provide additional Practice Session suggestions to help you understand the abilities and limitations of each, along with the trade-offs that you may have to make. Getting truly comfortable with these will get you very far down the road to capturing professional shots of your work.

38 the primary settings

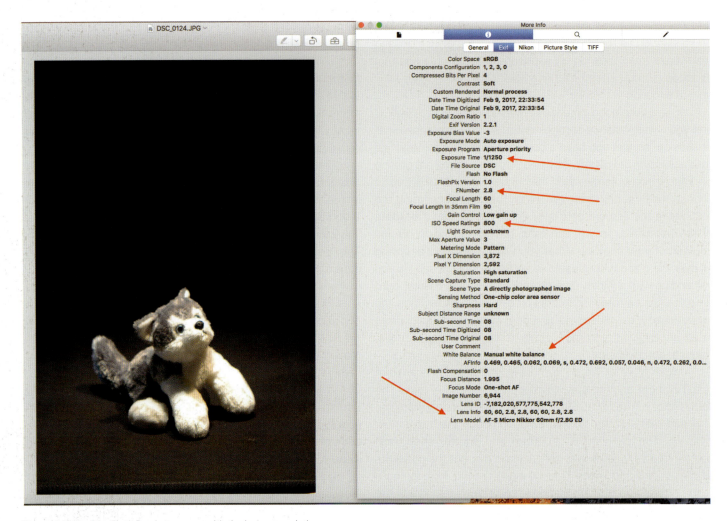

Figure 4.8: The MacBook Preview screen with the Inspector window.

chapter five

aperture

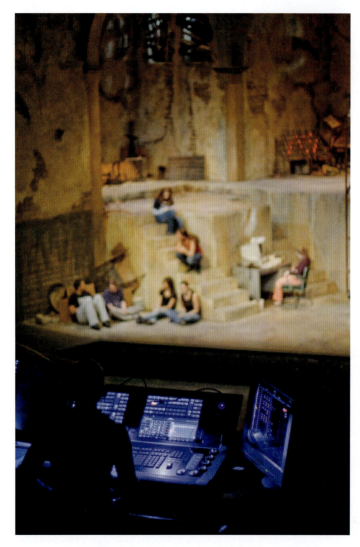

Student working at the light board, rehearsal of *Pentecost*, Penn State University, Sept. 2009.

As we learned in Chapter 4, the aperture of the camera controls the amount of light that enters the camera through the lens and passes along to the image-capture device. The aperture setting is referred to as the f-stop. The "f" stands for focal, and is sometimes also expressed as the focal ratio of the lens. As we also learned, this number is the ratio of the diameter of the opening to the focal length of the lens. The f-stop is not an absolute number, in that it doesn't measure a specific quantity of light, but instead measures a relative amount of light compared to the other f-stop settings. Typical lenses might have the following options available:

- f/1.4 – wide open
- f/2
- f/2.8
- f/4
- f/5.6 – middle of the road
- f/8
- f/11
- f/16
- f/22 – very tightly closed down

The amount of light gathered by the lens is simply and mechanically determined by the size of the opening that you set using the aperture ring on the lens. As you move from f/2 to f/2.8, you are "stopping down" the lens. The aperture is becoming smaller, and the amount of light reaching the capture medium is reduced. In this case, you are cutting the amount of light by half. As we learned in Chapter 4, with the Exposure Triangle, this is also referred to as 1 stop of light. The reverse is true when you "open up" the lens. If you were to move from f/2 to f/1.4, you would be opening up the aperture in the lens, and that step represents an increase in the amount of light. This would be 1 stop brighter, or twice the amount of light than before.

There are lenses available that exceed either end of this spectrum, and some that have stops measured somewhere between these numbers, but for the most part these are the

Figure 5.1: 35mm lens with aperture adjusted to an open setting.

Figure 5.2: 35mm lens with aperture adjusted to a closed setting.

standard numbers you will see on most every lens. On an older lens, you will see the focal length and the "maximum aperture" listed on the front of the lens, as in Figure 5.3, and for newer lenses, it is often found on the barrel of the lens and visible from the top of the camera, as in Figure 5.4. There may also be other letters and codes that refer to specific options that your lens has, or abilities such as "Macro" for close-up photography.

Even point & shoot cameras and smartphones will include this information somewhere on the body of the camera or on the lens. With most of these, you are stuck with what it is because you can't change out the lens on anything other than a mirrorless or DSLR-style camera body.

Regardless, it's good information to have, but can sometimes be misleading. As you can see, even the lens on my smartphone has a fairly fast maximum aperture of f/2.4, but it's not nearly as sharp or capable as a regular camera lens in lower-light situations.

It is very important to know the maximum aperture of your lens. Most all lenses will close down to at least f/16 or f/22, but depending on the quality, cost, and construction of the lens, it may or may not be able to open up as far as others. A lens that can open up to f/2 or f/1.4 would be considered a *fast* lens, in that it has a great deal of light-gathering ability. These are usually more expensive as well, due to the higher construction costs.

Figure 5.3: Manual 35mm lens with maximum aperture of f/2. (Shown as 1:2.)

Figure 5.5: Canon PowerShot zoom lens 5mm–100mm with variable aperture of f/2.8–5.7.

Figure 5.4: Autofocus 35mm lens with maximum aperture of f/1.8.

Figure 5.6: Olympus Stylus zoom lens 6.7mm–20.1mm with variable aperture of f/3.5–5.

Figure 5.7: Motorola Droid Maxx with **prime** lens with maximum aperture of f/2.4.

As of this printing, a Nikon AF-S Nikkor 50mm f/1.4G lens costs about $450, while the same focal-length lens with a maximum aperture of f/1.8 is about $230. There are a few other minor differences, but you will usually find that, if all other options are equal, you will pay a good bit more for the faster lens. In the end, if you can afford it, it is usually worth the cost…at least it has been for me over the years. I'm not sure that the difference of $220 is worth it between f/1.4 and f/1.8, but if the difference is between f/1.4 and f/2.8, then that represents 2 stops of difference, or four times the light-gathering ability. That has often been the difference between capturing the shot and wasting the shot.

So, we know that a wider aperture is better for capturing low-light shots, but there is a trade-off, other than the higher costs associated with faster lenses. That trade-off has to do with depth-of-field. Depth-of-field is the term that refers to your camera's ability to keep multiple planes in focus simultaneously. This is another situation where the camera can't replicate our eyes yet. As you look across the room, you should be able to see everything in focus. The book in your hands is usually in as sharp a focus as the wall across the room. Camera lenses are limited in this respect, so here's the first major trade-off you need to be aware of:

> The larger the aperture, the less sharp-focus depth-of-field that can be captured. The smaller the aperture, and hence, less light-gathering ability, the greater the depth-of-field.

So, the real challenge here is that we often want to shoot with a fast lens in order to maximize our exposure, but if we open up all the way, parts of our shot may be fuzzy. If I shoot with a lens set to a wide-open aperture, I will probably have to choose to have only the foreground, or the midground, or the background in focus, but not all three. As I stop down the lens, which is the term for closing the aperture down to a smaller opening, my depth-of-field increases. Eventually, I might be able to have the foreground and the midground in focus at the same time. Once I get stopped way down, perhaps to f/16 or f/22, I will find that I might be able to have the whole scene in focus. Some lenses tend to lose a little overall sharpness when stopped down beyond f/16, so it is advisable to avoid going all the way to f/22 if your camera exhibits this tendency. The depth of the scene still has an effect, along with how close I am to the various planes of focus. The other way to help this situation is to move further back from the objects. As I get further away, the plane within which everything will be in focus gets deeper, to the point that, even with a wide-open lens, I might be able to get all three planes in focus at the same time. Again, this is mitigated by how far away I can

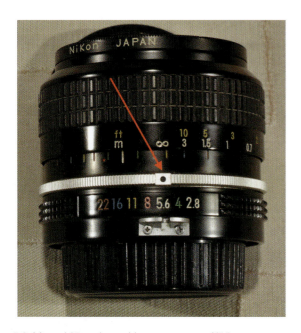

Figure 5.8: Manual 35mm lens with aperture set to f/5.6.

Figure 5.9: Manual 35mm lens with aperture set to f/4.

get, and how much distance there is between the foreground and the background. Selecting the aperture with a traditional lens is easily done by turning the aperture ring on the camera. Figure 5.8 shows this lens to be set for f/5.6.

Since the newer lenses in DSLRs require us to set the aperture using a selector wheel or menu buttons, we lose a fairly useful visual aid that is included on older lenses. Even though you may not see this on your camera lens, let's take a look as we delve into the concept of depth-of-field. If you look closely at Figure 5.9, you will see that the aperture is set to f/4. The ring near the front of the camera is the focus ring, and has white meter and yellow foot markings. There are colored vertical lines that correspond to the f-stop settings. The f/4 is green, and there are two green vertical lines. The green vertical lines in this shot line up with the 1 meter and 1.5 meter markings, which means that anything that is within the zone that is between 1 meter and 1.5 meters away from the focal

Figure 5.10: Manual 35mm lens with aperture set to f/11.

plane of the camera (the surface of the film or chip), will be rendered in sharp focus, while everything closer or further will be out of focus.

Now, if we adjust the aperture setting for this lens to f/11, you will now see that the yellow f/11 marking corresponds with the yellow vertical lines on the lens, which indicates that anything between 0.7 meters and somewhere greater than 3 meters from the lens will be in focus. In theory, if I know the exact distance from the objects in my shot to the focal plane, I can set the focus using this set of guides and the focus ring without actually looking through the camera to see if everything is in focus. Do I ever do that? No, definitely not, but you may see that setting being verified with a tape measure in older movie camera situations. On film and DSLR cameras, you will find a small symbol that indicates the location of the focal plane in the camera, so you could actually measure to that mark if you wanted. It is usually a circle with a horizontal line drawn through it, such as this: ⊖.

Let's look at some examples of how this plays out. In the following sequence of shots, I've placed several stuffed animals that are the same size on a conference table. Let's consider the cheetah to be sitting on the plaster line of our theatre, or at 0'. The wolf is 7' upstage of the cheetah, and the moose at the back is 14' upstage of the cheetah. In my initial set of shots, the camera is 7' downstage of the cheetah. If I shoot with my camera set to f/2.8, and focus on each of the three animals, I get the following sequence of shots:

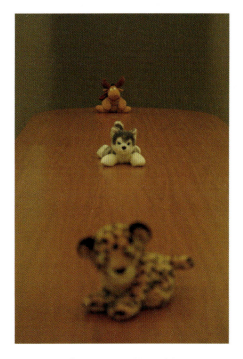

Figure 5.11: Camera set to f/2.8, 7' from the table, with the focus on the moose.

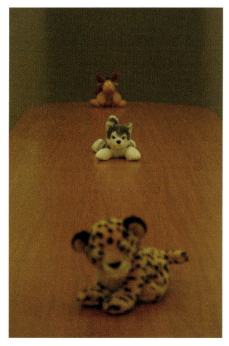

Figure 5.12: Camera set to f/2.8, 7' from the table, with the focus on the wolf.

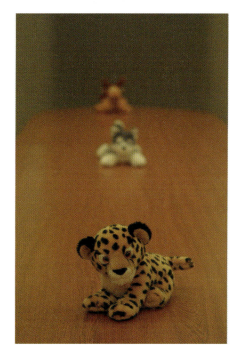

Figure 5.13: Camera set to f/2.8, 7' from the table, with the focus on the cheetah.

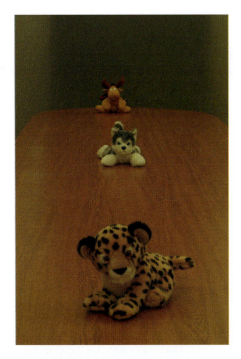

Figure 5.14: Camera set to f/16, 7' from the table, with the focus on the moose.

Figure 5.15: Camera set to f/16, 7' from the table, with the focus on the wolf.

Figure 5.16: Camera set to f/16, 7' from the table, with the focus on the cheetah.

You can clearly see the change in focus across the three shots as the shallow focal plane moves toward the camera. I then reset my camera to f/16, adjusted the shutter speed accordingly for proper exposure, and retook the same sequence of shots. If you look really closely, you can see very slight differences in the sharpness of focus on the moose, with it becoming slightly softer as you move from Figure 5.14 to Figure 5.16. Conversely, if you look at the cheetah across the three shots, it becomes slightly sharper as you move from Figure 5.14 to Figure 5.16. The wolf stays sharply in focus through the first two shots and just loses a little bit of sharpness in the last one.

Normally, we are shooting larger scenes from further back, which tends to minimize the issue of poor depth-of-field at wider apertures. I reset my camera for f/2.8, but moved it to a position 21' downstage of the cheetah, tripling the distance. I'm not using a zoom, but for ease of viewing the focus changes, I did enlarge and crop these shots.

As you can see, there is a slight shift in sharpness for the different animals, but not nearly as much as when the camera was positioned much closer to the subjects. The saving grace to all this is distance from the subject. The further back I get, the deeper the zone where everything is in focus. I still may want to use the idea of a shallow depth-of-field to help create visual focus in the shot though, as shown in Figure 5.20.

In this picture from the Russian Ballet Theatre of Delaware, you can see that the prima ballerina is clearly in focus, while the supernumerary dancers in the back are slightly out of focus. Aside from the other challenges of capturing this very dynamic moment, I was faced with a specific issue related to my planned use for this photograph in my wife's portfolio.

 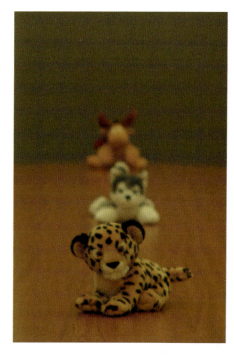

Figure 5.17: Camera set to f/2.8, 21′ from the table, with the focus on the moose.

Figure 5.18: Camera set to f/2.8, 21′ from the table, with the focus on the wolf.

Figure 5.19: Camera set to f/2.8, 21′ from the table, with the focus on the cheetah.

My wife had designed and built the gown for the ballerina, but the ballet company rented the costumes worn by the other dancers. By using a shallow depth-of-field, I was able to draw focus to her costume design work very specifically, which made it easier to show her work in her portfolio without any concerns that she was taking credit for the other costumes. Often, depth-of-field issues are perceived as a problem, but as long as you are aware of how it works, you can use it to your advantage to feature a specific element that you created for the production. You may also run across the term "bokeh," which refers to the feel or quality of the out-of-focus portion of an image. Some lenses are prone to turning out fuzzy areas that are pleasing to the eye in the way that they interpret the out-of-focus beams of light from those parts of the image area, whereas other lenses render the out-of-focus light as a pattern that is distracting. I didn't even know what bokeh was when I took this shot, so you can decide for yourself if the effect is pleasing or not! I am confident that the intent to isolate the one costume was effectively achieved, however.

So far, I've only been referencing fixed-focus, or "prime" lenses. These are lenses with a specific focal length that isn't adjustable, whereas zoom lenses allow the user to zoom in and out through a range of focal lengths. Zoom lenses are common on point & shoot cameras, since you only have one lens installed, and are also very useful in the DSLR world, but they come with a built-in Achilles' heel. Actually, they have two issues, both of which revolve around the maximum aperture. Most zooms don't have a very fast maximum aperture, mainly because of all the extra glass and such that goes into making a zoom lens. Many of the DSLR zoom lenses that I see today

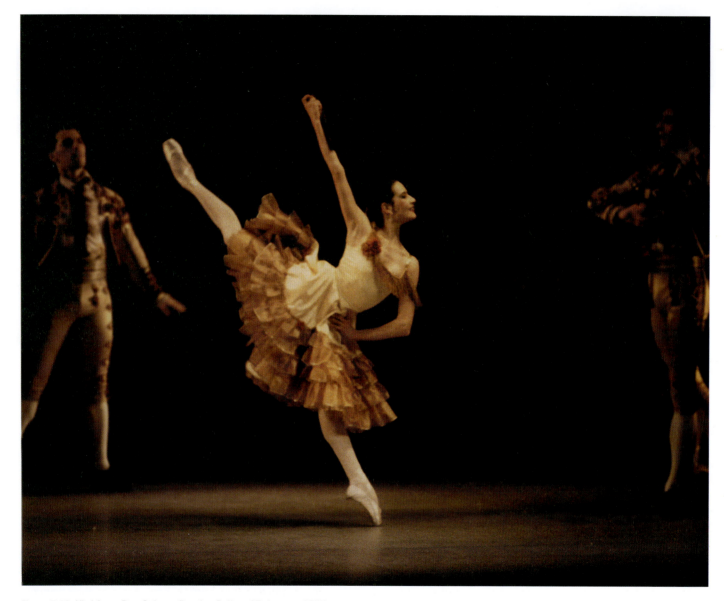

Figure 5.20: Kitri from *Don Quixote*, Russian Ballet of Delaware, 1995.

have a maximum aperture of f/3.5 or f/4. A fairly affordable long-range zoom that is currently available is the Nikon AF-S VR Zoom-Nikkor 70–300mm f/4.5–5.6G lens. It runs about $500 at this point, which is pretty inexpensive for a lens in this focal range with the **vibration reduction** (that's the VR in the title). You will notice that the maximum aperture is listed as f/4.5–5.6, and this type of lens is known as a variable-aperture zoom lens. This fact reveals the two issues that concern us with available-light photography. First, the best (fastest) this lens can do is f/4.5, which is less than one-fourth of the light-gathering ability of an f/2 lens. The second issue is that, as you zoom, your maximum aperture gets even worse, clocking in at a f/5.6, which is one-eighth of the ability of the f/2 lens. There are other lenses in this zoom range, with maximum apertures down to f/2.8, but you can expect to pay four to five times as much for them. It's also rare that you might need a long (telephoto) zoom in most theatre applications. There are also wide-angle zooms available, which might be a far better choice if you can afford the loss of a few stops of light. Nikon makes a fairly inexpensive 24–85mm wide-angle zoom with VR, that has a maximum aperture of f/3.5–4.5, for $500. They make another 24–85mm with a maximum aperture of f/2.8–4, but without the VR, for $750.

It is often hard to compare lenses just based on focal length, maximum aperture, and price, since there are many other considerations and options, so I urge you to read all of the specifications for your particular brand, and check out the online reviews. There are occasions when two fairly similar lenses might only be separated by 1 stop of maximum aperture, but the manufacturer has had to sacrifice a bit of quality in order to gain that extra stop. If you read a good number of user reviews, you may find that the more expensive lens isn't always the best. I have a 50mm f/1.4 lens and a 50mm f/1.2 lens, and the f/1.4 is by far the superior piece of glass. It's not worth the sacrifice in quality and sharpness to gain that extra fraction of a stop.

If you are working with a zoom lens, the important thing to be aware of is that the variable aperture (and resultant depth-of-field) is tied to the zoom setting of your lens. The wider the focal length, the wider the aperture. So that 24–85mm wide-angle zoom with the variable aperture of f/2.8–4 will allow you to use the f/2.8 setting when you are zoomed out to the wider 24mm focal length of the lens, but when you zoom in to the 85mm focal length, the camera will limit you to f/4.

If you look closely at the lens markings in Figure 5.21, you will see that the same color-coded focus marks exist on the zoom lens as they did on the prime lens in Figures 5.9 and

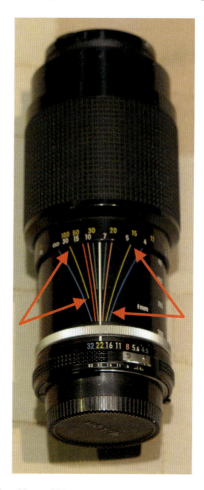

Figure 5.21: Nikon 80mm–200mm zoom lens with depth-of-field markings.

5.10. Because of the variable aperture, and the effect of the zoom itself, the depth-of-field markings are now shown as arcs. This lens is set to f/22 right now (color-coded in amber), and is set to the wider focal length of 80mm. As such, anything that is between 5 and 30 meters from the lens will be in focus. If we zoom way in, that focal plane is severely decreased in depth, as indicated by the amber-colored arcs that converge as the lens is zoomed out to 200mm.

With many entry-level cameras and point & shoots, you may find that you have an optical zoom and a digital zoom that work together. Most smartphones, including mine, just have a digital zoom and a prime lens. Optical zooms are actual pieces of glass moving in concert with each other to magnify the image and focus it on the capture medium. You are focusing a smaller part of the area seen by the lens on the same number of pixels. Usually there isn't any loss of quality with an optical zoom. Digital zooms are simply program options inside your camera that enlarge the image being captured by the camera, so there is an inherent loss of quality as the image is enlarged and cropped by the central processing unit (CPU) in the camera. This is something that you can do in Photoshop instead, so I would strongly urge you to avoid using the digital zoom feature in this type of photography. It's fine for zooming in on a few friends with your smartphone, which is almost certainly using a digital zoom to make that change, but you may end up with a better-quality shot by leaving the digital zoom function turned off, and then enlarging the shot yourself later on. The manufacturers and sales people may make a big deal about this function, but I don't count it as a useful feature because you can't tell what quality you are losing when the camera triggers the digital zoom function.

As you zoom through the range of the lens, you will find that the aperture changes by partial stops as you go. Aperture has always been measured in the common numbers found in the list at the start of this book, which refers to full stops. With older lenses with manual aperture rings, it was possible to select a 1/2 stop or a 1/3 stop between the "clicks" or "detents" that you would feel as you moved from one aperture setting to another. It would be very difficult to determine your actual setting, but an infinite number of possibilities exist between each setting, since you are just closing down or opening up the aperture mechanism. Modern DSLRs may give you the option for fractional stops, but you will probably be limited. Mine can do 1/3 and 2/3 of a stop between each full stop, but that is as far is it will break down the range between two full stops. Ultimately, this is fine, as I've almost never found more than 1/3 of a stop to be a deal-breaker when it comes to finding the correct exposure. The metadata concerning your choice of f-stop will be recorded with the rest of the info about the shot, unless you are using a really old lens that doesn't sync with your camera's CPU. Not having that data hasn't really been a hindrance, though, because I'm mainly concerned with the look of the shot when it's all said and done as opposed to what the numbers were. Still, it is useful information for you to refer to when you are evaluating your work at the end of the photo-call. Pull up the metadata on all the shots you like the best, and look at the data you find. Is there a common through-line? For example, is every shot you like the one that is under-exposed by a stop? If so, maybe you want to use the EV compensation feature discussed in Chapter 12. Use the metadata to inform your work, but don't get too obsessed with it.

Aperture Practice Session

1. Try shooting a regular scene in your space with several objects or people in the foreground and midground, and with a lit background.
 a. Set your camera up reasonably close to the subjects in your foreground. Shoot at your widest open aperture setting, and then close down to your middle setting (maybe f/5.6 or f/8), followed by a set of shots at your smallest setting. You will need to adjust your shutter speed or film speed accordingly to ensure accurate exposure across all

the shots. Evaluate your ability to capture depth-of-field at those different aperture settings. If you have a zoom lens, choose a middle-of-the-range zoom setting for now.

b. Now move your camera about two-thirds of the way back into your theatre seating, and shoot again. When you evaluate the resulting photos, you should see far less depth-of-field focus issues, especially at the f/5.6 or f8 setting, and you should have everything in focus with the smallest setting. If you are using a zoom lens in this situation, don't zoom in when you move for this experiment.

2. Shoot the same scene at f/16 and f/22, making sure that the focus and exposure are correct. Evaluate the sharpness of your shots to see if you lose any sharpness at the extreme end of the aperture range. If you have a lens that stops down even smaller than f/22, you should shoot at those settings as well.

3. If you are using a zoom lens, check to see if you lose light at a certain point in the zoom process, or if it is applied as a variable change across the entire zoom of the fixture.

4. If your camera has a hybrid optical-digital zoom, figure out how to turn the digital zoom off, or at least find out where it kicks in so you can avoid the use of it if you prefer that.

chapter six

shutter speed

Dream ballet from *Carousel*, Bucknell University, Oct. 2016.

As we established, shutter speed refers to the length of time that the camera's shutter curtain is open, exposing the capture medium to light. Typical shutter speeds, measured in fractions of a second, would follow this range:

- 1/2000 – very fast
- 1/1000
- 1/500
- 1/250
- 1/125
- 1/60 – middle of the road
- 1/30
- 1/15
- 1/8
- 1/4
- 1/2 – very slow

Often, the speed is displayed without the "1/," so you just see whole numbers, but they would be referred to as a fraction anyway. A shutter speed of 1/125th of a second might be noted as 125, but would be referred to as a 125th. Of course, there are super-high-speed cameras that are capable of much faster shutter speeds, and it is also possible to have shutter speeds that are measured in whole seconds, or even minutes if need be. Since a half-second speed might be shown just as a speed of 2, then a 2-second speed would be written as 2", and usually is shown the same way on the digital readout in your camera menu and viewfinder. Rarely are shutter speeds of whole seconds found in our work, but they may be useful for particularly low-light situations, and are great for photography of pyrotechnics or fireworks, which are often hard to time with taking a shot.

We are often working in fairly dark situations, which already affect many of our choices, and shutter speed is a crucial part of the equation. We want to be able to capture enough light for the proper exposure of our shot, but we are often attempting to capture people in motion, which is difficult with slow shutter speeds. If we are careful when planning out our photo-call, we can stage stop-action versions of otherwise dynamic situations, but there are some moments that just can't be stopped and frozen in time. This is the core issue that comprises the trade-off that we need to embrace with shutter speed:

> The faster the shutter speed, the easier it is to freeze a performer in motion. The slower the shutter speed, the more of the light that can be captured, but at the risk of suffering motion blur.

In a manual camera, shutter speed might be set through the use of a dial such as the one seen in Figure 6.1. DSLRs may have a dial as well, or may require you to navigate using a thumbwheel or a menu. Dig into your manual to learn how to set the shutter speed manually, as that will be very useful to you in some situations. It is important to note that, unlike the aperture setting, we can't set a manual camera's dial between two settings to get a half-stop of difference, as this can cause damage to the shutter mechanism. With a DSLR, you will possibly have fractional shutter speeds between the traditional full-stop speeds noted above, but you will only be able to choose what is on the menu, so you don't have to worry about damaging anything internally. For example, I can choose 1/3 stop intervals, so from 1/60th to 1/125th, I also have the options for 1/80th and 1/100th. What we need to do to get a properly exposed and crisp portfolio shot involves maximizing the light-gathering abilities of the camera in other ways so that we can use the fastest shutter speeds available to us, minimizing motion blur. As you recall from the Exposure Triangle, this involves some give and take with aperture and film speed. Let's discuss shutter speed some more before getting back to those relationships, though.

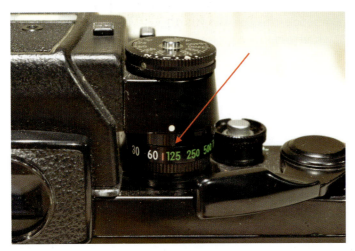

Figure 6.1: Manual shutter speed setting on Nikon SLR camera.

In the following set of shots, I set the camera up next to a table so I could bounce a small blue ball and capture the motion of the ball with the camera set to different shutter speeds. Here are four examples from across the range of possible speeds. I've included the aperture setting as well, so you can see how that had to change to maintain proper exposure with the different shutter speeds in use.

If you look at the shots, you will see that the ball is crisply frozen in mid-bounce in Figure 6.2, and then just begins to show a little blur in Figure 6.3. Already, that's too much blur for me, especially if it obscures an actor's expression. Figures 6.4 and 6.5 clearly demonstrate how quickly these shots become unusable when you are using the slower speeds to capture movement. You will also notice that Figure 6.5 is a bit more over-exposed than the other three, mainly because my camera had automatically set the aperture to f/22 and couldn't stop the lens down any further than that. Easy to adjust in Photoshop if you need to, but you generally won't be shooting with this slow of shutter speed most of the time anyway.

Most people have pretty good luck with getting crisp exposures without blur while handholding their cameras and shooting at speeds faster than 1/125th of a second when your subject is still. Once you get down to a 60th or below, you may start to see some blurring from either your subject, yourself, or both. Motion-blur can come from two main sources, the subject or the photographer. We will discuss methods to get the various subjects to hold still later on in Chapter 16, so for now, let's focus on the various ways we can ensure that we keep the camera steady. These methods include extra equipment, such as tripods or monopods, and external shutter releases, but also include various stances, some breathing techniques, practice with the shutter release button, and the use of a camera strap. If you choose to use a tripod, which is very common, you are providing a stable platform for the camera that will be far less influenced by you and your natural movements. Tripods come in many levels of quality, from $10–$20 online, all the way up to fancy (and expensive) cinema-worthy units in the several-hundred-dollar range.

shutter speed 55

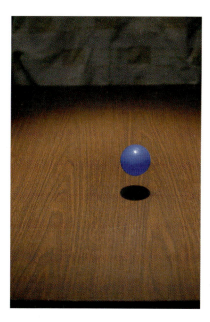

Figure 6.2: Bouncing ball #1: Camera set to f/2.2 at 1/1600th.

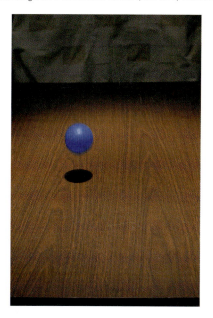

Figure 6.3: Bouncing ball #2: Camera set to f/7.1 at 1/200th.

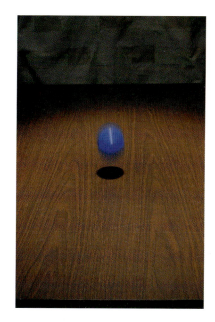

Figure 6.4: Bouncing ball #3: Camera set to f/13 at 1/60th.

Figure 6.5: Bouncing ball #4: Camera set to f/22 at 1/8th.

The main point, though, is that you have three legs forming a series of triangles that attach to the tripod head. The legs may have the ability to change length, the head should crank up and down, and the head should be able to pan and tilt so that you can align the camera square to your proscenium. All tripods have a threaded bolt that will screw into the hole in the bottom of your camera. This hole is 1/4-20, which means it is 1/4" diameter, with 20 threads per inch (TPI), which is a standard size across the industry. Larger professional units may be threaded for a larger bolt, which measures 3/8" and has 16 TPI, and may come complete with an adapter that allows the use of a 1/4-20 tripod. Regardless, if you plan to buy a tripod, you should be fine with the smaller of the two bolt sizes, which cover pretty much all consumer and prosumer level cameras.

Figure 6.7: Threaded bolt and removable baseplate.

Newer tripods also provide a quick-release base that you can screw into the threaded hole on the bottom of your camera that then snaps in and out of the tripod head, allowing you to pop it off quickly for a close-up shot. The label on my baseplate is to remind me to ensure that the plate comes back with the tripod when I lend it out. It's gone home on a few student cameras over its lifetime.

Further options include rubber feet for stability on smooth floors. These can often retract, revealing metal spikes for softer material. You can also see the levers for locking the legs at different lengths.

As with all things related to this area, the less time you have to spend messing around with the gear, the more time you will have to actually shoot the photos and concentrate on the art of what you are doing. Also, if you are spending $1,000–$2,000 on a DSLR camera and lens combination, consider the purchase of a quality tripod as cheap insurance. I've seen some pretty flimsy examples over the years, and witnessed more than one topple over because of a faulty joint. Not a risk you want to take right at the start of a major photo-call! If you want to further isolate yourself from the camera, you can

Figure 6.6: Basic tripod with baseplate.

Figure 6.8: Rubber tripod feet for smooth surfaces or delicate surfaces.

Figure 6.9: Steel spikes for outdoor use.

result. You as the photographer are no longer in contact with the camera while the shutter is open, and are not adding any shake to the image. The only vibrations that could affect the image are now isolated to the movement of the mirror and the actual shutter curtain of the DSLR itself. This is an interesting fact about DSLRs – they still have mechanical parts that swing a mirror up out of the way, and then open and close a mechanical shutter to expose the capture medium. The movement of these items can induce a very tiny bit of shake, which is usually compensated for in the construction of the camera. I am curious to see, over the next few years, if mirrorless cameras prove to be crisper or not, since they do not have the same moving parts flipping open and closed inside the body of the camera.

Now that I have sold you all on the benefits of a tripod, I need to come clean and explain that I rarely, if ever, use them. For practical purposes, I like to be far more mobile during a photo-call, often running up and down the aisles so as to vary the framing of my shots. I never shoot photo-calls with a zoom lens (for the reasons I mentioned in the last chapter), so if I want a close-up, I need to get close. Tripods often

also purchase a remote shutter release, which may be wired or wireless. This device allows you to trigger the shutter for longer exposures without actually touching the camera itself, and thus avoiding any unintended jostling of the camera while the shutter is open. Film cameras utilized a mechanical plunger-cable to remotely press the button, and eventually moved to an electronic version with later models. DSLR cameras may have either wired or wireless versions available, depending on preference and cost. All versions have essentially the same end

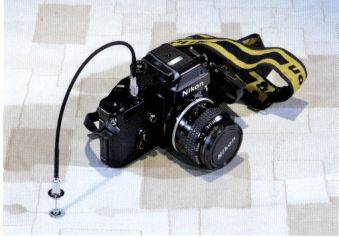

Figure 6.10: Traditional mechanical shutter release cable attached to Nikon SLR camera.

Figure 6.11: Modern electronic wired shutter release cable and remote.

require more space than a typical theatre aisle will provide, and are clumsy and in the way. If I am shooting with two cameras, then I will put one on the tripod and hold the other to avoid wasting time swapping them around, but then I am committing to taking *all* the photos with the tripod-mounted camera at the same distance and with the same framing and aspect ratio. Normally for me, as a lighting designer, this is just fine, but may not serve you as effectively depending on your specialty. I would, however, like to share with you some additional techniques for using tripods before moving on to some other options. I carry a short length of Paracord in my photo-call bag, which I can use to lash my tripod to the seats, allowing me to fit it in better. In the photo, you will see that the tripod is set with two legs toward the front of the camera, at full extension in the aisle. The third leg points toward the back of the house, and is nestled in the gap between two of the seat backs and the armrest. This is, in itself, asking for trouble.

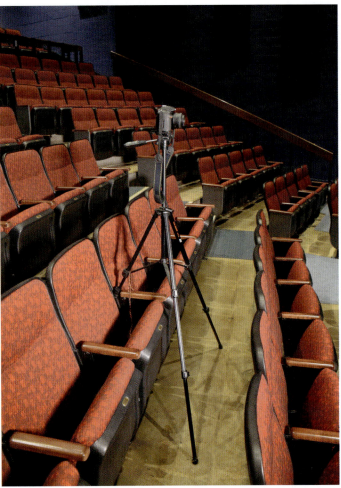

Figure 6.12: DSLR mounted on tripod with shorter leg lashed to seats.

I've utilized my Paracord to lash the third leg down tightly to the seating, though, and now have a pretty stable platform. Feel free to use whatever knots you are comfortable with, as long as you have a nice, tight connection to the bank of seating. Remember this is safety insurance for your camera and lens. If you are not familiar with lashings yet, ask a rigger for a quick lesson. One other tip I would offer relates to the

shutter speed | 59

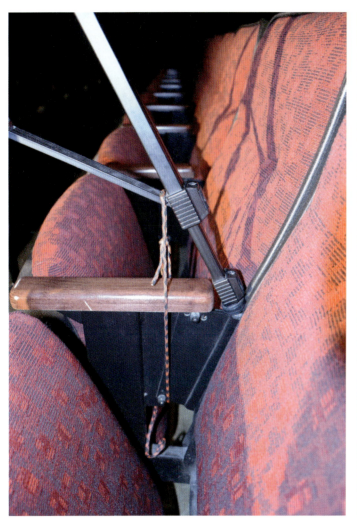

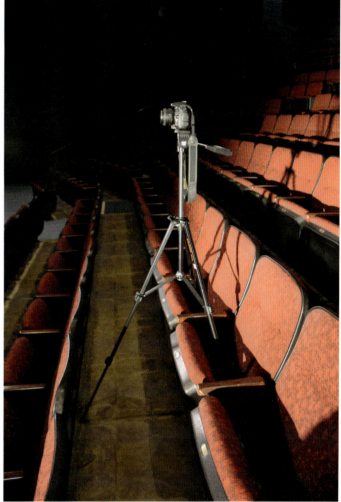

Figure 6.13: Detail of Paracord lashing on tripod.

Figure 6.14: Tripod set with two legs toward back of house and placed into the seating.

shortened leg. Often tripods have three leg sections, of gradually smaller diameters, to allow for them to slide into each other for storage. I always lengthen the thicker sections first, which are sturdier, so that I rely the least on the thinnest and weakest sections if possible.

Incidentally, I dislike walking away from my camera on a tripod, since other people may bump into it in the dark and knock the whole thing over. The lashing can help avoid this unfortunate accident. This is also one of the reasons I like to run photo-calls with the house lights on at a glow.

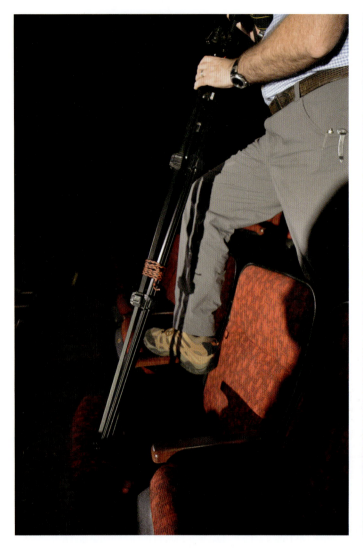

Figure 6.15: Tripod with legs lashed together to create a monopod.

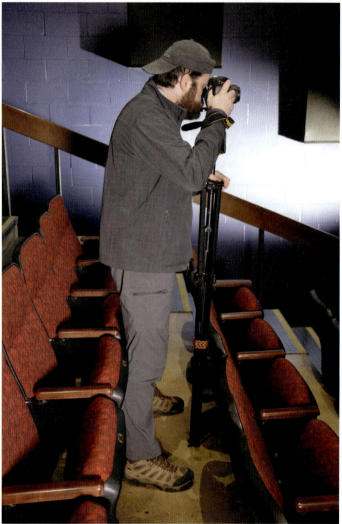

Figure 6.16: Converted monopod in use.

You may find that your seating won't allow this method, so you might need to figure out how to thread the legs of the tripod through the folded-up seats, as shown below in Figure 6.14. If you are lucky enough to be shooting in a venue with a conveniently placed wider cross-aisle, or a venue with continental seating, you may find you have enough room without all this trickery.

Another useful tool for steadying your camera is the monopod. At the risk of stating the obvious, this is a one-legged version of the tripod. This removes all the hassle of dealing with

a tripod that is stuck in the seating or doesn't fit, but isn't something that you can leave unattended. It is nice and mobile, and serves as a useful platform to help steady your camera a good bit. Not quite as good as a tripod, but more flexible in its uses. You can easily make a monopod out of your tripod by lashing the legs together with Paracord, tie line, or some gaff tape. You can hold the camera with one hand and the monopod with the other, or vary your grip however you like.

You may also want to purchase an actual monopod. Some are very simply a stick with a short 1/4-20 threaded rod at the end to attach to the camera, and others get more complex with more adjustment options for length or features on the head of the monopod. I own one that is actually a hiking stick with adjustable length, and a nice wooden knob on top that unscrews to reveal the threaded post for the camera. The foot of the monopod has a rubber stopper on it, but this end may also be removed to reveal a spike, which is useful for softer surfaces outdoors. The one disadvantage is that, since its primary purpose is a walking stick, it isn't as tall as my tripod-monopod conversion, and I have to hunch over to see through the viewfinder. As such, I would suggest that you be sure that the monopod is tall enough for your comfort, or if it's a multi-purpose unit, that you are comfortable with the compromises.

Finally, with the monopod, in whatever form you choose to use it, there isn't really a need or use for a shutter release device, since you have to hold onto the camera anyway. There are also some newer styles of tripod that involve very flexible legs that may be wrapped around things to hold your camera in place where you don't have access to a flat surface. While great for all sorts of outdoors applications, they are limited in usefulness in the theatre unless you have a railing in your space that is in the right location. I've also found that they are great with lighter-weight cameras, but am currently a bit reluctant to trust their holding abilities with my heavier DSLR. You may find that there are other products that have come onto the market since this writing, and if they work for you, go for it.

If you choose, however, to forgo the tripod, monopod, and shutter release mechanisms, there are still a number of

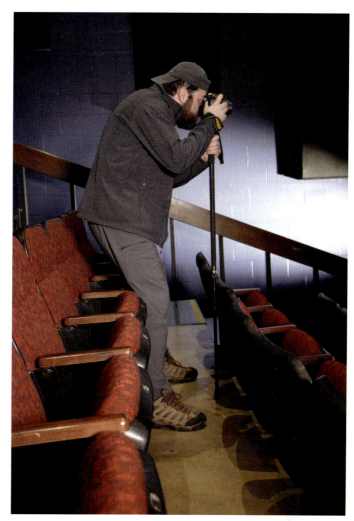

Figure 6.17: Monopod/Walking stick in use.

methods for you to employ to reduce camera shake. The first step is simply learning to time your breathing. With all photography, it is important to relax and remain calm, even if you are under pressure to get through the call quickly. Second, when you get ready to take the photographs, breathe in deeply, and then out. When you are almost done breathing out, pause and

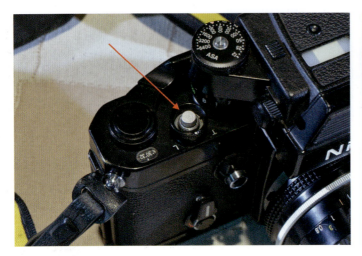
Figure 6.18: Traditional shutter release button on Nikon SLR camera.

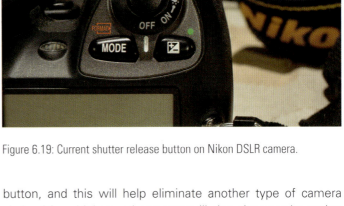
Figure 6.19: Current shutter release button on Nikon DSLR camera.

take the shots, and then finish your breath. When you inhale, your torso is tensing up, and when you exhale, your torso relaxes. This timed-breathing practice helps to remove any tension in your body when you are taking the shots. It may seem difficult at first, but eventually it becomes second nature as you work through the photo-call. The third step is to learn to squeeze the shutter release button, as opposed to pressing or clicking it. While this control is pretty familiar to even the most novice photographer, we do need to revisit this, because it can be an issue with long exposures. On older cameras, the shutter release button is a fairly solid and large button, as seen in Figure 6.18. Once we evolved to current DSLRs, however, the form factor and solidity of that button hasn't really changed, as you can see in Figure 6.19.

If you just press down on the button, you are introducing some movement that twists the camera a bit. Some people are also very aggressive and mash the shutter button because they are in a hurry. Instead, firmly grasp the grip on the camera (usually on the right side), and gently squeeze the button with your hand. The pressures exerted by the rest of your hand in other directions mitigate the downward pressure on the button, and this will help eliminate another type of camera shake. Many higher-end cameras will also give you the option to partially depress the shutter release in order to trigger autofocus and metering functions, so it's a good practice to get into so that you can use these functions to your advantage instead of just jamming on the button and hoping for the best.

The next piece of equipment, and in my opinion the most important, is the camera strap. The strap is useful for hanging the camera around your neck, but can be employed in a far more useful way to help steady the camera when you are actually shooting. You will need to experiment a bit to get the length just right, but once you get it worked out, you will have a simple and fast way to lock down your camera. Whenever I pick up my camera, or someone else's, I loop the strap around my arm as you will see demonstrated. If I ever lose my grip on the camera, it won't fall more than a few inches. Having the strap around your neck will keep the camera off the floor as well, but you can't really use it to provide a stable shooting platform, and just having the strap loop over your shoulder like a purse or messenger bag leaves too much room for the camera to fall and strike the top of the seating row in front of you.

shutter speed 63

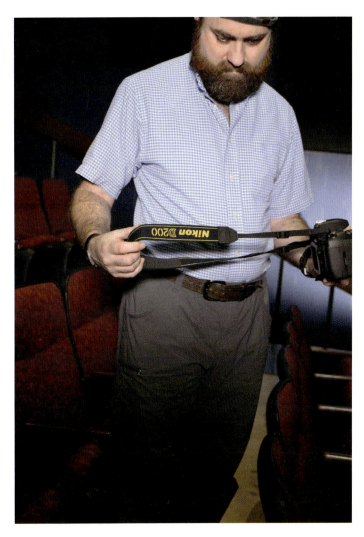

Figure 6.20: Step 1: Extend the strap and remove any twists or kinks.

This sequence is shown for right-handed use of the strap, but could be adapted for left-handed use if you are more comfortable that way. Unfortunately, cameras generally have the better handgrips molded into the right side of the camera, so you usually have to shoot that way. Feel free to adapt to what works for you and is fast, secure, and comfortable.

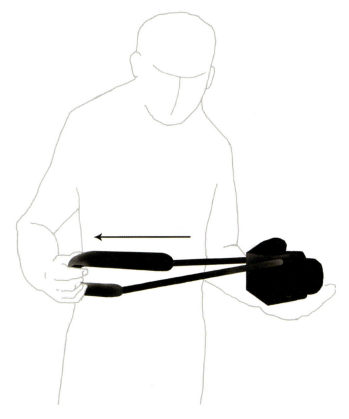

Figure 6.21: Sketch of Step 1.

If done correctly, you now have the loop of the strap around the back of your upper arm just above the elbow, and the strap ends cross each other as they connect to the camera. The strap end connecting to the left side of the camera crosses over the top of the strap end connecting to the right side of the camera. Once you have the strap arranged correctly, you may need to adjust the length of the strap or it won't do any good. The final part of this technique, and what makes it actually work for you, is having a good amount of tension on the strap once you are gripping the camera. If you are looking closely at the picture of the strap from above, you

64 shutter speed

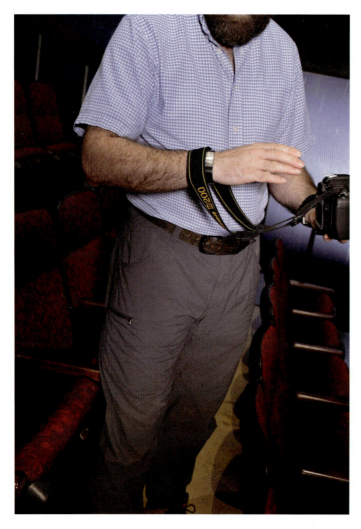

Figure 6.22: Step 2: Reach right hand up through the loop of the strap from below.

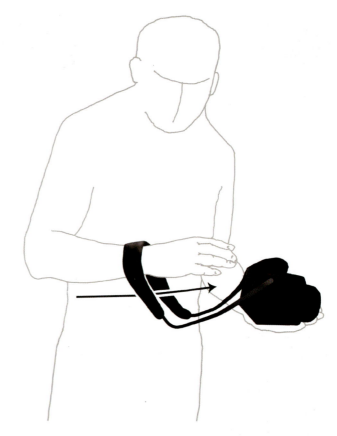

Figure 6.23: Sketch of Step 2.

can see that the strap is nice and tight around my arm, and my wrist is flexed somewhat. Just by flexing or relaxing my wrist a little bit, I can adjust the tension on the strap as I move the camera around to different shooting positions. In doing this, I am using my arm bones as part of a natural tripod, and I don't have to rely just on the muscles in my wrist to keep the camera steady. After an extended period of constant shooting, your wrist will tire quickly, and this technique will help alleviate that issue. The tension that you create with the strap locks the camera in and makes it feel like an extension of your arm. Because the tension is in the strap, you don't have to tense up your arm muscles nearly as much, which also helps hold the camera steady.

Once you have mastered the use of the strap as a brace, you can employ it in quite a number of situations for taking your shots. The three shooting poses I use the most are shown here, but you may need to move around and adjust as

shutter speed | 65

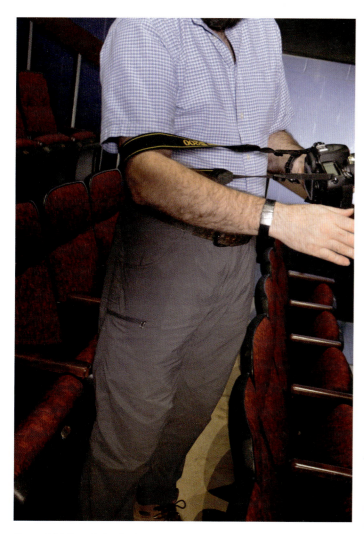

Figure 6.24: Step 3: Settle the loop of the strap just above your elbow so your arm passes over the strap end on your right, and under the strap end on the left.

needed to get the shots you want depending on the front-of-house architecture of your venue. I have on occasion found myself standing on the seats, laying in the aisles, or otherwise running around from place to place as the situation demands.

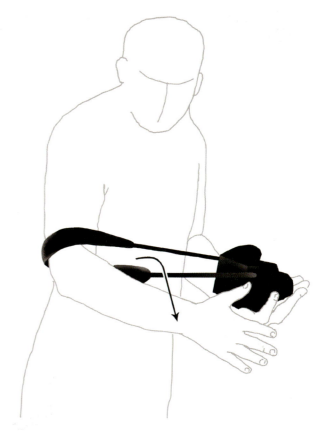

Figure 6.25: Sketch of Step 3.

This is another reason why I am usually reluctant to use a tripod…I need to be mobile to take advantage of opportunities to frame my photos as the photo-call unfolds. Which stance to use is highly dependent on where you need to be in the house to properly frame your shot, which we talk about more in Chapter 9.

The first stance, and the one that I use most, is a sitting pose using the theatre seats. I sit on the back of the chair, with my feet on the armrests. I find that if I sit in the chair instead, my knees are too far down from where I need them to be to rest my elbows and create this pose.

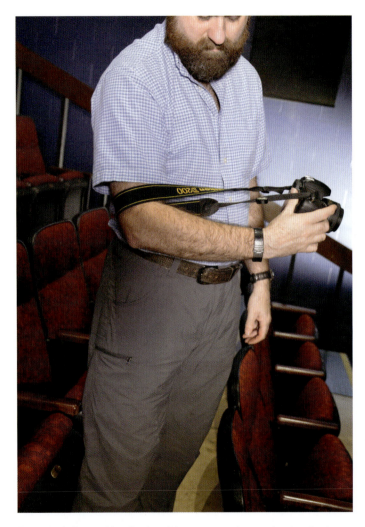

Figure 6.26: Step 4: Now for the tricky part – reach around and under the right-side strap end and grip the camera; your hand moves clockwise around the right-side strap to accomplish this.

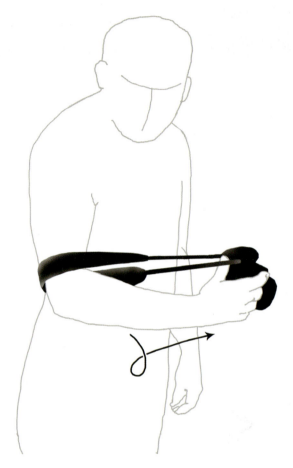

Figure 6.27: Sketch of Step 4.

Obviously, you should take care not to damage the seating in your space, but I have never found this use of the seating to cause any issues. If you view this pose directly from the side, you can see that the pose positions the camera in a very comfortable place for me, and hopefully will scale appropriately for photographers who are taller or shorter than I am.

Triangles are the most stable geometric shapes in nature, and if you look closely, you will also note that I've created several triangles with my pose. Each hip–knee–foot triangle is planted securely on the seating in two places, and by placing my elbows on my knees, I've created another set of triangles with my arms and upper body that supports and steadies the camera.

shutter speed 67

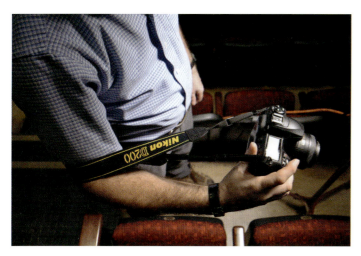

Figure 6.28: Step 5: Final arrangement of straps and adjusted for comfortable tension.

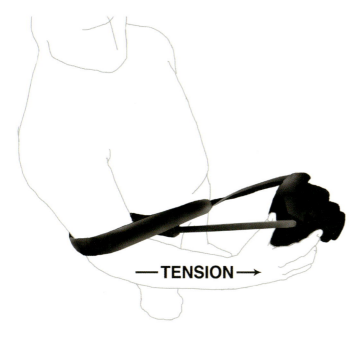

Figure 6.29: Sketch of Step 5.

Figure 6.30: Seated on back of chair in the house.

There is also a final triangle created between my elbows, lower arms, and the camera that completes the pose. Ultimately, this is quick, easy, and very steady.

If a seated pose doesn't work for you, or perhaps there aren't seats where you need to be for the best shot, there are two other stances that I use fairly often. The first can

Figure 6.31: Side view of seated pose.

Figure 6.32: Front view of seated pose.

be accomplished in a row of seating, allowing you to brace one or both legs against the seating rows in front and behind you, or can be done anywhere else you might be able to brace against something. This stance can also be used fairly effectively when you aren't able to brace against anything, as it provides a solid base. This is derived from a pistol-shooting stance called the Weaver stance that has been employed by law enforcement for decades. One foot is slightly forward and pointed toward the stage, and the other foot is turned at a right angle, making an L. Because your feet are perpendicular to each other, you can control front-to-back and side-to-side body sway more easily.

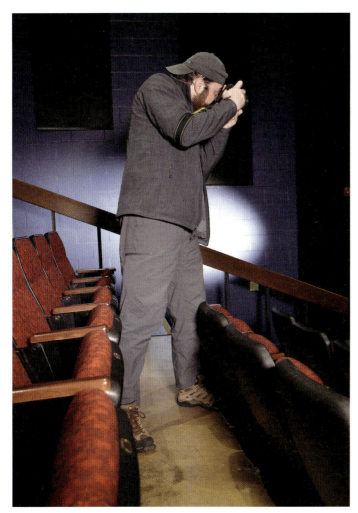 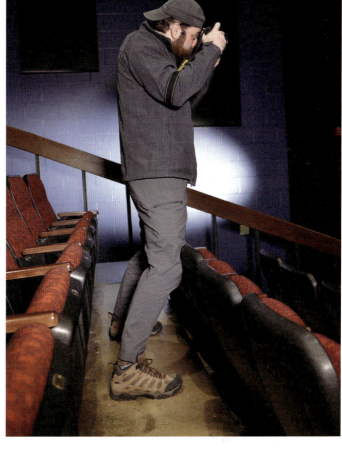

Figure 6.33: Side view of "Weaver" stance.

Figure 6.34: Side view of "bracing" stance.

The third option is a stance that requires some seats to lean against. You set your feet about shoulder-width apart, and stand close to the row of seats in front of you. Bend your knees and lean up against the seat backs, and you will create a very stable base to shoot from. Note that the seat backs are above my knees…this makes the stance much more stable and comfortable than if you are in a steep house and the seat backs hit your shins.

You will also note that in all three of these methods, I am also using the tensioned strap to lock the camera in on my arm. If you are lucky enough to have a flat balcony rail in the right place, or some other bit of architecture that works for

you, there's nothing that says you can't just set your camera down on it and shoot from there. Ensure that the focusing ability of the lens isn't obstructed by whatever you are setting the camera down on, especially if you are relying on autofocus. This will help avoid any damage to the autofocus motors in the lens if it were to jam up against something.

One final word about timing. If you flip back to the cover of this chapter, you will see a dance moment from the dream ballet in *Carousel*. Obviously, this is not a pose that the dancers can hold for long, if at all. The trick here with capturing this kind of movement has to do with timing as well as maximizing your shutter speed. This was shot with an ISO of 800, an aperture of f/2, and a shutter speed of 1/200th. Not a super-fast shutter compared to the 1/1600th I used to catch the bouncing ball, *but* I was also relying on my knowledge of the movement. I knew from watching the show that the female dancer would hold her pose for a tiny fraction of a second as her momentum carries her arms and leg out to the full extent of the pose. By timing my shutter release with that moment, I was able to catch her frozen in time.

Shutter Speed Practice Session

1. Work out how to manually change your shutter speed, and then try to handhold a shot of a still scene at 1/1000th, 1/250th, 1/125th, 1/60th, 1/30th, 1/8th, and 1/4th. Be sure to take a breath and steady yourself each time so that you can get a sense of the point at which you are introducing motion blur into the shot.
2. Work with a performer or two to try and take shots of them moving through a space.
 a. Begin with them moving slowly, perhaps performing a waltz. It's important that feet and hands are moving throughout so that you can look for potential motion blur at the extremities. Don't bother with anything below 1/60th, as you are sure to have some issues.
 b. Once you've tried that, have the performers move through the space more energetically, and try to capture their movements with a fast shutter speed. If you can shoot at 1/1000th or 1/2000th of a second, try that. You will need a well-lit space and a nice wide aperture, so be careful that depth-of-field issues don't get in the way of capturing crisp shots of the performers.
3. Try to stop action like the dancer I photographed in the cover of the chapter. You can start with a bouncing ball, and then work with a performer later. Have someone drop the ball from the same height each time so that you can get used to a consistent bounce height.
 a. Shoot with a slow shutter speed, perhaps around 1/60th to start, and see if you can freeze the motion of the ball at the point where it hits the apex of its bounce before falling back down again. This might take quite a number of tries.
 b. Once you have achieved that, you can move to 1/30th or 1/15th and try again.
4. Experiment with the tripod or monopod before you get into a photo-call so that you can decide what works for you. Make sure your gear is solid and stable.
5. Also try shooting from the various stances that I have described so that you can get comfortable with them. Be sure to take some time to adjust your camera strap so that it really fits your arm snugly and comfortably. Once you have the strap length comfortably dialed in, you will really feel like the camera is an extension of your forearm.

chapter seven

film speed

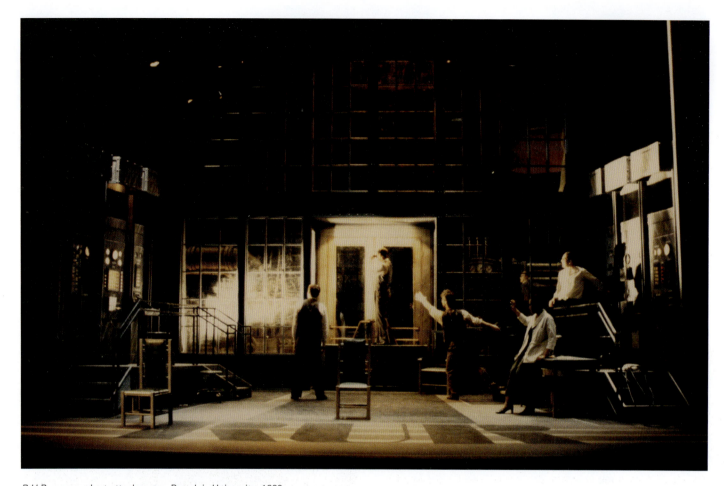

R.U.R., power-plant attack scene, Brandeis University, 1993.

Film speed is the setting that governs the sensitivity of your camera's image sensor. It mirrors the way that we used to rate physical film in terms of sensitivity, and follows a pretty standard scale. The speed of the film referred to its ability to sense light and fix the image. The speed was given as an ASA number, or sometimes ASA/ISO, but is now fairly universally referred to as the ISO sensitivity, or simply ISO. Most off-the-shelf slide or print film was available in speeds noted as multiples of 100:

- 1600 – very fast
- 800
- 400 – middle of the road
- 200
- 100 – very slow

There are also several less common variants at both ends of the range. The higher the number, the greater the sensitivity. Films with a higher number are referred to as "fast" films,

and lower numbers are "slow" films. Most movie film is very slow, often in the 25 or 50 ISO range. As with apertures and shutter speeds, a move from one setting to another on this list is a change of 1 stop of light sensitivity. Changing from ISO 200 to ISO 400 will give you the same exposure as if you had changed the aperture from f/5.6 to f/4.

For many years, the most common type of film used for theatrical photography was a special slide film made by Kodak in the Ektachrome line. This slide film was color balanced for theatre lighting, and came in speeds of 64T, 160T, and 320T. The "T" stands for tungsten, and we will investigate that aspect of things in the next chapter. For now, let's just focus on the speed of the film. Slow films need a lot of light to expose properly, whereas fast films are far more sensitive to light, and don't need nearly as much light to effectively capture the image. Here's the trade-off we must be aware of:

> The faster the film speed, the greater the "grain" or "pixilation" of the resultant image.
> The slower the film speed, the greater the amount of light that is required to capture the image.

If all film speeds were the same, then we would just shoot really fast film and be done with things, but the images we get with faster film speeds are potentially very grainy, and may not be suitable for large, glossy portfolio prints. On the other hand, we often find ourselves shooting very dark scenes, which are not conducive to quality exposures with slower film, and we may want to use a faster film speed to help get the correct exposure. We have to find a sweet spot within these trade-offs and maximize the quality of the shot while still getting the correct exposure. For years, because the only good film for theatre use was a fairly slow film, I focused on getting very fast lenses, and working toward using slower shutter speeds, since the ISO could only go so high. When I began, the Ektachrome film was only available in speeds of 64 ASA and 160 ASA, and then a few years later Kodak also brought out a 320 ASA. There is a trick that many of us used to eek a bit more sensitivity out of this line. The 64 ASA was just way too slow, so I never shot with it. With the 160 ASA, and later the 320 ASA, we could "**push**" the film, which meant that you would set the camera up so that the camera "thought" the film was faster than it really was. Then, when you took the film in to be processed, you would have the lab process the film slightly differently, which was called "**push processing**." This would allow you to shoot a roll of 320 ASA film, but set the camera up as if the film was 640 ASA, which was a whole stop better. Some films allow for a great deal of push-or-pull processing, but the Ektachrome was really only tolerant of 1 stop worth of pushing. Regardless, that is a good deal better than plain old 160 ASA film out of the box. If you look at Figure 7.1, you will see that it is actually set up for 640 ASA, since the red indicator is set for the second notch after the 400. The first notch is 500 ASA, and these two settings are 1/3 and 2/3 of a stop from 400 ASA to 800 ASA.

Figure 7.1: Manual ASA/ISO setting on Nikon SLR camera.

Why is this important with digital photography? The image sensor in your camera is governed by the same set of trade-offs, and is set up to work in a way that is similar to the various film speeds that we used to use. It is adjusted by changing the ISO sensitivity setting. When you set the ISO sensitivity to a lower number, such as ISO 200, you are telling the camera to utilize the pixels in the image-sensing chip in a certain way that results in a high-quality image, but requires a lot of light to accurately expose for. When you set your camera to a higher ISO sensitivity, then you are telling the camera to utilize the pixels in a different way that allows you to capture a properly exposed image while requiring less light. The main concern is that the image quality will not be as high, and may be very noticeable, even at lower levels of enlarging.

What is great about the flexibility of today's DSLR cameras is the fact that you can switch between various ISO sensitivity settings easily, even during the photo-call. I still recommend, however, determining an ISO sensitivity setting before you begin your shoot, and sticking with it throughout the evening. If you do need to change it, you can always check the metadata to remind yourself of the change in settings that you made. This is certainly much easier and more convenient than keeping a handwritten log during a hectic shoot.

Figures 7.3 through 7.6 represent four versions of the same shot. The first example was shot with a fairly low ISO setting, requiring a wide aperture and long shutter speed to hit the correct exposure. The second example uses a much higher ISO setting, enabling us to shoot with a faster shutter speed. Shots three and four allow for even faster shutter speeds, but

Figure 7.3: Cheetah toy with film speed set to ISO 100, f/2.8 at 1/8th, no digital NR.

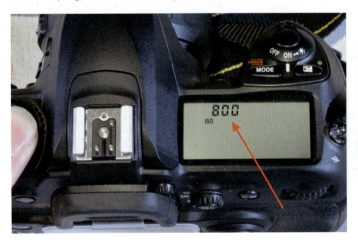

Figure 7.2: ISO sensitivity setting on Nikon DSLR camera. ISO set to 800.

Figure 7.4: Cheetah toy with film speed set to ISO 800, f/2.8 at 1/160th, low-level digital NR.

Figure 7.5: Cheetah toy with film speed set to ISO 1600, f/2.8 at 1/125th, high-level digital NR.

Figure 7.6: Cheetah toy with film speed set to ISO 3200, f/2.8 at 1/250th, high-level digital NR.

Many cameras now include digital **noise reduction** (NR), which is a built-in feature that attempts to clean up the image inside the camera. My DSLR has an automatic NR feature that is enabled when the ISO is set above 800, but can be enabled at lower levels as well. Since I shot at 640 ASA for most of my professional career before going digital, I am fairly comfortable with the results I get when I run my DSLR set to 640 ASA. Of late, however, I tend to shoot at 800 ISO, since that's the fastest ISO setting I can use before the heavier version of the digital noise reduction system kicks in. I try to avoid invoking this feature, even in my camera, in favor of using better lenses and slower shutter speeds. I feel that, while the camera's CPU is purpose-built for what it does, I'd rather have the image file pure and unchanged by the camera, since I can always change the setting on the picture once I have it in Photoshop. I'm also better off getting a great exposure with lots of light by using a fast lens and slow shutter, as I will have more clean data to work with later on. I retook the shot in Figure 7.5, but with the NR disabled, and you can see the result in Figure 7.7. While the camera seems to have changed its shutter speed from 1/125th to 1/40th, the rest of the settings were the same. I actually prefer the quality in this shot over the one with the NR

Figure 7.7: Cheetah toy with film speed set to ISO 1600, f/2.8 at 1/40th, digital NR disabled.

you may notice that there is a slight degradation in quality with the second shot, and certainly by the third and fourth shots. Oddly, the color of the background also drops off in brightness and vibrancy as we move to the higher ISOs. Is this worth the trade-offs with the other two settings?

turned on. Your experiences may differ, but the only way to know is to shoot some test shots and compare.

Given the costs of Ektachrome film ($12–$15 a roll), plus an additional $12–$15 for processing, and a fee to cover the extra costs of doing a "push," followed by the week or more required for turn around, you can see why DSLRs are much more convenient and flexible, especially related to this situation. If needed, you can change the ISO sensitivity for that one really dark scene in the show, whereas, in the past, you were stuck with the ISO of whatever roll of film was in the camera until it was all used up. I should also mention that Ektachrome film is heat sensitive, so you have to keep it in the fridge (my butter tray is full), and also keep it cool when it is in the camera and out in the theatre. I used to bring a small cooler with me to keep the film at the right temperature. Otherwise, if the film gets heat damaged, the colors become wildly skewed, rendering the roll useless. If this film becomes regularly available again, that certainly will be a concern for anyone who wants to try it.

Now that we have investigated the first three exposure settings, and understand the trade-offs associated with each setting, go back and check out the Exposure Triangle in Chapter 4, and review it again. If you look closely, I have included small pictographs that point out the trade-offs for each of the three settings: depth-of-field, motion blur, and pixilation. I hope this diagram continues to be useful to you as a resource as you get to know your camera well. Just remember that the three settings all represent the same thing: relative changes in light intensity measured in stops. Any change in one direction on the triangle can be countered by a change of one of the other two settings.

As a more practical example, go back and look at the shot of the ballet dancer in Figure 5.20. As I mentioned before, I chose to allow the depth-of-field to be very shallow, but that wasn't exclusively an artistic choice – it was born out of a certain amount of necessity as well. I was shooting Ektachrome 320 with a 1-stop push, so my film speed was 640, and that fact couldn't change. I also knew I needed as fast a shutter speed as possible, so I needed to use a wide aperture anyway to help bring in as much light as possible during the quick exposure needed to catch her pose. Now, this was all done well before digital cameras, so I don't have the metadata on this shot. I can only assume I was shooting with a 50mm f/1.4 lens, probably bracketing the aperture between f/1.4, f/2, and f/2.8 in order to keep the shutter speed consistently fast. I still had a choice with how close I stood to the stage, which influenced the depth of my in-focus focus field.

In my own work, I now tend to run the DSLR set to 800 ISO, an aperture around f/2.8, and then select a shutter speed as appropriate to get the correct exposure. Since I have a great deal of control over motion blur, through careful photo-call planning and a practiced hand, that is the one trade-off that I am least concerned with. Depth-of-field is also not a major concern at the distances I am shooting for most things, but it does come into play with closer process shots.

Film Speed Practice Session

1. Determine how to change the film speed setting on your camera, and determine if there are any noise-reduction features. If so, do they apply all or only part of the time?

2. Try to duplicate what I did in Figures 7.3 through 7.6, but with a few more ISO settings thrown in. You will have to try blowing these up on the screen to see the pixilation clearly, and this is one of the experiments where you might need to try a quality print or two to see the differences.

3. Try to duplicate what I did in Figures 7.5 and 7.7, but focus on one faster ISO sensitivity setting, and take one shot with noise reduction on and one with it off. This may or may not be possible with your particular camera, but if it is, it's important to know what that setting is doing to the file before you get it out of the camera.

chapter eight

white balance

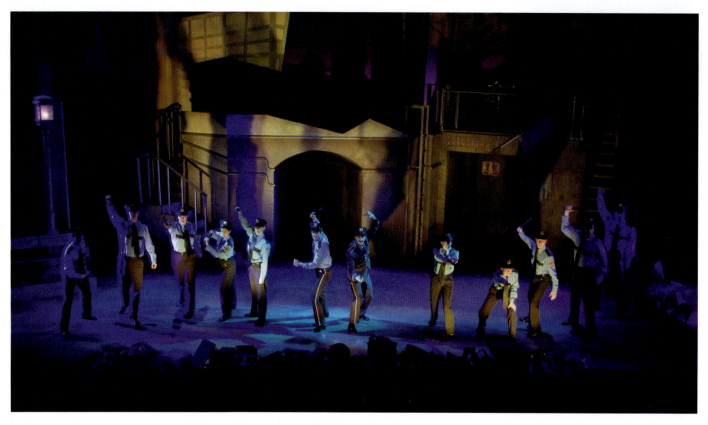

Cop song, *Urinetown*, Penn State University, Oct. 2006.

White balance is one of the most critical things that you need to be aware of when taking theatrical shots, and is a major difference between stage photography and most other types of photography. The issue at the heart of this situation is that theatrical lights are color-balanced to a different color temperature than daylight, which is where most people take pictures. Color temperature is measured in degrees Kelvin, and is a quantification of how warm or cool the light is. I'm not talking about anything having to do with colored gels or other color-changing effects; I'm just talking about the original source light. We will concern ourselves with the colored stage light later. First, let's take a look at the visible spectrum of light:

As you can see, the visible spectrum occupies a small but important sector of the electromagnetic spectrum. It transitions from invisible ultraviolet at around 400 nanometers (nm) and is visible from 400nm up to 700nm, where it transitions to infrared light. Our eyes can only perceive this narrow band of electromagnetic energy. Together, these wavelengths make up all the colors we can see. Light can be characterized by referring to its color as red or green, and this is fine when we are talking about light that has been altered through the use of gels, dichroic filters, or the mixing of LEDs. We do need to also be able to characterize the color of the original source light. I'm sure that you have observed that candlelight is much

white balance

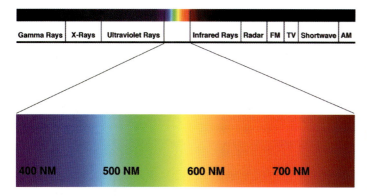

Figure 8.1: Visible spectrum of light.

warmer than fluorescent light, although fluorescent lights are a poor example because they are a mix of just a few sets of wavelengths, as opposed to a strong representation across the entire visible spectrum. We often think of sunlight as warm and inviting, but in actuality, aside from sunrise and sunset, the light of the sun is cool and bluish in nature. The Kelvin scale measures its 0° point at −273.15°C, or −459.67°F, also known as "absolute zero." This is the point where all matter ceases to move or vibrate. Certain forms of matter emit light when they become warm, and we can use a spectrophotometer to measure the color of the light emitted by a "black-body" sphere as it is heated. The color temperature of the light radiating from the object directly correlates to the sphere's temperature measured in degrees Kelvin. One of the best examples of this phenomenon is the light that is emitted by the metal that forms the filament in a typical incandescent lamp. As more and more electrical current flows through the filament, a greater and greater amount of light energy is created. What is odd for us, though, is the fact that the hotter the temperature, the colder the light emitted becomes.

The typical incandescent theatrical stage light tends to emit light at 3200°Kelvin, which is actually somewhat lower on the scale. Fluorescents emit light around 5600°Kelvin, and sunlight can range far beyond that, approaching 10,000°Kelvin at high noon on a clear day. This might seem odd, as it goes against everything we tend to think about the sun when we are kids. Most kids have drawn that stereotypical picture of a house with a fence and windows and doors, perhaps with a chimney, and this scene usually includes a yellow sun. Compared to theatrical light, however, the sun is very cold, while theatre lighting is much closer to the warmth of a fire or candlelight. This wide range of color temperatures did not affect early black-and-white photography, which merely recorded the relative intensities of a scene in shades of black, white, and grey. With the advent of color photography, however, the early scientists made a choice to use chemicals that reacted to cold white light, so that early color films could accurately reproduce the colors found outdoors in the sunlight. Since then, almost all films available off the shelf in stores were balanced to render accurate colors in daylight. The flash feature in most cameras is also a colder white light, so the light from the flash doesn't distort the colors too much.

As you can see from this scale, theatre lights tend to be very, very warm. Since we know that almost all incandescent

Figure 8.2: Kelvin temperature scale.

theatre lamps are designed to emit light at 3200° Kelvin, we use this as our baseline for all other decisions relating to color temperature. We do now use many other types of sources in shows, so you may also find fluorescents, LEDs, arcs, or even the occasional sodium or mercury-vapor lamp. For the most part, however, we use light that is measured at that 3200°Kelvin mark. Humans like warm light. We are drawn to it…it provides comfort and is pleasing to our eye. Cold white light, such as arc or fluorescent, often seems harsh and unforgiving, and does not provide us with the same sense of comfort.

Since most all film stock and its chemistry were balanced for outdoor lighting primarily, when you use "daylight" film inside, the colors become very orange. Since most people still

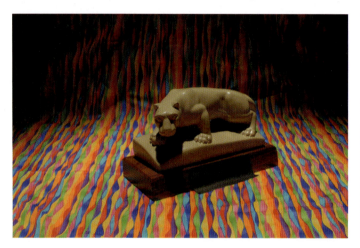

Figure 8.3: Object lit with incandescent source, D200 set to 3200° Kelvin.

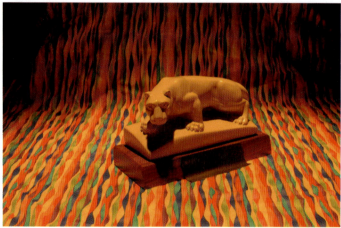

Figure 8.5: Object lit with incandescent source, D200 set to 6300° Kelvin.

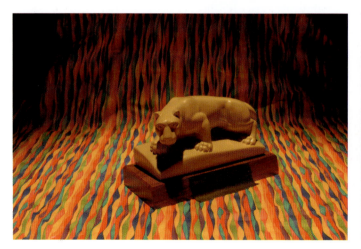

Figure 8.4: Object lit with incandescent source, D200 set to 5600° Kelvin.

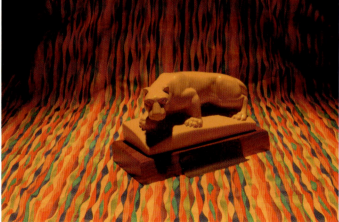

Figure 8.6: Object lit with incandescent source, D200 set to 10,000° Kelvin.

tend to shoot outdoors or under cooler fluorescent fixtures, today's DSLRs and point & shoot cameras will come preset for these colder color temperature situations. Often, the main indicator of this mismatch is the tendency of your pictures to appear overly yellow or even orange and brown. Here are a number of test shots taken with the camera set to several different color temperature settings, and under several different light sources. You can see that the settings need to match the source in order to render the colors effectively and accurately. I also included a shot of each source from my camera phone, which has no color temperature settings, although I suspect that there is a bit of automatic white balancing going on.

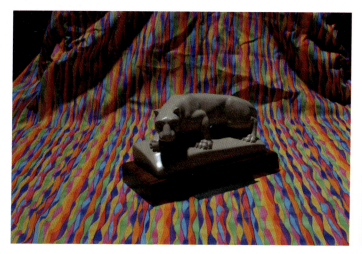

Figure 8.7: Object lit with white LED source, D200 set to 3200° Kelvin.

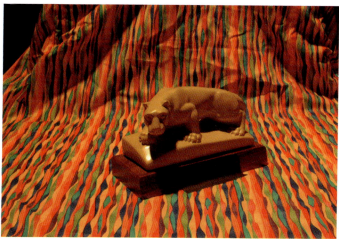

Figure 8.9: Object lit with white LED source, D200 set to 6300° Kelvin.

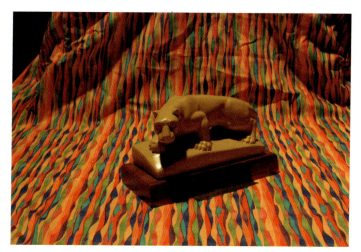

Figure 8.8: Object lit with white LED source, D200 set to 5600° Kelvin.

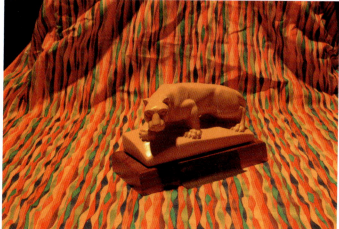

Figure 8.10: Object lit with white LED source, D200 set to 10,000° Kelvin.

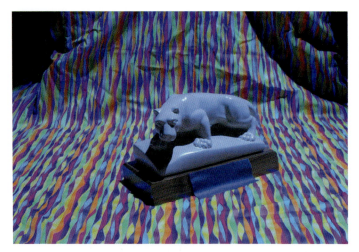

Figure 8.11: Object lit with white arc source, D200 set to 3200° Kelvin.

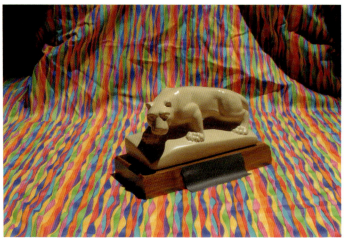

Figure 8.13: Object lit with white arc source, D200 set to 6300° Kelvin.

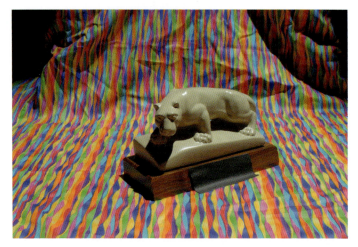

Figure 8.12: Object lit with white arc source, D200 set to 5600° Kelvin.

Figure 8.14: Object lit with white arc source, D200 set to 10,000° Kelvin.

The solutions to correct the camera and film, before we had DSLR cameras available, were one of these three techniques:

1 Least useful – work with the photo lab to skew the colors back to normal during the printing process. This was all the way before Photoshop made digital photo editing so simple and accessible. This option was not cheap, easy, or terribly effective.

2 Least expensive – shoot your daylight film with a blue filter over the lens to cool off the incoming light, balancing it to the expectations of the daylight film. Not a perfect solution,

white balance | 83

Figure 8.15: Object lit with incandescent source, shot with Droid Maxx camera phone.

Figure 8.17: Object lit with white arc source, shot with Droid Maxx camera phone.

Figure 8.16: Object lit with white LED source, shot with Droid Maxx camera phone.

as some colors were less successfully translated than others. You would use an "80A" filter to correct 3200° Kelvin light to 5500° Kelvin light. Looking at the Kelvin scale, this puts us right up there with flash and cloudy daylight, which is right where the chemistry of daylight film is at its best. The real downside of this is that the blue filter costs you 2 full stops of light, which, as we already know, is tough to lose when you are shooting in a dark theatre. Also, the filter can't manufacture light intensity in the lower part of the visible spectrum; it can only cut down the warm bias of the theatre light, so again, this is not the most accurate final representation of your look.

3 Best solution – use film that is balanced for tungsten light. Luckily, there is just such a film…or at least there was until Kodak discontinued its manufacturing about a decade ago. Luckily, I also now hear that Kodak is re-releasing some versions of Ektachrome, but it's unclear if that will include the tungsten-balanced varieties. The rest weren't appropriately formulated for tungsten light. The issues here are that those are *very* slow ISO speeds, and that in the end you have slides, not negatives, for making prints. I'll talk a bit more about how to handle that in Chapter 18. The film, the processing, and the printing from the slides for a portfolio added up to fairly high costs per portfolio-worthy print. This fact drove myself, and many of my colleagues, to be very selective about what shots we kept, and what we spent our meager starting salaries on.

Figure 8.18: 52mm 80A filter for my film cameras.

Figure 8.19: Roll of Kodak Ektachrome 320T color slide film.

The flexibility of today's DSLR cameras, as they relate to color temperature, is a huge stride forward in the world of photography. However, your camera may be set up to maximize the color accuracy of your shots in regular daylight, which will lead to the very same issues when it is used to take photographs under theatre light. Luckily, our cameras are able to adjust their color temperature sensitivity on the fly. You can very easily move from shooting in daylight conditions to shooting in tungsten-lit theatrical conditions. This is a setting where precision and flexibility will vary greatly depending on the cost of the camera that you have purchased. Even basic point & shoot cameras have the ability to adjust their color-temperature sensitivity, but may not have the specific Kelvin setting that we're looking for. Often you will find four simple pictograms, such as a light bulb, a tubular fluorescent bulb, a cloudy sky, and a sunny sky. If this is the case, you'll want to use the plain light bulb symbol, which should be pretty close to the color temperature of tungsten light. If, however, you have the option of actually setting the color temperature then you'll want to choose 3200° Kelvin, or at least as close as you can get to that number. One of the great advantages of the higher-end cameras is the ability to actually choose a specific color temperature, and the extreme ease and speed with which you can change that setting. Therein lies the trade-off with white balance:

> Your ability to adjust the color-temperature sensitivity of your camera is directly related to how much you are willing or able to spend on the camera equipment.

This doesn't mean that a less expensive camera can't do what we need it to, but you may have fewer choices, more difficulty accessing those choices, or less precision in the settings available to you.

Many modern cameras also have a number of special settings, which may include such things as the ability to sepia-tone a photograph, or convert a color photograph to black and white. While these are all very interesting and useful features, don't let your camera do all that work, which may be difficult to undo later. Instead, you can certainly make a copy of the

Figure 8.20: Setting the D200 to 3200° Kelvin.

original and apply similar filters in a program like Photoshop later on. I highly recommend that you set your camera up to only capture the purest, closest possible representation of the actual situation, and then only make changes to copies, so you can still go back to the digital file later on.

Now you may be wondering what all this has to do with anything if you're dealing with a lighting design where all the lights are colored with gels. There may not be a single white light in the entire rig, but it is still critical to color balance your camera to the source light behind the gel. If you haven't set your camera to react appropriately to the **full spectrum** of the tungsten source, then your camera will not be able to correctly interpret the color of the fixtures that have gels in them. Let's look at the light output of some of the fixtures that might be in use on your show. This is very important to keep in mind if you are also taking process shots. Figures 8.21 through 8.26 show the **Spectral Power Distribution (SPD)** of various light sources across the visible spectrum. SPD will show the relative power of each of the wavelengths present in the visible portion of the electromagnetic spectrum. You will easily be able to see that the measurements of sunlight and incandescent light show that these two sources emit light across all the wavelengths, while the LED and arc sources are combinations of all of the wavelengths, but not all as equally powered. In fact, the incandescent source has a smoother curve than the two daylight sources, although the daylight sources are constantly shifting around based on atmospheric conditions, so consider those more of a guide than a lab-quality benchmark.

The fluorescent fixtures are the least like anything else, with their big spikes within the spectrum. Our brain tends to fill the gaps a bit, but we can usually tell that the colors are a bit "off." This is primarily due to the fact that, if the light source doesn't contain a certain wavelength that correlates to the color of the object being lit, then there isn't any light for that object's color to bounce back to our eye. The most obvious example of this is the pale orange-white light you will see late at night in big parking lots. Those fixtures are usually some sort of arc source with a very poor **Color Rendering Index** (CRI). This is a very useful measurement to look at the next time you go to the hardware store to buy new light bulbs for your house. Now that most incandescent bulbs are no longer manufactured or sold, there has been an explosion of LED replacements flooding the market. Some are far better at replicating the old incandescent bulbs than others, and one good way is to check out the CRI number on the package. The other wrinkle here is that CRI values can only be compared across sources that have the same basic color temperature. For our purposes, the CRI of a standard HPL 575-watt lamp found in the ETC Source Four Leko is usually from 95 to 100, which means that it is essentially equivalent to the reference source.

You can see that the distributions produced by the sun and the regular Leko are very different from each other, hence the strong difference in color temperature. The other sources are either biased in one or more areas of the visible spectrum, or are a combination of spikes in several specific areas. This makes many of these non-incandescent sources tricky to capture accurately, since they are made up of these spikes, which represent an uneven SPD curve. You can't, however, set your camera to different color-temperature settings for every shot

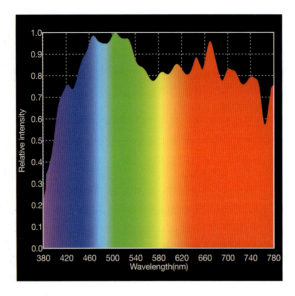

Figure 8.21: SPD of daylight at noon with a clear sky.

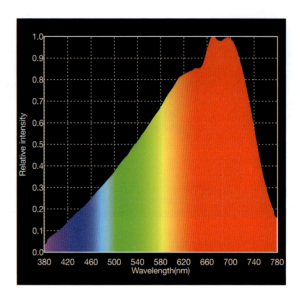

Figure 8.23: SPD of ETC Source Four Leko with incandescent HPL 575-watt lamp and no gel.

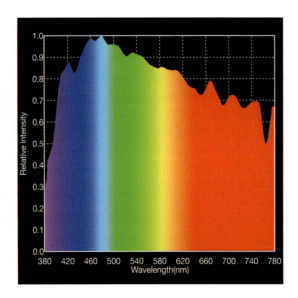

Figure 8.22: SPD of daylight at noon with a cloudy sky.

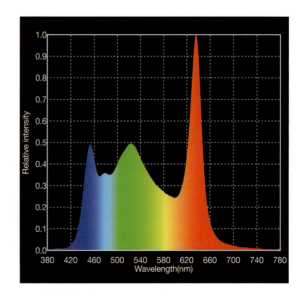

Figure 8.24: SPD of ETC Source Four Leko with Series 2 Lustr+ LED color engine, set to white.

white balance

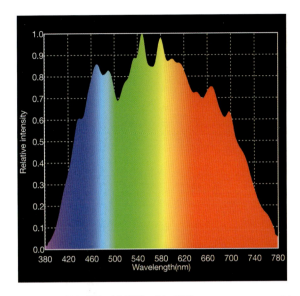

Figure 8.25: SPD of Vari*Lite VL3000 with 1200-watt arc source, set to white.

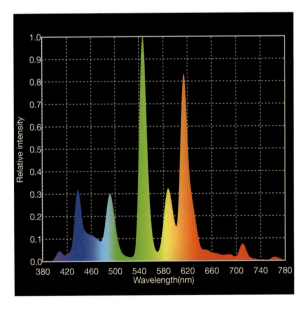

Figure 8.26: SPD of cool white fluorescent tubes.

that you are taking, or you'll go crazy chasing your tail trying to keep up and keep track of what you are doing.

As I said before, it's important to be thinking about the color temperature of the source, since that will influence the colors of all the gels or color mixing that is going on. The lighting designer is mixing all these colors together on stage with the over-arching influence of warmer theatre light. As a designer, I often choose to use a cold-white fixture as a special since it is something that looks and feels distinctly different from the rest of the rig. Even if I am using LEDs, arcs, or other unusual sources, I am choosing them based on my personal and professional bias to prefer slightly warmer incandescent light. As our technology evolves, we may have a different conversation about this in ten years, but I feel confident in suggesting that we are probably safe in making this assumption for the time being.

Now, let's look at the influence of gels or color mixing on the Spectral Power Distribution of a fixture. Here are two sets of measurements comparing an incandescent Leko and an LED Leko, both in a saturated red color (Figures 8.27 and 8.28), and another pair of measurements for the same fixtures using a medium-blue color (Figures 8.29 and 8.30). Look at the similarities between the two, but note that they are definitely not identical. Even though it is the most advanced LED engine available in a theatrical fixture, the Lustr+ uses only seven LED emitters to emulate the colors we see, so there are invariably some wavelengths that are not represented the same exact way.

Also, compare these SPD graphs with the graphs of each of these fixtures when they are not colored, as seen in Figures 8.23 and 8.24, and you will see how each fixture is affected by the color used. Notice how much red is in the SPD curve of the Roscolux 68. This is a very warm blue, and all that red and infrared can fool your camera's color balance. I have also included an SPD graph for Roscolux 90, which is a saturated green color, so that you can see how that performs. Note the slight difference between the incandescent source and the LED source.

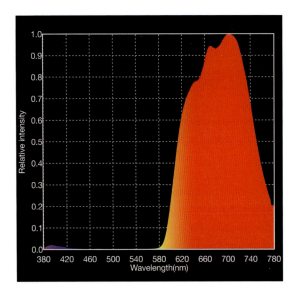

Figure 8.27: SPD of ETC Source Four Leko with incandescent HPL 575-watt lamp with Roscolux 26 gel.

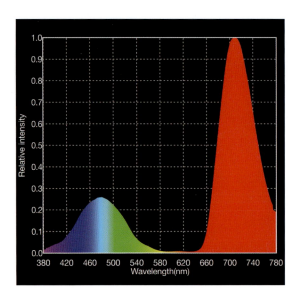

Figure 8.29: SPD of ETC Source Four Leko with incandescent HPL 575-watt lamp with Roscolux 68 gel.

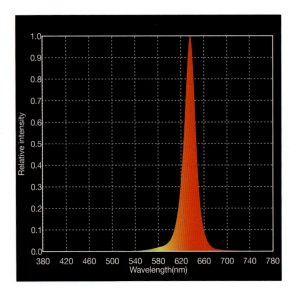

Figure 8.28: SPD of ETC Source Four Leko with Series 2 Lustr+ LED color engine, set to emulate Roscolux 26 gel.

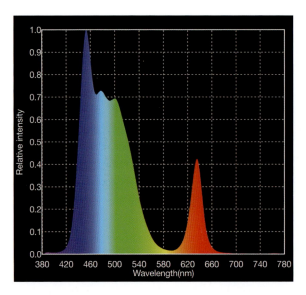

Figure 8.30: SPD of ETC Source Four Leko with Series 2 Lustr+ LED color engine, set to emulate Roscolux 68 gel.

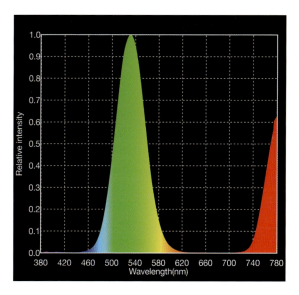

Figure 8.31: SPD of ETC Source Four Leko with incandescent HPL 575-watt lamp with Roscolux 90 gel.

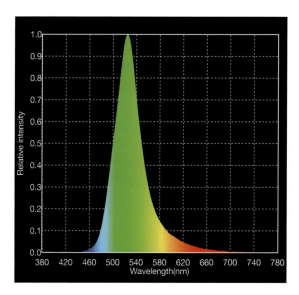

Figure 8.32: SPD of ETC Source Four Leko with Series 2 Lustr+ LED color engine, set to emulate Roscolux 90 gel.

Along with these graphs, here are photographs of several objects under these different colors of gelled light. The ball is a medium blue, and the rectangle of foam is a cool white, along with the rainbow of colors in the fabric. Look at how some of the colors shift or go grey depending on the color on them.

All of these color interactions are important to be aware of, since there are so many different factors affecting the color in your final shot. As long as you are aware of them and can control how they affect your shots, you will eliminate several unknowns, and will guarantee less frustration and more accuracy in your work. The presence of so much colored light in the theatre also has a direct impact on one of the settings you might have available to you. You may have discovered an auto white-balance feature (AWB) in your camera's menus while you've been adjusting the color temperature. I would urge you to avoid using this setting if at all possible.

The auto white-balance feature is very useful for snapshots in odd lighting conditions for the novice user. By now, though, we know what we are looking at, and know what is going on behind the scenes with color and color temperature. The auto white-balance setting basically tells the camera to look at the scene, find something white, and adjust the camera so that the thing it *thinks* is white is color shifted to match a reference white stored in the camera's software. This reference white is probably closer to daylight than theatre light, and your manual may tell you what its color temperature is. The problem here is that you may be taking pictures of a show without any white in it...or maybe the cues use very saturated gels that are heavily affecting the paler colors. Your camera will try to shift and interpret the colors it sees in an attempt to skew them to match an artificial standard reference color. Here's how things might become skewed. Let's look at this statuette under clear, pink, and teal light. First, let's revisit the Spectral Power Distribution of the Leko when it's clear (Figure 8.23), and compare it to the SPD of the same fixture with Roscolux 44 (Figure 8.37) and Roscolux 70 (Figure 8.38) in the fixture.

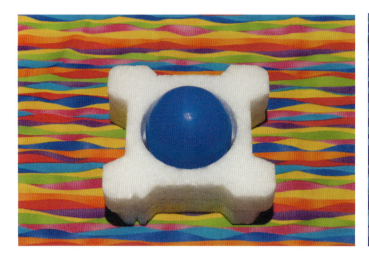

Figure 8.33: Ball, foam, rainbow cloth under clear incandescent Leko.

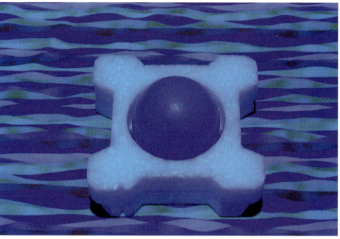

Figure 8.35: Ball, foam, rainbow cloth under incandescent Leko with Roscolux 68.

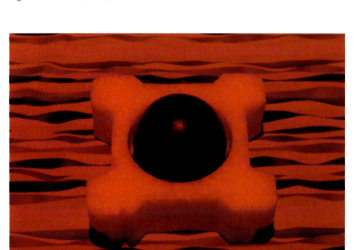

Figure 8.34: Ball, foam, rainbow cloth under incandescent Leko with Roscolux 26.

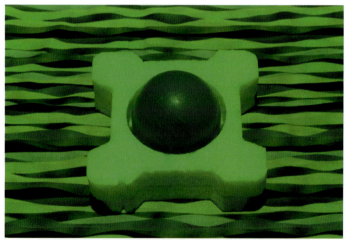

Figure 8.36: Ball, foam, rainbow cloth under incandescent Leko with Roscolux 90.

Now, let's look at the still life with the fixture without gel. In Figure 8.39, I've set the white balance to 3200° Kelvin, and in Figure 8.40, I set the camera up to auto white balance. You can see that the auto white balance has been strongly influenced by the incandescent light, which is much warmer than the daylight color temperature that the camera is most likely calibrated to. This is a perfect example of one of the biggest issues people ask about when it comes to stage photography.

white balance

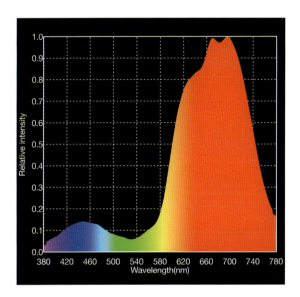

Figure 8.37: SPD of ETC Source Four Leko with incandescent HPL 575-watt lamp with Roscolux 44 gel.

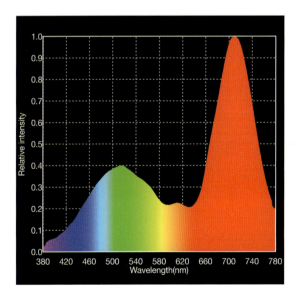

Figure 8.38: SPD of ETC Source Four Leko with incandescent HPL 575-watt lamp with Roscolux 70 gel.

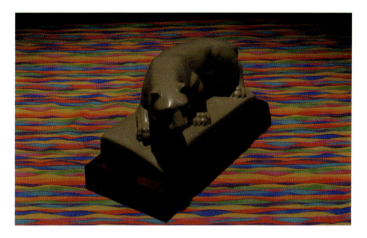

Figure 8.39: Lion and fabric under clear incandescent light, camera set to 3200° Kelvin.

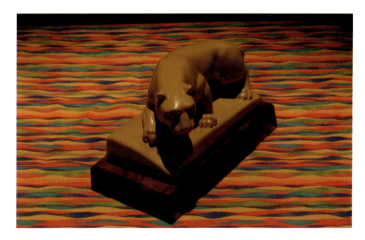

Figure 8.40: Lion and fabric under clear incandescent light, camera set to auto white balance.

When you look at the first pair of images, you will see that the camera has shifted the colors somewhat, but you might be able to rescue the second shot in Photoshop, although it won't be a perfect version of what you could get with the temperature set properly to begin with. However, when we look at the

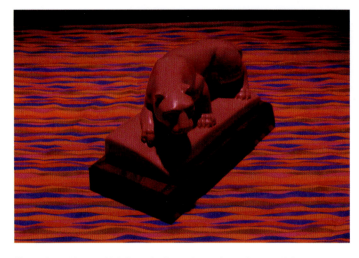

Figure 8.41: Lion and fabric under Roscolux 44 incandescent light, camera set to 3200° Kelvin.

Figure 8.43: Lion and fabric under Roscolux 70 incandescent light, camera set to 3200° Kelvin.

Figure 8.42: Lion and fabric under Roscolux 44 incandescent light, camera set to auto white balance.

Figure 8.44: Lion and fabric under Roscolux 70 incandescent light, camera set to auto white balance.

second and third pair of shots, the camera doesn't have any white to reference, so it has a much harder time interpreting what white is, and how to skew the colors to accommodate the situation. As we might have guessed, the AWB has a tendency to push the colors into the warmer part of the spectrum, so the nicely rendered fuchsia in Figure 8.41 is pushed too far into an orange-pink color in Figure 8.42. Likewise, the teal color in Figure 8.43 gets warmed up to the point of becoming pale

green in Figure 8.44. The resultant images in Figure 8.42 and 8.44 can hardly be considered useful to us in terms of color accuracy.

If you are working in film/TV or video, you will find that the cameras are usually set to a cooler color temperature, and that the fixtures are often balanced to match that color. Often, film/TV lights are arc sources, and are rarely colored with gels, so you need to adjust for a higher color temperature, often in the 5600–6500° Kelvin range. Conversely, you may also be in a situation where the crews are shooting an indoor scene and will put up color-correcting gels over all the windows to shift the daylight coming in to a warmer color temperature to match the additional lights deployed around the set. The most important suggestion I can make here is to check with the lighting and camera crews to see what color temperature the lights are being adjusted to, or what color temperature the cameras are being set to, and go with that number as a starting point in your camera. Shoot a few test shots and see what you get out of that, and modify your settings accordingly.

White-Balance Practice Session

Since this is one of the most overlooked settings, and quite possibly one of the most critical, I urge you to spend a good bit of time experimenting with the capabilities of your specific camera by trying these experiments:

1. Find the white-balance or color-temperature settings, and get comfortable with adjusting them. You might need to delve into the manual if your settings are buried in a menu somewhere, but be sure you can quickly and easily find and adjust them.
2. Set your camera for 3200° Kelvin, or as close as you can get. If you only have pictograms, your manual may tell you what color temperature those pictograms represent, so you can make the best choice.
3. Go into the theatre, and place a multi-colored object under a single tungsten incandescent source without any gel in it. Take a few pictures and then view them on a color-accurate monitor to ensure you are getting the right colors and color balance. If you aren't, then try viewing the pictures on a different monitor or try changing the settings to another close setting and see if the pictures improve or degrade in terms of color.
4. Try printing a picture, or if you can, have one professionally printed and evaluate the color in the final print. Go back and look at it while also viewing the original setup that you photographed. Issues of inaccurate color should be very apparent, if you have any. If not, then write down the settings that are working best for you so that you can recreate the situation easily and quickly at the next photo-call.
5. Remember that the color temperature of the light in the room where you are viewing the monitor or the photo prints will also influence what you see. Try to avoid rooms with fluorescent or LED sources, as they are not as full-spectrum as incandescent light.
6. Just so you can see the difference, keep your tungsten settings in place, and then take pictures outside in the bright daylight. In addition to having to shift your exposure, you will find that everything has a bluish cast to the colors, and won't be an accurate representation of the colors in the actual shot.
7. Try setting your camera to the other color-temperature options, either according to the pictograms, or according to the Kelvin scale shown in Figure 8.2. Shoot your theatrical setup at 4200° Kelvin, 5600° Kelvin, or even 10,000° Kelvin if your camera can hit that. Note the shift in the color balance and determine the best settings for your situation.
8. Now, if you are using primarily LED fixtures, or a hybrid mix of them, try shooting some test shots at 3200° Kelvin, 3600° Kelvin, 4000° Kelvin, 4400° Kelvin, 5000° Kelvin, 5600° Kelvin…etc., or at whatever intervals you

find work for your situation. Make sure that the colors of the LED fixtures are set to clear, or possibly to emulate a tungsten source. Evaluate these shots with a calibrated monitor or with a quality print. There are so many brands and models of LED fixtures, with new ones coming out all the time. The manufacturers may specify the color temperature of the fixture, but I've found those specifications to be terribly inaccurate, and also, they don't use the same measurement methods from company to company, so the results could be very misleading. The only way to truly figure this out is with a bit of trial and error. Take the test shots and carefully note the color-temperature settings you are using, and then compare them to the real thing. Once you are viewing some color-calibrated results, you will be able to determine the actual color temperature of the units at full. If you have more than one type of unit, then try this test with each type individually. You might find that one emulates 3200° Kelvin and the other 5600° Kelvin. If you have fairly divergent measurements, then you might need to try this test with a cue from the show a day or two before the photo-call. It's not easy to say from one cue to the next what the percent of usage of the different fixture types are, but if you are not the lighting designer, you can certainly consult with them about this. Try a few cues that are generally brighter and full-stage, and see what results you get.

9. I have found, in my own experience with LEDs so far, that I am still choosing my colors in the LED fixtures with an overall bias toward the feel of the tungsten sources I used through the first 25 years of my design training. So even if there is a mix of different sources, or even in one situation where I was taking photographs of an all-LED rig, I still set my camera to 3200° Kelvin. As we begin to see more and more spaces that are exclusively LED lights, this tungsten bias may shift, but it is worth thinking about for a while yet. Some manufacturers are considering a "red-shift" feature that will cause the LED fixtures to get warmer as they fade down, mimicking the traditional "amber drift" experienced when incandescent fixtures are faded down to a low level on a dimmer.

10. If there are arc sources or other non-tungsten sources such as fluorescent or sodium-vapor, then you can try the same experiment on a selection of cues. Some of these types of fixtures take a while to warm up and shift color over time, so consult with the lighting designer about these types of fixtures if you need to.

11. In the end, the actual number setting isn't always as important as finding the setting that gives you the most color-accurate rendition of the scene that you are capturing. Use some careful practice time in advance, and evaluate the results before you get into the photo-call, and then go with the settings that work best for your camera and your eye.

chapter nine

framing your shots

Stroke and sedation moment, *Wings*, University of Connecticut, March 1990.

Framing your shots is very simple to do, as long as you stop for a moment and think about the composition within the viewfinder. The aspect ratio of an image is the relationship between the width and the height of the image, expressed as a simple proportion. The aspect ratio of the image-capture chips in all DSLRs is 3:2, but there are many other possible aspect ratios for other types of cameras, with 4:3 and 16:9 becoming more popular as consumer equipment is now being designed to work with wide-screen televisions and projectors. What is important is that we see a rectangle that is wider than it is taller when we are shooting in landscape mode, or a rectangle that is taller than it is wider when shooting in portrait mode.

During all of my discussions about holding the camera or using a tripod, I demonstrated everything with the camera in landscape, since that often matches the aspect ratio of most proscenium theatres. Almost every proscenium I've ever seen (there are a few odd exceptions) is wider than it is taller. Also, I am usually taking wider shots of the overall stage for my work. I do frequently find that I need to switch to portrait mode for other areas, such as my wife's costume work. In Figure 9.1 and 9.2, you can see the same setup photographed in both landscape and portrait mode. An argument can be made that each is useful in its own right, depending on the needs of the various artists involved. The landscape version shows more lighting and scenery, while the portrait is better for props, costumes, makeup and hair, and the performer. If you plan to shoot in portrait mode, be sure to practice your stances or set up your tripod for this in advance. To make life easier, when I turn the camera to portrait mode, I try to always turn in the same direction (counterclockwise is my preference for holding), so that I won't have to deal with rotating images in two different directions when it's time to review them.

Let's look a bit closer at these three common aspect ratios, and what they mean. In order to understand what sort of aspect ratio and cropping choices we might make, we also need to discuss the **Rule of Thirds**. The Rule of Thirds is one of the most basic concepts found in image composition. Take any potential shot that you want, and divide the image into thirds, both vertically and horizontally. This works no matter what size square or rectangle you have.

When you place a subject right in the middle, the shot may feel awkward or overly staged, and it may also lack dynamic energy to the composition. Instead, try to place the

framing your shots | 97

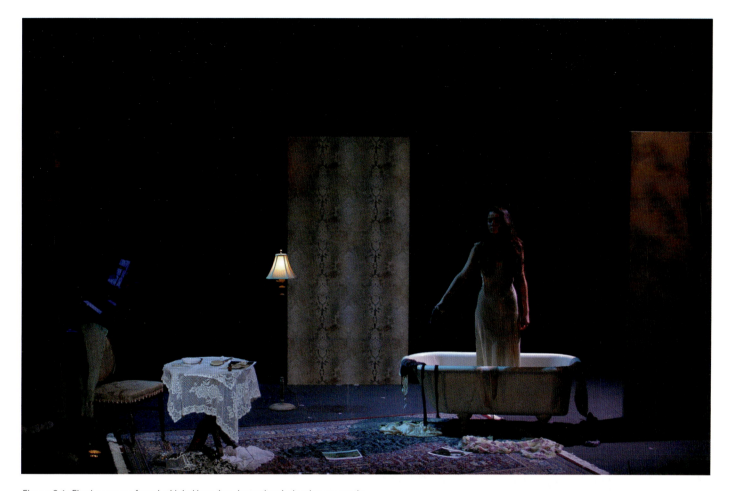

Figure 9.1: Final moment from La Voix Humaine, long shot in landscape mode.

objects or subjects that are the primary focus near the intersections of the one-third lines. Another technique, as shown in Figure 9.4, is to align horizontals, like the edge of the horizon, with one of the horizontal one-third lines. This can create interesting and dynamic visuals in your shots.

In Figure 9.5, you can see that there is a diagonal line between the character of Billy and the female dancer, which creates a visual link and guides the eye. For the sake of clarity concerning the Rule of Thirds, I chose to artificially crop this photo into a 3" x 3" square, for the sake of clarity concerning the Rule of Thirds. Let's look at the rule applied to another shot that is adjusted to fit our common aspect ratios. In Figure 9.6, I have imported the image into Photoshop, and the image is natively in a 3:2 aspect ratio. I've turned on the crop tool, which includes a handy "Rule of Thirds" overlay grid that can assist you in your editing.

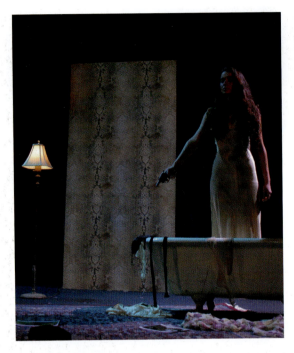

Figure 9.2: Final moment from *La Voix Humaine*, closer shot in portrait mode.

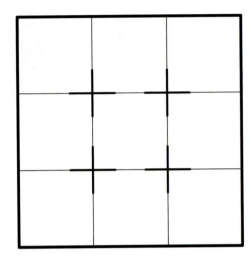

Figure 9.4: Rule of Thirds with intersections highlighted.

Figure 9.3: Rule of Thirds on a 3" x 3" square.

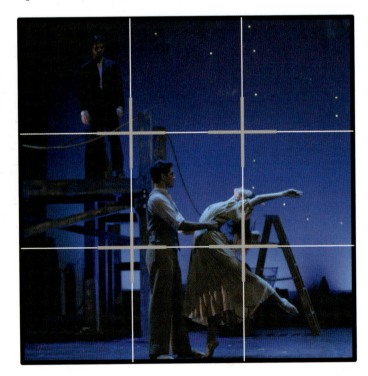

Figure 9.5: Rule of Thirds applied to *Carousel* production shot.

framing your shots | 99

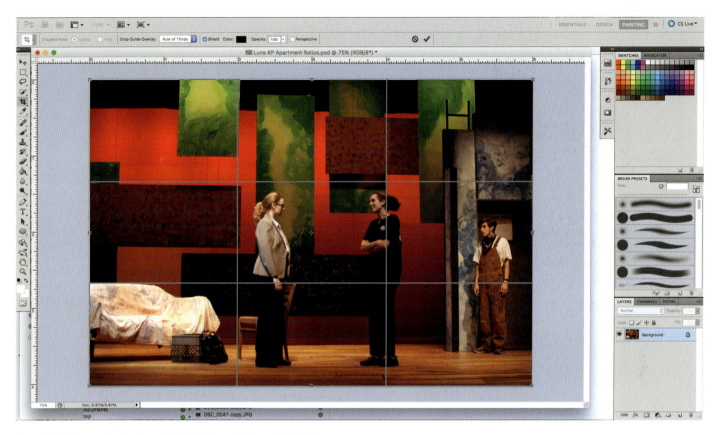

Figure 9.6: 3:2 aspect ratio, *Luna Gale*, Allegheny College, Feb. 2017.

As you can see, the two main female characters are on or right near the vertical one-third lines. I could crop this image down a bit, losing some of the sofa on the left, and this would proportionally adjust the vertical one-third lines so that both female characters were right on them.

Another option would be to convert this image to a 4:3 aspect ratio. I began by resizing the image so that the vertical height was 6 inches, which means that I need to crop out enough of the image so that the horizontal width is 8 inches, and that will maintain the new 4:3 aspect ratio. Using the crop tool, and my Rule of Thirds overlay grid, I can choose to crop out part of the sofa on the stage right side of the photograph in order to trim the width down to 8 inches. As you can see, this has also moved the female characters so that they are on or adjacent to the vertical one-third lines.

Finally, if we wanted more of a widescreen feel to this photograph, we can resize and crop it to arrive at a 16:9 aspect ratio. In this version, I resized the photograph so that it was 16 inches wide, and then turned on the crop tool again and adjusted the grid so that it covers 16 inches of width and 9 inches of height in the image. As you can see, in order to adjust this photograph to fit this new aspect ratio, I had to make

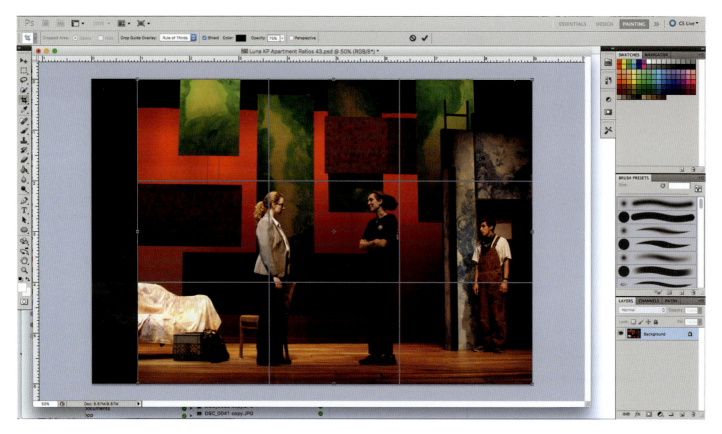

Figure 9.7: 4:3 aspect ratio, *Luna Gale*, Allegheny College, Feb. 2017.

some cropping choices at the top and bottom of the image. I chose to place one of the horizontal one-third lines so that it passes right through the faces of the two female characters, making them strong focal points of the composition.

When scaling images in Photoshop, it is very important to keep the Constrain Proportions option checked, otherwise you will end up with images that are compressed or distorted either horizontally or vertically. You can see in the screenshot where that option appears during the image-resizing process. By keeping the proportions constrained, when I resized the image to be 16 inches wide, I ended up with 10.708 inches of height, which I subsequently cropped down to the 9 inches required to maintain the ratio properly.

There may be some specific reasons why you don't want to employ the Rule of Thirds, perhaps because you need to capture a specific object or subject that just doesn't lend itself to this situation. That's perfectly fine, as long as you are thinking about the composition of the frame. I often suggest that a skill with composition for photography translates very directly to developing your skills for the composition of elements within a proscenium arch. This would especially apply to scene designers, lighting designers, choreographers, and directors.

Figure 9.8: 16:9 aspect ratio, *Luna Gale*, Allegheny College, Feb. 2017.

Ultimately, what do you need for your portfolio or website? If you want to adjust or crop your photos so that they conform to these standard ratios, that's fine, but if you have other overriding reasons to choose other aspect ratios for your final images, then go with what works for you. No one looking at your portfolio is going to get out a ruler to see if you are conforming to these ratios, but you should be aware that the aspect ratios we use are the result of many years of artists determining which aspect ratios are most pleasing to the eye. If you want to delve more deeply into this topic, and don't mind some math, look into the Golden Rectangle or Golden Ratio, which mathematically define certain desirable and scalable aspect ratios.

There is one more significant mechanical influence on the size and format of your images, which has to do with the image-sensor size. In the days of 35mm film, the frame was 36mm x 24mm per exposure, which is a 3:2 aspect ratio. Full-frame DSLR cameras are made with a sensor that is the same size as this for several reasons, but most important to me is the ability to use older, high-quality lenses on modern DSLR cameras. The downside is that the full-frame sensor cameras tend to be the really expensive ones, and were certainly out

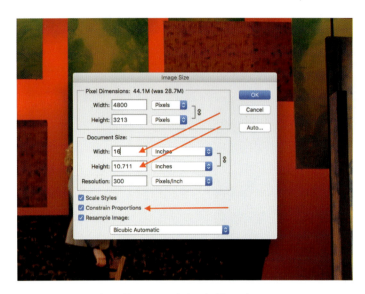

Figure 9.9: Image size adjustment window in Photoshop.

of my price range when I started into the digital realm. Most all of the consumer and prosumer camera models are instead fitted with a slightly smaller image sensor often referred to as an APS-C. This size of sensor is derived from a more recent type of film that had a brief heyday before being relegated to the scrap heap with the advent of digital photography. The sensor size varies slightly between manufacturers, and sometimes even between model lines, but averages about 24mm x 16mm, which is still an aspect ratio of 3:2. This means that there is a crop factor of 1.5, or that the APS-C sensor is 67 percent the size of the full-frame sensor. For the most part, this isn't an issue, as long as you are careful to purchase the correct lenses for your camera. Lenses and bodies are interchangeable within some brands, but this added functionality carries with it some pitfalls. If you do own a brand that allows for this, here are the major compatibility concerns. There are four possible combinations:

1. Full-frame body and full-frame lens: in this case, you have the best possible combination of body and lens, and should not experience any cropping or vignetting in your images.
2. Full-frame body and cropped-frame lens: in this case, your camera may recognize the fact that you have a cropped-frame lens installed, and may automatically adjust what you can see through the viewfinder to match the reduced size of the image that will be recorded by the image sensor. If this doesn't happen automatically, you will need to be aware that the image will only be two-thirds as large as what you can see, since it is being mechanically cropped by the architecture of the lens. Basically, the crop lens will only focus its image on the center two-thirds of the image sensor.
3. Cropped-frame body and cropped-frame lens: in this case, you should also experience full and effective use of the entire surface of the image sensor, since the crop frame lens is designed to work with the smaller **APS-C** sensor format.
4. Cropped-frame body and full-frame lens: in this case, the image captured by the full-frame lens is actually larger than the APS-C sensor size, which results in some loss of the overall image. Essentially your image will spill over the sides of the smaller sensor and not be fully recorded.

To further investigate this issue, we need to talk a little bit about field of vision. Most humans have a cone of vision around 60 degrees, if we just look at what is directly in front of us with both eyes. Including peripheral vision, our field of view is actually much wider, and approaches 180 degrees for most people. For now, though, let's concentrate on the area we can see clearly when we focus on something directly in front of us. As a lighting designer, when I am working on the design of a show, I will sit at a tech table that is often two-thirds of the way toward the back of the house. This distance often allows me to see the entire stage from edge to edge within my primary vision. With my full-frame 50mm camera, I could usually capture most of what I wanted, or might have to move back

a row or two. With my APS-C format camera, I need to use a 35mm lens instead to get the field of view I want.

Now, if I were to go and try to use my 50mm full-frame lens on my APS-C camera, I have to take into account the fact that the projected image is larger than the sensor, which is similar to having a longer-focal-length lens on the camera. To determine this effect, simply multiply the focal length by the crop factor to get the new "apparent" focal length. In this case, 55mm x a 1.5 crop factor = 75mm apparent lens size. A 75mm lens is getting into the lower end of telephoto lenses, and this makes sense. You will get an image that is zoomed in by a third, as opposed to the entire image you see in the viewfinder. Obviously, this is probably the least desirable situation, unless you are hoping to use older lenses you already own, or plan to buy a full-frame DSLR later on, and don't want to re-buy all your lenses.

One of the most important things you can do to prepare for a successful photo-call is to plan out where you will shoot from. If you can visit the theatre in advance of the call and walk around with your camera, you can pre-plan which lens or lenses you need to use, and if you will need multiple cameras, a tripod, helpers, or not. I also might make notes on my photo-call list of which seat and row I want to be in for certain shots so that I don't have to figure it all out again on the day of the shoot. Usually you only really have time to shoot each setup from one vantage point, and in a portfolio presentation, I'd rather see three different looks from the show, as opposed to three different views of the same look. That said, not every shot you show has to be from the exact same vantage point. I, as a lighting designer, usually feel the need to show the entirety of the stage so that everyone can see how I treated the whole look, rather than just the part we are focusing on. Other areas might want to show a close-up; for example, a costume technician might want to feature just one outfit that they built, and not worry about the rest of the cast. A props person might want to feature a particular prop that they built in use. Think clearly about your intended use, and what you need to capture for that use to be effective.

You could zoom or crop this photo a bit, if you like, to focus even tighter on the costume, but I like to have some set context available so that you can show how the colors of the main object of interest interact with the rest of the world of the play. If we were talking instead about the prop martini glass, or perhaps her makeup, an even closer shot would probably be better. Of critical importance, however, is your background. When you think about a shot, think about what is behind the object or person you hope to capture. In this case, there is some color and some visual interest with the different set pieces, but if I had moved to my right and shot this image with the amber wall behind the actor, it would have stolen the focus of the photograph. You can even argue that the amber wall is a bit bright, which I could agree with. I did shoot a second version moving much further to the right, and that then uses the darkness as a background, although you will see the ever-present exit light in the shot. You could Photoshop that out if you like. I was trying, however, to frame the actor so that they were centered in the right-hand archway, and the partial arch in the background is also pointing toward the center of the photograph. There are times, although infrequent, where you can use elements of the set to influence the viewer's eye, especially if you are careful to plan out your shot. This is certainly a regular practice in art photography, where the composition of the photograph is truly up to you. We are bound by the fact that we need to capture certain things in our work, but that doesn't mean that you can't look for ways to increase the strength of your composition.

Another way to look at this can be seen in the following sequence of shots. I never do this for real, but the actors were kind enough to hold the pose long enough for me to move around and shoot this moment from some different angles. This production was presented in the Pavilion Theatre, which is a very deep 3/4-thrust space. As such, most of the audience actually sits on the sides of the performance space as opposed to the end. Figure 9.12 shows the view from the audience section located downstage center of the main playing space.

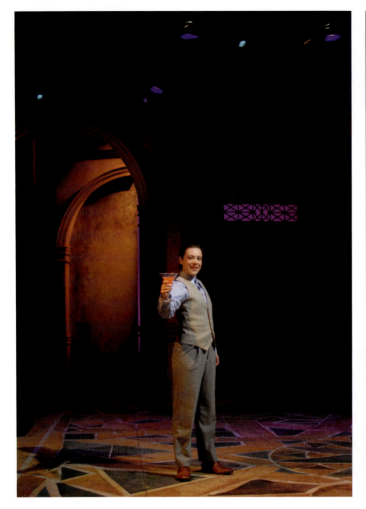

Figure 9.10: Shot of a character's costume from *Twelfth Night*, Penn State University, Nov. 2016.

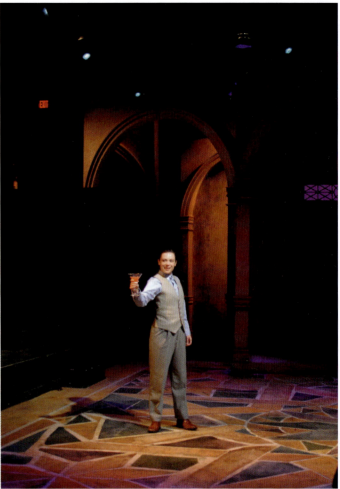

Figure 9.11: Alternate shot of a character's costume from *Twelfth Night*, Penn State University, Nov. 2016.

The two characters standing upstage are a main focus of the scene, but the rest of the characters are also participating. From this angle, we don't see many faces, as is often the case with the necessarily fluid **blocking** that is called for in thrust venues. This is the view of the action that about 20 percent of the audience saw. Figure 9.13 and Figure 9.14 are both from the seats located stage right of the main playing space. Figure 9.13 is shot from the second lowest row of seating, and Figure 9.14 is shot from the highest row of seating.

The main difference between these shots is just how many people are visible, and what they are standing in front

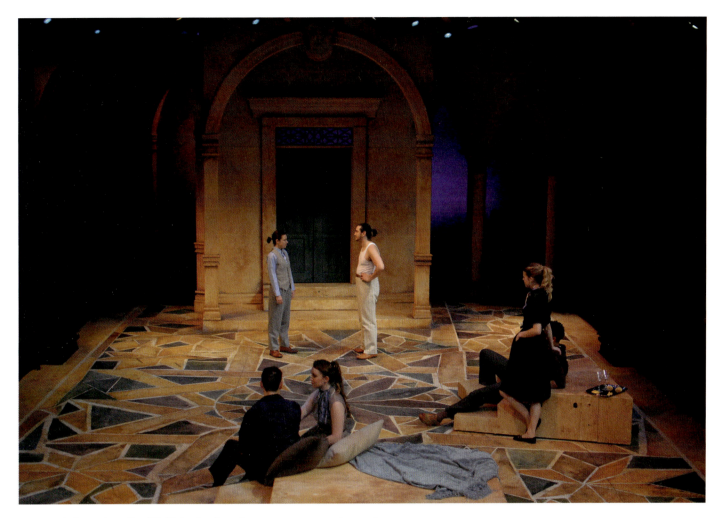

Figure 9.12: Scene from *Twelfth Night*, shot from downstage center seating section.

of. The two characters upstage aren't included in second and third shots, mainly because I don't have a wide-angle lens that won't start to "fisheye" at that distance. If I really needed the other two, I need to move further back to include them, and that also changes the character of the shot. But let's take a closer look at the difference between Figure 9.13 and Figure 9.14. As I move further up the rows from where I was to take the shot shown in Figure 9.13, two things are changing. As I increase distance, I am able to get more real estate in the shot, but based on the common fact that theatre seating tends to be on an incline, I am also increasing my angle to the stage. The difference is especially visible when you compare the look of the steps on the platform in the lower-right corner of each shot. The third shot in Figure 9.14 is steeper, but I'm able to

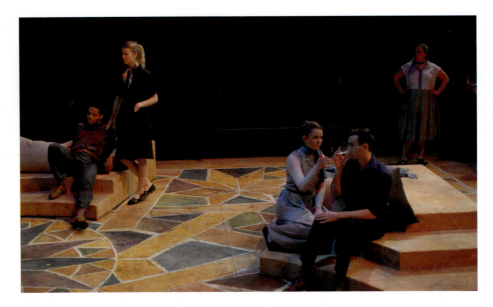

Figure 9.13: Scene from *Twelfth Night*, shot from a lower row in the stage right seating section.

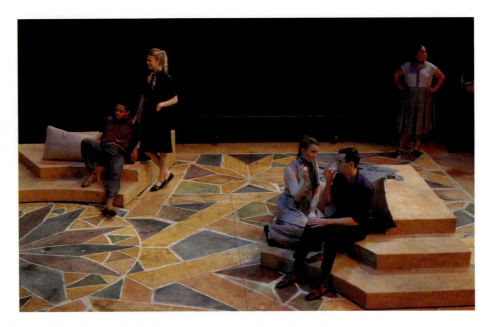

Figure 9.14: Scene from *Twelfth Night*, shot from the highest row in the stage right seating section.

include more of the scenic unit than in the second shot. Most houses have a rake to their seating, and sometimes it can be a pretty extreme rake, so this distance-and-rise situation may affect you severely, as it does in this particular space. Think about wider lenses, or shooting from an opening in the seating that allows you to avoid the increased height with the distance if that is possible.

Now, if we look at Figures 9.15 and 9.16, this is again two very different angles of the same moment in the play. I like the fact that Figure 9.15 features the set as a backdrop, rather than the not-very-nice theatre seats seen in the background of Figure 9.16. I actually went through the house during

Figure 9.16: Court scene from *Twelfth Night*, shot from the lower rows in the center of the stage right seating section.

Figure 9.15: Court scene from *Twelfth Night*, shot from the downstage center seating section.

Figure 9.17: Court scene from *Twelfth Night*, shot from the downstage right vomitory.

the break between the end of the show and the start of the photo-call and picked up trash and forgotten coats and gloves that would have otherwise been plainly visible. I tried to get all the seats to stay up at a consistent angle, but some were a bit troublesome, and reflected the bounce light a bit differently.

One of the problems, however, with Figure 9.15 is that we can't see the expression on the face of the actress in the foreground, since she is turned upstage. By moving my position, and shooting from the side, I was able to capture her face in Figure 9.16. Additionally, the actress in the foreground is actually blocking our view of some of the performers in the background, which is a bit awkward. Depending on your needs, one of these pictures may be better than the other, but neither of them solve all the issues. This is certainly one of the challenges with taking pictures in a 3/4-thrust venue. I took a third shot from lower down and deep into a vomitory entrance to the space, so that I could gain distance without gaining height, and ended up with Figure 9.17. We still don't see the one actress's face, but she's not standing directly in front of anybody anymore and the set forms a significant portion of the background instead of chairs. This might be the best option for this particular moment, knowing that we're never going to see everybody's faces simultaneously from any possible vantage point in the whole space.

Here are another pair of shots from the same show, with a similar blocking issue. You will notice that the two actors are playing a slightly different angle, which allowed me to tuck into the same vomitory, and still capture a profile and a full face.

In this production shot (Figure 9.20) from *1776*, I took a much more "involved" shot, primarily for the benefit of the costume designer. There are positives and negatives about this shot, so it really depends on your needs if something like this is useful to you. On the one hand, the character to the right is dark and a bit out of focus, but then he isn't the main subject of the shot, so perhaps that is okay. The main subject is the actress, and especially her dress. For this reason, the shot is limited in its usefulness to the entire company, but is a

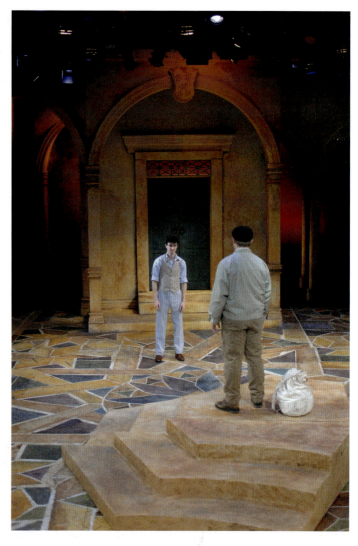

Figure 9.18: Exterior scene from *Twelfth Night*, shot from the downstage center seating section.

far better use of framing for the one design area. I also like the fact that the actor's arm creates a strong visual diagonal that causes our eye to focus right where I wanted it. Note also that the high angle of this shot means that I am capturing some of

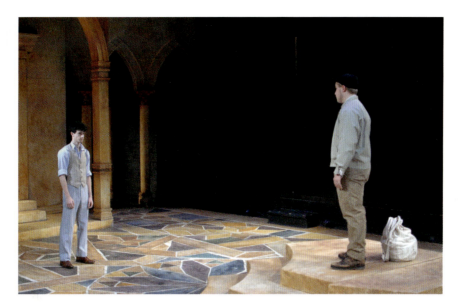

Figure 9.19: Exterior scene from *Twelfth Night*, shot from the downstage right vomitory.

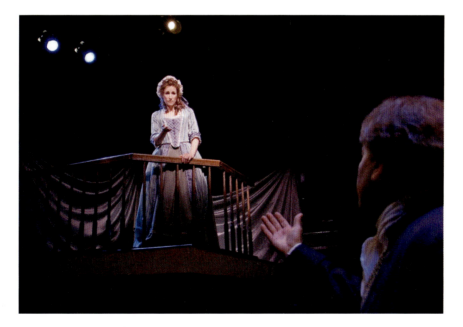

Figure 9.20: Production moment from *1776*, Penn State University.

the lighting instruments on the grid of the theatre. I carefully moved around to avoid lens flare, and tried to position the visible fixtures so that they help reinforce the imaginary diagonal line that begins with the actor's arm and ends with the two pale blue fixtures.

If you plan your shots in advance, and know what you want to see in the frame and beyond the frame, you will certainly be more successful in capturing what you need, and be happier with the results.

Framing Practice Session

1. If you expect to shoot from a variety of locations at your next call, you should walk around the venue with your camera and confirm a few things.
 a. What's behind and beyond the shot I want to get?
 b. Do I have the right lens to capture the entire shot without cropping anything important or being zoomed out too far?
 c. Do I need to adjust my plans for a tripod or monopod, or evaluate the stances that I might use to handhold the camera?
2. Walk into the theatre, and try to find the row where you can comfortably see everything in your primary cone of vision without having to turn your head side to side. Now look through your viewfinder and see if your lens crops or zooms what you see. If you have multiple lenses, try them all out, and see which one suits your needs the best for the particular venue that you are in. If you were using a zoom lens, and are perhaps taking pictures of individual costumes and full-stage shots, then you should ensure that your zoom lens is capable of zooming in close enough and zooming out far enough to catch both these extremes. Have someone stand on stage as a scale stand-in for the performers so that you can get a sense of this. Once you know how far you have to zoom in and out, then you will also be able to evaluate whether or not you're going to be in a situation where your zoom lens may not be able to utilize its maximum aperture. This would be useful information for you to have in advance rather than discovering it on the day of the shoot.
3. If you haven't spent much time photographing things in portrait mode, then this would be an excellent chance to see which stances are most comfortable for you, or if your tripod is capable of flipping your camera 90° to the side.
4. If you are in an ornate theatre and want to capture the extents of the proscenium, then this is also a good time to see if the 3:2 aspect ratio of your DSLR can appropriately capture that portion of the architecture. If not, you may need to go with a slightly wider focal length lens and then reframe your pictures in a 4:3 aspect ratio, giving you a little more height to the width of the image.
5. Carry your camera around with you and try to get in the habit of taking snapshots of interesting people and things, while carefully planning how the people and things in the foreground relate to the background. This will help you plan your shots in non-traditional spaces.
6. Grab a common household object, and attempt to photograph it from several different angles and distances. See if you can figure out how to tell a different story with the same object just by varying your view of the object.

chapter ten

the secondary settings

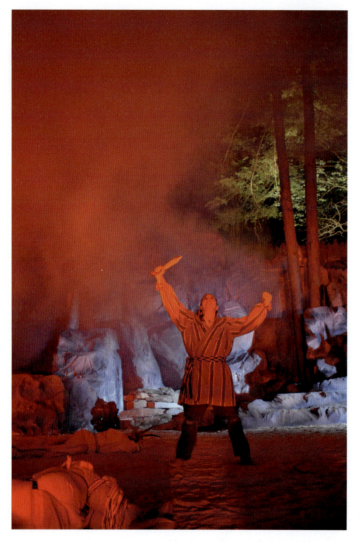

Battle of Horseshoe Bend, *Unto These Hills*, Cherokee Historical Society, 2007.

Now that we have dealt with all the various settings that are required to get a properly exposed, focused, and framed shot, let's investigate some of the really great features that are available to us with most DSLR cameras. Over the next few chapters we will investigate various metering modes, auto-bracketing, and EV compensation settings. What's different about these three settings is that they are simply automating things that we would normally just do manually. All of these settings are usually things that I will decide upon before the start of a photo-call and will leave in place for the duration of the shoot, with the possible exception of altering EV compensation settings if I notice that things are turning out significantly over-exposed or under-exposed. The other great thing about these three settings is that they all allow us to concentrate more on getting good shots, and eliminate the need to count how many pictures we've taken or artificially adjust our exposure based on the unusual lighting situations we might find ourselves in.

Meter Priority

Meter priority settings aren't really anything terribly new, as they have been available on film cameras for many decades. However, in conjunction with auto-bracketing, they are a very powerful tool. Simply put, the various meter priority modes that you can select from will either partially or fully automate your camera's ability to correct the aperture and shutter speed for the proper exposure for each shot. Metering modes usually come in at least four variations, including **aperture priority**, **shutter priority**, manual, and program modes. Smartphones and point & shoot cameras, along with the lower end of entry-level cameras, may have these as options, but often have these built in to a more user-friendly format. They will come with various pictograms to select from that will do some of the work for you, if you are taking pictures in certain circumstances. Simply match the pictogram on your camera to the situation that you're trying to photograph and click away. While all of these modes are certainly useful for the novice photographer, allowing them to select one that is appropriate for taking close-ups of nature versus another best suited for taking portraits of friends, they are rarely appropriate for our purposes. Unfortunately, I've never seen a "take pictures in the dark

theatre" button, so unless you know exactly what settings these various pictograms represent, it's probably better to control the settings individually ourselves, so that we can adjust them for our particular circumstances.

Auto-Bracketing

Auto-bracketing is the practice of taking multiple exposures of a single "setup" during a photo-call to ensure that you have a selection of exposures to choose from when selecting photographs for your portfolio. In the age of film, this was a fail-safe for several reasons, the main one being the delay in time between the photo-call and getting your slides back from the camera shop.

Auto-bracketing is one of the great new features available to photographers in the digital age. This feature allows you to automatically take multiple shots, with a preset exposure variation between the shots, all with one shutter-release press. In the past, photographers with all-manual cameras would need to frame up the shot, take one exposure, and then reset the camera to another variation, take another shot, and repeat as needed.

EV Compensation

The EV compensation function allows the user to semi-permanently alter the response of the camera's light meter. This is done either to recalibrate a meter that is reading slightly off, or to reset what we think the camera should consider to be optimal exposure. The second option is the one that I find myself relying upon fairly frequently in my work.

Any time that we can leverage new features in our camera that then allow us to spend more time concentrating on the accuracy and artistic nature of our photographic work, the better. By the time this book is published, there may be new features out there, and it is my hope that we can continue to discuss how to utilize all of the features and functions of today's cameras to further our craft.

chapter eleven

meter priority

meter priority 115

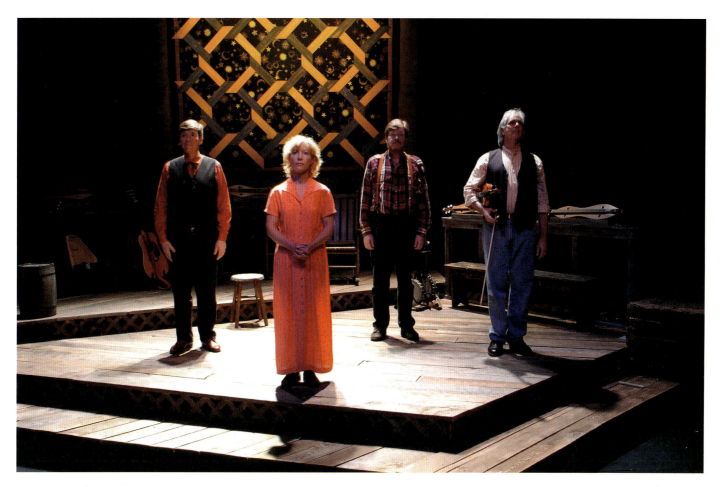

Porch at night, *Singin' the Moon Up*, July 2005.

Your camera most likely comes with a number of meter priority settings, otherwise known as metering modes. These modes tell your camera's meter how to react to the light that it is sensing, and how to adjust the various settings to optimize the shot for the best exposure. Auto-exposure settings have been around for quite a while, and are almost essential if we want to work quickly and efficiently during a photo-call. Many smartphones and point & shoot cameras rely almost exclusively on preset auto-metering selections. When coupled with auto-bracketing, which we will learn about in the next chapter, some of these metering modes are extremely useful.

On higher-end cameras, you will usually find at least four modes, including aperture priority, shutter priority, program, and manual. Simply put, aperture priority mode allows you to select the aperture that you would like to use and it instructs the camera to select the shutter speed that is appropriate for obtaining the optimal exposure for the shot. Likewise, shutter priority allows you to select the shutter speed you would like

to work with, and then instructs the camera to select the most appropriate aperture to achieve optimal exposure. Program mode links appropriate aperture and shutter speed pairings for the shot you'd like to take, and then lets you scroll through these pairings, allowing you to select the best combination of the two for the shot. Finally, manual mode returns you to full control over all the settings yourself, and allows you to choose the aperture and shutter speed as appropriate for the shot that you like, based on the meter in your viewfinder. It does not, however, prevent you from taking a shot that is "off the meter," which is very useful for us, since we are often in situations where we need to under-expose or over-expose the shot to capture the details of a certain moment.

Manual mode is great for experimentation and certainly very useful if you are comfortable with your camera settings. The program mode in my camera is very effective, but since I shoot frequently with auto-bracketing, I usually pick aperture priority, or occasionally shutter priority. Figure 11.1 shows the arrangement for my DSLR. Hold down the mode button, and then use one of the embedded thumbwheels (not visible) to scroll through the options. Currently my camera is indicating an A for aperture priority in this example.

I prefer to use aperture priority, mainly because I have control over the movement of the performers and have reduced the blur I impart to the picture. There have been a few times when I have been surprised by the camera choosing a fairly slow shutter speed without me realizing it, especially when bracketing. The camera may shoot at 1/15th, 1/8th, and 1/4th, and that last exposure seems like it's going on a while! Rarely do I find that the camera wants to shoot with a shutter speed that is faster than possible. More often than not, I find instead that it wants to shoot with a fairly slow shutter.

Figure 11.2 shows the method for selecting metering modes on the Canon PowerShot, and is typical of this level of camera. There is an easy-access selector dial located adjacent to the shutter release button, which allows you to quickly and easily move between the same set of standard metering modes. You'll notice that the M for manual and the P for program are the same, along with an Av for aperture priority and a Tv for shutter priority.

Now if we look at the other side of the dial we will also see some of the pictograms I mentioned earlier, including a running figure, a landscape, and a portrait, amongst others.

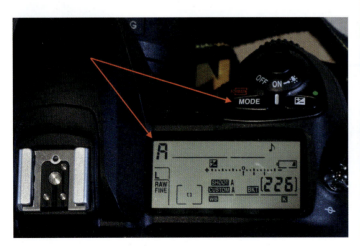

Figure 11.1: Nikon DSLR mode button and setting indicator.

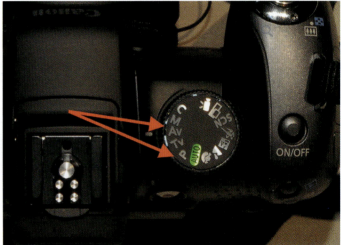

Figure 11.2: Canon PowerShot metering mode selector, standard settings.

These are for sports photography, landscape photography, and close-ups of people, respectively, as you can probably guess. These presets can be very useful, as they make a number of settings changes for you that the manufacturer has determined are appropriate for these particular situations. For example, when set to the sports mode, the camera selects a high shutter speed, and makes other adjustments to the focus and exposure metering to provide great freeze-frame moments of a sporting event. It would be very useful for you to become familiar with what settings are being changed by the camera when you select one of these preset metering modes. By now, if you have experimented with all of the practice sessions so far in this book, you should be pretty familiar with most of the settings that these presets might be adjusting. While great for casual photography, you should be very comfortable with setting the camera up yourself by now, and may find that not every aspect of these presets works for you. If, however, you find that one of these hits a real sweet spot for your particular photographic style, then feel free to use it.

This is also a good point to talk about shooting menu banks. More advanced cameras will often have an option for you to set up your own presets or menu banks, which often go way beyond just setting up the metering mode of the camera. You may be able to set up a shooting menu that selects the metering mode that you'd like to use, the film speed, your preferred color space, file type and size, auto-bracketing options, and even your white-balance settings. This is certainly a very fast and convenient way to jump between the complex group of settings that are required for shooting in the theatre and the settings that you might use for more casual photography.

My camera can retain four banks, although I really only use two, one for normal use and one for stage. There are some settings that stay the same across both at this time, so here is a comparison of the settings that change in my "Stage Use" bank versus the "Normal Outdoors" bank. I use these as a starting point, but can easily change them on the fly if I need to.

Option:	Stage Use Bank:	Outdoors Bank:
Image Quality	JPEG Fine	JPEG Normal
Image Size	Large	Medium
RAW Compression	NEF	Off
White Balance	3200°K	Auto
ISO Sensitivity	800	400
EV Compensation	–1.0 EV	0

When in the Stage bank, I still have to select an aperture (usually starting at f/2.8), set the metering mode to aperture priority, ensure that auto-bracketing is on, and set it to take three exposures with a 1-stop offset. When back outdoors, I move to no bracketing, metering set to aperture priority, and a starting aperture of f/5.6.

If your camera has shooting menu banks, then I urge you to use them as a way to make sure that you don't forget one of the many settings that needs to be correct for your pictures to come out right. If you don't have this possibility in your particular camera, then write down all the options that you want to make sure are properly set on a 3 x 5 card and throw it in your camera bag. That way you can quickly review

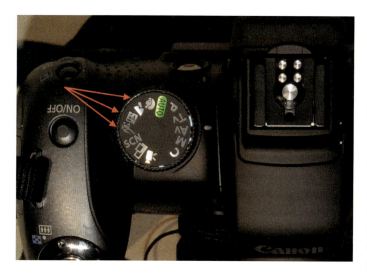

Figure 11.3: Canon PowerShot metering mode selector, presets.

it before the photo-call as a checklist. Several of my older film cameras used to have the ISO setting on a small ring on the bottom of the lens and I shot more than one roll of film with an incorrect ISO setting, causing some trouble when it came time to process the film.

Meter-Priority Practice Session

1. Let's begin by utilizing your camera in full manual mode. Work out how to adjust the aperture and shutter speed while looking through the viewfinder so that you aren't "chimping" or fumbling about to find the right dials and buttons. Once you are familiar with those settings, and can easily and quickly manipulate them to get your exposure on the meter, then you can move on.
2. Using the aperture-priority function, try setting several different apertures, and shoot a few setups with each while allowing the camera to select the shutter speed. What happens if the aperture that you have chosen is forcing the camera to shoot with a shutter speed that it can't use? Is there a flashing indicator somewhere in the viewfinder that alerts you to this concern so that you can consider adjusting the aperture to allow the camera to shoot with a shutter speed it is capable of?
3. Using the shutter speed priority mode, try setting a few different shutter speeds and shoot a few setups, while allowing the camera to select the aperture. The options for aperture are far more limited than the options for shutter speed, so you are much more likely to run into a situation where your lens just can't open up or close down any further than it already has. What sort of indicator does your camera show inside the viewfinder to alert you to this concern?
4. If you have the possibility of setting shooting menu banks, then try designating one for your stage use, set it up with the options you want, and then flip back and forth between it and normal use. Make sure that the settings are all changing to what you need for your theatrical photography.

chapter twelve

EV compensation

EV compensation

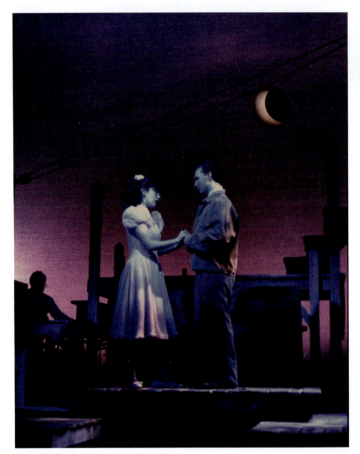

Night scene, *The Fantastiks*, Nutmeg Summer Stage, June 1992.

Figure 12.1: EV compensation menu button.

Figure 12.2: Once pressed, you can access and change the EV compensation. This is currently showing an EV compensation of –1 stop.

Exposure value, or EV, is another way to talk about light values. One EV is the same as 1 stop, which continues to make our life easy. Exposure value (EV) compensation, sometimes also known as EV correction, is a semi-permanent change you can make to your camera's light meter. When your camera comes out of the box, it will be set to an EV compensation of 0. Essentially, it is doing nothing to influence your camera's meter one way or the other. By adjusting this setting, you are shifting your meter's idea of what middle grey is either up or

down the scale, which directly changes your meter readings and the resultant exposure settings. There are several reasons why you might want to adjust this setting; the two main reasons have to do with meter calibration and the metering behavior of your particular camera.

Most DSLR meters today should be very accurate, and, as usual, the more you spend, the more you can expect in terms of quality and calibration. In the days of film, camera meters could vary, and there was a fairly simple test you could do that involved taking some controlled shots of a neutral surface, developing the film, and then reading the amount of silver halide on the surface of the negative with a densitometer. Compared to a set of available tables, you could then determine if your meter read too light or too dark. Okay, maybe it wasn't a *simple* test…

If you want to take your camera into a very controlled studio environment, you can use that 18% grey card we discussed in Chapter 3. If you set up a white light on the card, and photograph the card, there are ways to use that specific picture to influence the white balance and help you determine if your meter is properly calibrated. The methods for doing this vary by manufacturer, so you will have to do some research if you want to try this with your equipment. To be brutally honest, I've not done this with my DSLR, because the results I've been getting lead me to believe my meter is on the money, or at least close enough, especially when I'm bracketing.

Figure 12.3: "On the meter" exposure taken with an aperture set to f/2.8 and a shutter speed of 1/8000th.

Figure 12.4: Same shot with −1 EV compensation.

Figure 12.5: Same shot with +1 EV compensation.

You may find that the meter in your camera, or perhaps your camera's interpretation of the information obtained from the meter, results in your photographs being too bright or too dark. You may even find that there is a difference between how accurate the meter is reading when you have the film speed set to ISO 400 versus ISO 1000. Try to shoot the grey card test shots with the settings you plan to use in your photocall. If you find that your meter is reading a bit off, you can introduce an EV compensation to counterbalance that issue. If your shots are over-exposed, set the EV compensation to a negative value, and, conversely, if your shots are under-exposed, choose a positive EV value.

The second reason has more to do with how you are using your meter, and possibly anticipating exposure issues you might run into. If your shots are bright and fairly evenly exposed across the entire frame, then this won't be as much of an issue, but as we discussed in Chapter 3, there are several ways to set up your camera's metering. If you go with spot metering, then you can have far more control over just what part of the shot you want, but it might not be the brightest part of the shot, so maybe not the best thing to meter off of. I usually run with at least –1 stop of EV compensation, not because my meter is off, but to counteract the percentages that affect the camera's meter when it's in field metering mode.

Figure 12.6: Test shot taken at an aperture of f/2.8, a shutter speed of 1/320th, and no EV compensation. This bracketed shot is under-exposed by 1 stop from being "on the meter."

Figure 12.7: Test shot taken at an aperture of f/2.8, a shutter speed of 1/160th, and no EV compensation. This bracketed shot is "on the meter."

Figure 12.8: Test shot taken at an aperture of f/2.8, a shutter speed of 1/80th, and no EV compensation. This bracketed shot is over-exposed by 1 stop from being "on the meter."

The following set of shots is bracketed (more on bracketing in the next chapter), but because the meter is trying to give you the best exposure for the overall shot, the main object is over-exposed and the detail is blown out.

I have purposely set the camera to field metering in order to demonstrate the need for EV compensation, and this is a really fine example of what I was talking about when discussing field versus spot metering in Chapter 3. When you look at the picture, the wolf toy is less than 20 percent of the entire surface of the image, so the camera is trying to force the black portion of the picture to be middle grey.

Knowing that this will probably happen in advance, if I preset my camera for a –1 stop EV compensation, I can let the camera's meter still do its job, but I don't have to think about adjusting the exposure for any of the shots I'm taking. Once I've applied the EV compensation, my results will shift in exposure, as seen in Figures 12.9–12.11.

I found that the camera meter was having a tough time with the vast amount of black in the shot compared to the white, so I reset the EV compensation to –3 EV, and reshot the sequence, as shown in Figures 12.12–12.14.

Figure 12.9: Test shot taken at an aperture of f/2.8, a shutter speed of 1/640th, and an EV compensation of –1. This bracketed shot is under-exposed by 1 stop from being "on the meter," but in reality, is 2 stops under-exposed.

Figure 12.10: Test shot taken at an aperture of f/2.8, a shutter speed of 1/320th, and an EV compensation of –1. This bracketed shot is "on the meter," but in reality, is 1 stop under-exposed.

Figure 12.11: Test shot taken at an aperture of f/2.8, a shutter speed of 1/160th, and an EV compensation of –1. This bracketed shot is over-exposed by 1 stop from being "on the meter," but, in reality, is "on the meter."

Figure 12.12: Test shot taken at an aperture of f/2.8, a shutter speed of 1/2500th, and an EV compensation of –3. This bracketed shot is under-exposed by 1 stop from being "on the meter," but, in reality, is 4 stops under-exposed.

Figure 12.13: Test shot taken at an aperture of f/2.8, a shutter speed of 1/1250th, and an EV compensation of –3. This bracketed shot is "on the meter," but in reality, is 3 stops under-exposed.

Figure 12.14: Test shot taken at an aperture of f/2.8, a shutter speed of 1/640th, and an EV compensation of –3. This bracketed shot is over-exposed by 1 stop from being "on the meter," but in reality, is 2 stops under-exposed.

Now I finally have a set of shots that will be useful. I also know that if most of the show will be like this, I may just run the whole call with my EV compensation set at –3, or I might choose to vary it a little bit as the shots require. This is easy to do on the fly if your camera's controls are set up for it, but not if it's buried in a menu somewhere. If that's the case, do some additional testing with a few cues before your shoot, so you can start with the best setting for the overall shoot. Depending on your equipment, this might be a setting you can roll in and out as the situation demands, but I tend to group this one into the "set-it-and-forget-it" pile.

EV-Compensation Practice Session

1. If your camera has EV compensation, figure out how to access and adjust it.
 a. To begin, ensure that your EV compensation is set to 0.
 b. Set up a high-contrast, well-lit still life, similar in values to the one I've used.
 c. Adjust the camera settings for field metering.

 d. Using one of the metering modes, take a few shots and see if you are experiencing any under-exposed or over-exposed areas.
2. Experiment with adjusting the EV compensation by 1 stop/EV value and retake your shots to see if they are turning out the way you want them now.
3. If that is helping, but not enough, try 2 stops/EV values.
4. If your camera does not have EV compensation, you may need to run things manually, and intentionally under- or over-expose your shots based on your experience with the above practice sessions. If this is also too difficult or time-consuming, then the next chapter on bracketing should help as well.

chapter thirteen

auto-bracketing

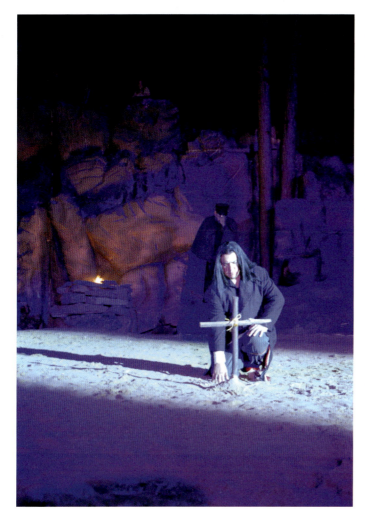

Trail of Tears, *Unto These Hills*, Cherokee Historical Society, 2007.

Bracketing your shots is a practice that grew out of necessity. Simply put, you attempt to take multiple exposures of the same setup or shot, with each exposure varying slightly from the others. In the days before you had a digital preview screen on the back of your camera, you had to shoot enough exposures to give yourself a good chance of ending up with a portfolio-worthy shot. Much of my early photo-call practices revolved around two unavoidable facts. First, film came in rolls of a defined length, usually 24 or 36 exposures. Second, it was often several days, if not more than a week, before you would be able to get your slides back from the specialty developer. Add on a few extra days to the darkroom time if you were also shooting with a "push" as discussed in Chapter 7, and the show was most likely struck and gone before you knew if you had anything useful from the shoot.

In order to properly bracket the shots and make sure I didn't run out of film, I usually planned to do three exposures per setup, and a total of 12 setups. If you loaded your film and tensioned it correctly, you might get an extra shot or two at the end, but, in general, this was a way to ensure that you had enough film, assuming a 36-exposure roll, to get three exposures of each of the planned setups. Now, changing out a roll of film takes a bit of time but isn't out of the realm of possibilities during a photo-call. You might need to give folks a break for a few minutes and take care of the film change-out, or you could swap to a second pre-loaded camera, and maybe just move the lens over. This is, of course, predicated on having two camera bodies that are identical, or nearly so, in order to preserve a continuity of look across all the shots from the night. Additionally, you now needed to shoot 36 more exposures so that you didn't waste expensive film. As I mentioned before, Ektachrome 320 is heat sensitive, so you couldn't just leave a half-finished roll in your camera for a later time…it was important to get it out and off to the developers in a timely manner.

In order to bracket your shots in this situation, you would need to determine the proper aperture and shutter-speed settings for each shot. Once your performers are set, take one exposure "on the meter," and then usually one shot underexposed and one shot over-exposed. Perhaps you want to shoot with a constant medium depth-of-field, so you have set your aperture to f/5.6, and your light meter is telling you to set the shutter speed to 1/250. You might then shoot at f/5.6 and

1/500 for your under-exposed shot, and then set your camera again to f/5.6 and 1/125 for your over-exposed shot. Doing all this manually is tedious, prone to error, and takes time. I usually set my camera for the under-exposed shot first, then the one "on the meter," and finally the over-exposed shot, so that I was only having to turn the shutter speed dial in one direction. This allowed me to keep the camera in position, properly framed, and get my shots all done fairly fast. This practice gives you a range of 2 full stops of light across the three pictures, and you'd have a fairly good chance of capturing an image that has the proper exposure and amount of detail you want to see.

So, what does any of this have to do with our lives in the digital world? I'll get to that in just a bit, but I want to make sure we have all the foundations laid for the proper use of this technique. There are a number of variables that you can apply to the practice of bracketing, including the number of shots you are taking, the exposure "offset" between each shot, and the starting point for your series of shots. I've already explained the most common and basic application of this technique, which is manifested in a series of three exposures, with a full stop of "offset" between them, and with the middle shot centering on the combined settings that the camera's meter has determined to be the best for the situation. As we learned in Chapter 3, the meter isn't always right, and we need to be aware of this when bracketing so that we know what adjustments we might need to make to give ourselves the best series of shots to choose from.

I have, on occasion, chosen to bracket with up to five exposures per setup, usually when there is a very broad range of contrast zones present. The loss of details in the shadows versus the possible over-exposure of something very light-colored or white are of concern, and I might want to cover my bases with some extra exposures on the edges of what the meter is telling me. I might also choose to make the offset between exposures smaller, so by shooting a few extra, I am covering a wider range with more "middle ground" to look at. Mechanical cameras can't really shoot at shutter speeds other than the preset ones built into the camera, without causing possible damage to the shutter curtain mechanism. You can, however, choose an aperture setting somewhere in between the standard ones available on the lens. The standard settings have a detent, or a click you can feel when you adjust the aperture, but it is easy (although not markedly precise) to find a spot somewhere between two standard f-stop settings. This gives you a 1/3- to 1/2-stop (very approximately) "offset" rather than the full-stop offset you will get by going up or down to the next click on the aperture ring.

Now, where the DSLR camera really shines is if it has the ability to auto-bracket, meaning that you preset the number of shots you would like to take, the exposure offset between the shots, and finally the order of the exposures, and then

Figure 13.1: This is the auto-bracket menu button on my camera, which gives you quick access to adjusting the number of shots and exposure offset.

when you are all set with your camera, you just have to hold down the shutter release button and let the camera go to work. The camera will automatically determine the optimum settings based on your program selection (usually aperture priority or shutter priority), and then proceed to take as many exposures as you have asked, with the proper exposure offset between them. As with many settings, some cameras may have this feature buried in a menu, or it may be quickly accessible through a feature button.

In Figure 13.2, you can see that it is currently set for three shots with a 1.0-stop offset. My camera has the ability to shoot one, two, three, five, seven, or nine frames, and can use an offset of .3, .7, or 1.0 stop. I have occasionally used the five-frame option, but can't see using it much, and probably would never use the seven-frame or nine-frame options. The main reason is that I'm going to end up with far too many files to go through. We will discuss file formats more in Chapter 14, but for now, let me also share with you the fact that I have my camera set up to save two copies of every exposure I take, one in **JPEG** and one in a version of RAW. That means if I shoot with a three-frame setup for bracketing, I'm actually saving six computer files. It suddenly adds up very quickly in terms of storage space and sorting time. You may also ask, "Why should I bother to bracket when I can just look at the preview screen on the back of my camera?" I still bracket for several reasons:

1. I don't trust the little screen to show me all the finer details, especially in the darker parts of the photo.
2. I don't want to take the time to look at each shot on the back of the camera and then have to make decisions about adjusting the exposure…that just takes too long.
3. I don't want to get home, download my pictures, and suddenly discover someone's hand was moving in the shot, and I don't have any fallback options.
4. With a DSLR, it's so darn easy and fast, and it doesn't cost me any extra money to do it.

The following series of photographs is from a production I designed of *La Voix Humaine*. As you can see, the performer is dressed in a light-colored gown, and due to the sparse and presentational style of the scenery, there is a great deal of black in the shot. The meter is going to want to open up a great deal to try and expose for the overall field of values in the photograph. As is often the case, I have chosen to run my camera with a −1 stop EV compensation setting. I wanted to ensure I got a nice range of possible images to choose from, so I chose a five-shot bracket. All shots were taken with the ISO set to 800, and white balance corrected to 3200°Kelvin, and were all influenced by the EV compensation. Since the camera was set to aperture priority, the auto-bracketing feature changed the shutter speed, and because I had selected an exposure offset of .7 rather than 1.0, the camera adjusted the shutter speed to increments of 7/10th of a stop, leading to some odd numbers that aren't normally in the list of shutter speeds. The meter was telling the camera that f/2.8 @ 1/60th was the proper

Figure 13.2: This is the auto-bracket menu on my camera, where you can see the exposure range and number of shots selected. These can be adjusted on the fly with the two dials embedded in the shooting grip.

Figure 13.3: This shot was taken with an aperture of f/2.8 and a shutter speed of 1/160th.

Figure 13.4: This shot was taken with an aperture of f/2.8 and a shutter speed of 1/100th.

exposure, and then it took a set at +/– .7 stops and +/– 1.4 stops, yielding five exposures over about three stops of range.

I happen to prefer the fourth shot in the series (Figure 13.6), mainly because there is a far better sense of depth between the black background and the performer's hair. She is distinct from her surroundings and yet still "in the world" of the scenery. I find that the last, and brightest, shot (Figure 13.7) makes her pop out too much from the set, and her hair is too blue. Now, if you recall, the meter has been altered by the –1 stop EV compensation, so in reality, the camera *should* have wanted to set the camera for an aperture of f/2.8 and a shutter speed of 1/30th rather than 1/60th. That means that my preferred exposure out of this series, the one that ended up shot at 1/40th, is about 1/3 of a stop *underexposed*. I also feel like this image is the best representation of what I saw from the tech table when I was writing the cues, which is ultimately the goal with all this.

By choosing more or less shots, you give yourself more or less options for a shot that will work for you, and by choosing smaller or larger "offsets," you are determining the fact that you may be choosing from widely spaced differences in exposure or closely spaced options. It really depends on each

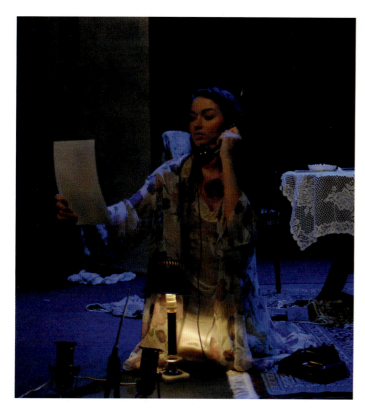

Figure 13.5: This shot was taken with an aperture of f/2.8 and a shutter speed of 1/60th.

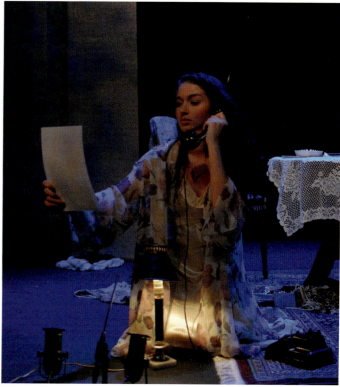

Figure 13.6: This shot was taken with an aperture of f/2.8 and a shutter speed of 1/40th.

shot, and what you are trying to get out of the shots you have chosen to take. Finally, some cameras may even offer you the ability to choose the order with which the shots are taken. I usually leave mine set to go in order from most under-exposed through most over-exposed, but often you can also select the option to shoot "on the meter" first, then one under and one over, if you were doing three shots. I prefer them to be in order of exposure, as it makes it easier to look through them on my computer and compare adjacent exposures, rather than having to jump around. Ultimately, once the shot is taken, I tend to care little about the associated numbers or settings, or even which shot the camera thought was "on the meter"...I am now just going by eye to determine which one is the best representation of what I created.

I almost always bracket with the camera set to aperture priority. There are two main reasons for this, and a caveat. First, I am usually shooting fairly dark situations, and want to take advantage of my "fast" prime lenses. I am making a choice to go for more light-gathering ability over depth-of-field considerations, so I would prefer that the three shots I take don't have a varying depth-of-field across the three exposures. The second reason has to do with the architecture of your lens. DSLRs of today have the ability to alter the shutter speed a great deal, and have a lot wider range of shutter speeds to

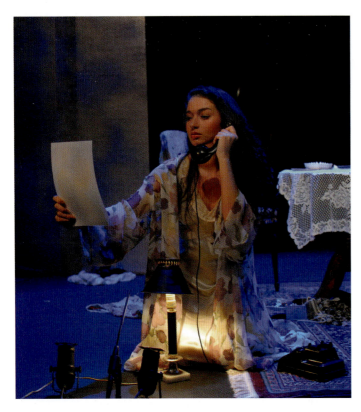

Figure 13.7: This shot was taken with an aperture of f/2.8 and a shutter speed of 1/25th.

pick from, especially when we go toward the longer-opening end of the spectrum. This isn't the case when you are dealing with the aperture of the lens, which is mechanically limited to a certain maximum and minimum aperture. You may find that if you are trying to bracket with shutter priority set, your camera might not be able to take the shots you want. If your lens has a maximum aperture of f/2.8, and you have set your camera to a shutter speed of 1/500th, and your camera's meter has determined that the best exposure for the shot you want to take is f/2.8 and 1/500th, then you will be stuck. Your camera will be able to take the shot that is "on the meter," and a shot that is 1 stop under-exposed at f/4 and 1/500th, but your lens is incapable of opening up any further than f/2.8 for the over-exposed shot. To rescue this situation, you would have to change your shutter speed to 1/250th and let the camera bracket from there. It would then be able to choose f/4 as the shot "on the meter," and one over-exposed shot at f/2.8 and one under-exposed shot at f/5.6. The caveat to be aware of is that when shooting a fairly dark scene in aperture priority, your camera might need to run the shutter speed out to very long exposure times. If you are listening to your camera, you can hear the mechanical noise made by the swinging motion of the mirror and the shutter curtain as they move to expose the image sensor. Usually with a three-shot bracket, you might hear the camera go "click...click, click...click, click.....click" as it moves through the shorter shutter speed exposures to the longer ones. On occasion, when shooting a really dark shot, even with my lens set to a very wide maximum aperture, I have been surprised to hear my camera go "click……click, click............click, click............(holding my breath even more)............click." That extended series might include some shots taken at half a second and possibly multiple seconds. Usually that means they won't be terribly useful, since it's so hard to handhold that long. Even if you are pretty steady, it just won't have the crispness that the other shots might. If you are using a tripod, monopod, or one of my strap, bracing, and breathing techniques, you might still have some motion or sway from the subject, but at least you can eliminate your contributions in that regard. Just remember to keep squeezing the shutter release button until the camera has finished its run of shots. If you let go too soon, it might shorten the exposure of the last shot, or it might not take the whole sequence. If I'm shooting a three-shot run, but let go after the second shot, my camera doesn't reset… it waits until I hit the shutter release button again, and then it dutifully finishes that run by taking the third of the three shots. Not a big deal, but I just need to pay attention, and know that I haven't gotten the full bracketed run of what I wanted from the previous setup, and that I don't yet have a full run of the setup I'm now looking at.

Interestingly enough, I figured out a neat trick as I was working on taking some pictures with another DSLR. I wanted to bracket with that camera as well, but it wouldn't allow me to set up a –1 stop, 0, +1 stop bracketing scenario. It would only allow –2 stops, –1 stop, 0 *or* 0, +1 stop, +2 stops. I was using this camera to take pictures of my own camera for other parts of this book, so it was a loaner and I was trying to figure out its menus when I suddenly realized, "Oh, I can just use the EV compensation feature to move the range covered by this odd bracketing up or down a stop." So, I set the camera up to have a –1 stop EV compensation, and set the auto-bracketing up to use the 0, +1 stop, +2 stops scale, which meant that I ended up with an actual set of exposures that was –1 stop, 0, and +1 stop. If I'd already wanted to run with a –1 stop EV compensation, I could have set the camera up for –2 stops of EV compensation, or just used the –2 stops, –1 stop, 0 bracketing option. I am regularly thankful that all these settings are essentially interchangeable! With my usual –1 stop of EV compensation, I am regularly getting a bracket that is –2, –1, and 0, and this has served my needs well.

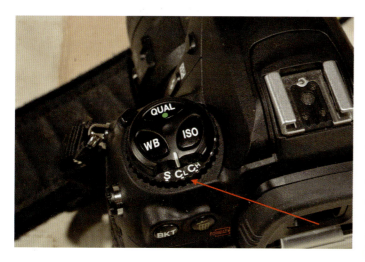

Figure 13.8: The bottom part of the large dial here is marked S, Cl, and Ch, which refer to the shooting mode.

There is one additional dial that I need to ensure is properly set for my auto-bracketing to work correctly, and you may need to set a similar option. On the top left of my camera there is a dial underneath some of the other buttons, which controls the shooting mode.

When set to S, it will shoot a single shot each time the shutter release button is pressed. When set to Cl, it will operate in "continuous low-speed" mode, and will shoot all of the exposures I've selected in the auto-bracketing menu with just one press of the shutter release button. This has to be a "press-and-hold" action, but it will stop when it hits the third or fifth shot in the series. The Ch represents "continuous high-speed" mode, which does the same thing; it just operates faster between shots. The Cl and Ch settings are useful when you want to shoot a bunch of frames really quickly, such as at a sporting event, but when auto-bracketing is engaged, it's not as important, since both will just shoot what you've asked for and then stop. Once you release the shutter release button at the end of the set of exposures, it's all set and ready to take the next set of bracketed exposures.

The cover image for this chapter was taken during my first photo-call with a DSLR, and I wouldn't have been able to successfully capture all the diverse moments in this show without the aid of the auto-bracketing feature. This show uses a great deal of atmospherics, and includes lots of dynamic movement and energy. I set the camera to five exposures, since I was new to it, and just shot like crazy. Luckily, I was able to capture a few really great moments. I bought the camera a few weeks before I went down to work on the show, but didn't have time to read the manual until a few days before the shoot, at which point I committed myself to a full day or two of study in order to get comfortable with it. According to the metadata, the chapter image was the 657th taken by the camera since new, so I must have shot a lot of practice shots beforehand. Figuring out how to manipulate the buttons and dials took some time, but was far easier due to the solid understanding I had of the Exposure Triangle relationships. As long as you have that down, and have a good idea in your head about what's going

to happen when you press the shutter release, you can move between brands of gear with relative ease.

Bracketing Practice Session

1. If your camera has an auto-bracketing feature, figure out how to turn it on and adjust it for a run of multiple exposures. Try all of these with a "still-life" setup first.
2. Experiment with how many exposures you can take and if you need to change anything else about your camera, like my "shooting mode" dial, in order to have it work correctly.
3. Change the order of shots, try it, and decide what you like best.
4. Change the offset between the shots, try that as well, and check out the results.
5. Open the various files from your bracketing in Photoshop (or similar), and you can read the metadata associated with the file, which will tell you how your camera adjusted its exposure to give you what you asked for. (This is exactly what I did with the *Voix* pictures…I hadn't known beforehand which shutter speeds the camera selected.)
6. Experiment with setting up auto-bracketing in conjunction with EV compensation, and see what your particular results are.
7. Experiment with setting your camera for aperture priority versus shutter priority.
 a. Remember the trade-offs between these two types of exposure adjustments, and then determine which results work for you.
 b. Try backing your camera into a corner by setting it up to run in shutter priority, and see what it will do if it is faced with the prospect of not being able to set the apertures you need. This is similar to the practice session in the meter priority, but with the bracketing, you might find you get two out of three, but what happens when the third can't be taken because your aperture is already fully open or closed?
8. Try shooting just part of a run of bracketed shots, and see how your camera behaves. Does it finish the run, or does it wait?
9. Once you have become comfortable with the settings that you want to work with, try taking some bracketed shots of a live subject. Get them to hold a pose for a bit and see if you can quickly and efficiently get the shots you need before they start to sway. You have to pay attention to what you are doing with focus, framing, all your exposure settings, and your stance, but you also have to keep an eye on your subject to see if they have started to sway or fidget.
10. If your camera does not have an auto-bracketing feature, you can still take advantage of this practice; you will just have to set your camera up for manual use, and then work with your camera's light meter to determine the best shot. From there, you will then have to adjust the aperture or shutter speed as you see fit to get the number of shots you want with the offset you want. Since you are manually controlling the exposures, you are also setting the bracketing order as you go, but can vary it pretty easily for each shot. In the past, I might have been shooting the bulk of the photo-calls using a –1 stop, 0, +1 stop range, but might change to a –2 stops, –1 stop, 0 stop range for one shot because there might be something very light colored that I don't want to take a chance on washing out.
11. A great practical example of this is the musical *Guys and Dolls,* where the male main characters are wearing colorful, but often darker, suits, until the final scene when the whole cast comes out and celebrates the wedding of Nathan and Adelaide. The lead, Adelaide, reappears in a white wedding dress against all the more saturated fabrics of the rest of the cast. This is very similar to the situation we discussed concerning the Zone System, and

if you aren't careful, your camera will want to set up an exposure that makes everyone but her look great, and she will look like a blown-out white blur with no detail. If you have to do this manually, then practice is even more important in advance. You should try to get to the point where you don't have to look at the dials if possible, but still know which way to turn them to get what you need. If you have a good set of readouts in your viewfinder, you should be able to see these settings change without taking the camera away from your eye.

chapter fourteen

digital file formats

digital file formats | 137

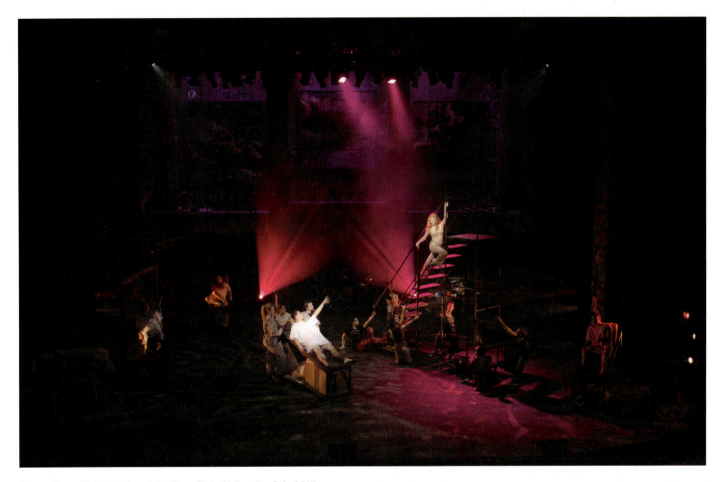

Extraordinary Girl, *American Idiot*, Penn State University, Feb. 2017.

Digital cameras create photographic image files for each shot you take, and as we learned in the previous chapter, you might even set your camera up to record multiple file types simultaneously. The type of files your camera outputs may be adjustable in terms of file type or file quality, and you should become familiar with the possibilities and options before you start shooting so that you get the best quality images at the end of the day. Most all cameras will output files in a file type that is easy to view, such as JPEG, which is one of the most common. JPEG (or JPG) stands for Joint Photographic Experts Group, and this file type is a compressed version of the original image taken by the camera.

There are two types of file compression, "lossy" and "lossless." Lossy file compression actually loses some of the data from the original file in order to significantly reduce the file size of the image. These types of compression often make it difficult to blow the pictures up or get high-quality prints. Lossless compression reduces the file size without a major

impact on the quality of the image, but you won't get quite as small a file. JPEG images are a lossy type of compression, which result in much smaller file sizes. They are also subject to generational degradation. This means that the repeated editing and saving of the file will result in a loss of quality in the image.

Other file formats that you might run into include:

- JPEG 2000, which can be either lossy or lossless compression.
- **TIFF (Tagged Image File Format)**, also can be either lossy or lossless compression.
- **GIF (Graphics Interchange Format)**, which is a lossless format, but used primarily for smaller and less complex images, and isn't suitable for the finer detail we need in our images.
- BMP (Bit Mapped) files are uncompressed and lossless, and are a very common format, especially on Windows-based machines, but may not be as high a quality as you need.
- PNG (Portable Network Graphics) uses lossless compression, and is the successor to GIF files with much better resolution and color ability.
- RAW formats are uncompressed or slightly compressed (lossless) files that represent the greatest possible amount of data saved for an image, and include everything captured by the camera with no in-camera editing. RAW files are sometimes renamed by the various manufacturers, but the concept is the same. Nikon uses the extension **NEF (Nikon Encapsulated Format)**, Canon uses CD2, and there are many others.

There is another format, EXIF (Exchangeable Image File Format), which governs the storage and exchange of metadata associated with each photographic file. Data points such as date, time, shutter speed, aperture, color space, and camera information can be saved with the actual picture data and translated by photo-editing programs. This type of exchange is built into JPEG, TIFF, and PNG files, and this data is also inherently available in RAW format files as well. If you look back at Figure 4.8, you will see that the data on the right comes from the Exif tab in the Mac OSX Preview Inspector window.

Table 14.1 shows the relative sizes and options for the various image files I can produce in my camera. Check your manual for information about the size of your image files, and what quality options may exist; this will be important when you decide on the size of the memory card you need for your camera.

Table 14.1: Image size options, pixel counts, and print size.

Image Size	Pixel Count	Printed Size at 200dpi
Large (10.0M)	3,872 x 2,592	19.36 x 12.96 inches
Medium (5.6M)	2,896 x 1,944	14.48 x 9.72 inches
Small (2.5M)	1,936 x 1,296	9.68 x 6.48 inches
NEF	3,872 x 2,592	19.36 x 12.96 inches*

*When converted and printed at full scale.
Table excerpted from Nikon D200 Manual, page 32.

Image size refers to the size of the final image in pixels. I recommend that you shoot in the largest size and highest quality format that you can afford to fit on your memory card. Smaller files are great for various web applications, cell-phone wallpaper, and so forth, but you can always shrink down a large-format, high-quality file to a smaller duplicate for those purposes. You can't blow up a small file for use in portfolios without a serious drop in quality due to the missing pixels that your computer now has to invent according to its image zoom algorithm.

Note that the pixel count and the printed size is the same for the Large JPEG and the NEF files. Where the difference lies is the compression of the two different types. My shots for *Carousel*, one of the shows featured in this book, average about 4.8MB for the JPEG version of each file, and about 16.5MB for the NEF version of each file. This is approximately four times larger on average for the NEF version, which means there is four times more data (and hence, detail) in the NEF version of the shot.

Table 14.2 shows a bit more information about the level of compression applied to each size of JPEG available. You may or may not have as many options, but you should explore

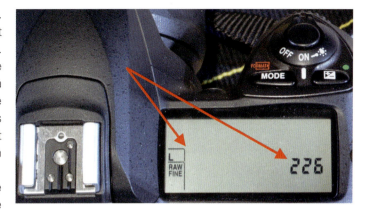

Figure 14.1: File format and size setting in lower left corner, and remaining exposures counter in lower right corner.

this and determine what you are gaining or losing by utilizing the various compression levels that may be available. These options will also determine how many shots you can fit on the card you have.

My camera is showing on the left of the screen that it is set to save a Large size, Fine quality JPEG, and a RAW image file per exposure. It also shows the number 226 to the

Table 14.2: Image format options.

Mode	Type of Image Recorded
NEF (RAW)	RAW data straight from the image sensor, and stored on the memory card in NEF Format
JPEG Fine	Records JPEG image with 1:4 compression
JPEG Normal	Records JPEG image with 1:8 compression
JPEG Basic	Records JPEG image with 1:16 compression
NEF (RAW) + JPEG Fine	Two images, one RAW, and one JPEG Fine
NEF (RAW) + JPEG Normal	Two images, one RAW, and one JPEG Normal
NEF (RAW) + JPEG Basic	Two images, one RAW, and one JPEG Basic

Table excerpted from Nikon D200 Manual, page 28.

Table 14.3: Exposure count based on file types (Nikon D200 & 8GB CF card).

JPEG Quality	JPEG Size	Include RAW File	# of Possible Shots*
Basic	Large	n/a	3,500
Basic	Medium	n/a	6,000
Basic	Small	n/a	12,600
Normal	Large	n/a	1,800
Normal	Medium	n/a	3,100
Normal	Small	n/a	6,600
Fine	Large	n/a	911
Fine	Medium	n/a	1,600
Fine	Small	n/a	3,500
Basic	Large	+ RAW	427
Basic	Medium	+ RAW	450
Basic	Small	+ RAW	469
Normal	Large	+ RAW	383
Normal	Medium	+ RAW	422
Normal	Small	+ RAW	454
Fine	Large	+ RAW	317
Fine	Medium	+ RAW	373
Fine	Small	+ RAW	427
None	n/a	Yes, RAW only	487

*If I'm recording two files per shot, the counter still treats them as one shot.

right, which is a count of how many images I can still save. If I bracket three exposures per shot, which generates six files per shot, that gives me 37 setups I can take. This is probably more than I need, but now I know that if I have 15 to 18 looks to shoot, I can do, on average, two bracketed runs of each.

I run a tried and true 8GB CF card in my D200 (largest card I could buy at the time), which has a great capacity for a long photo-call, but I do need to clear it out after a big shoot.

If you look closely at the numbers, once you decide to shoot in RAW, the added JPEG doesn't really reduce your count very much. Looking even further, there isn't much of a difference between how many pictures I can get with a Large Fine JPEG and a Small Basic JPEG (317 versus 459), when I'm also saving in RAW. I don't really want to have to look through 300+ images for one show anyway, so this serves my purposes quite effectively. If you like to shoot a great deal more than I do, go for it…there's nothing wrong with that, and you may hit upon some awesome shots. Just be aware of the extra time and storage space needed when you sit down to cull through everything.

Your camera has a default naming convention for the files it generates, which is usually a sequentially numbered

alpha-numeric abbreviation for something. Some cameras allow you to reset the prefix before the numbering, and also will let you restart the numbering sequence. Be aware that this is a double-edged sword. It's convenient to have your groups of show files all start at 001, instead of some random range of numbers, but that means that you might have three different files all with the same name, but in different folders. So far, that hasn't been an issue for me, as I keep my files in a careful folder structure, and make copies that get distinct names when I need them for something, such as all the image files for this book. The file-naming setting in my camera is set to DSC, which is the default, and results in files that are sequentially named DSC_0001.jpg and DSC_0001.nef. These files appear next to each other in most file sort/view options, which is very useful, since the JPEG serves as a quick thumbnail that you can view to decide if you are keeping or tossing that image.

Memory cards, which are now our primary storage device, have evolved into many different sizes, shapes, speeds, and storage capacities. Best deals are often found on Amazon or Newegg, but you might find sales at the local electronics stores as well. Pay attention to the user reviews when available to get a sense of reliability. A few basic guidelines to follow:

- Buy as large a storage size as you can afford, in case those cards go out of production (which happened to me with the xD card format for my Olympus point & shoot).
- Buy cards designated as high-speed cards so that you aren't waiting for pictures to save during a hectic shoot.
- Spend a few extra bucks if you have to, but buy quality brands that have been around. SanDisk, Crucial, Kingston, Lexar, PQI, and Samsung have served me well over the years.

The Compact Flash (CF) Card has been a solid storage card for many years, but most cameras have now moved to Secure Digital (SD) and microSD, which are easy to find and use. Newer cameras may even come with multiple card slots,

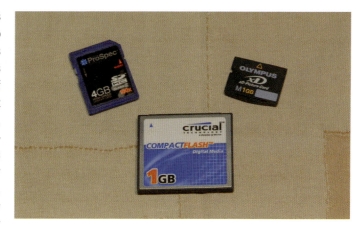

Figure 14.2: Three memory cards for digital storage of photos. Clockwise from bottom, Compact Flash (CF) Card, Secure Digital (SD) Card, eXtreme Digital (xD) Card.

so you can be downloading one card while still shooting on the other.

I just purchased a new adventure camera for outdoors use, and it saves to a microSD card, which is smaller than my thumbnail, and about as thick. For this camera, I bought a SanDisk 64GB microSDXC, which is a high-speed data card capable of 80 megabits per second (MB/s).

This will allow me to take full high-definition (HD) video and have the card save in real time. This wasn't even the largest capacity card available, but had the best reputation for reliability. This card is also reputed to be waterproof, temperature proof, shock proof, and X-ray proof, although I haven't tested those extremes yet. In order to easily use these cards, they usually come with a small adapter, which is the same as a regular SD card in size and shape that the microSD slips into for downloads. Certainly, this kind of data speed and card durability is very desirable for what we do, and these types of high-speed cards are available in many different formats.

Just since I started writing this book, there have been some exciting new advances in terms of file formats and

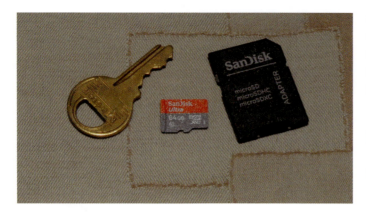

Figure 14.3: MicroSD memory card with SD card adapter.

types. Apple's iOS 10 has just been released, and if used in conjunction with the iPhone 6 or 7, along with one of several apps, you can now shoot and save in RAW format. Apple, Samsung, and Motorola are all marketing smartphones with 4K ultraHD displays and 4K resolution cameras. As we discussed before, the quality may still be hampered by the tiny lenses in the phone, but there are accessory lenses that you can purchase that will also mitigate this. Finally, the Droid Moto now pairs with a $250 add-on camera accessory from renowned manufacturer Hasselblad, which includes a 10x *optical* zoom and shoots in RAW. I look forward to seeing where this technology goes in the next few years, and hope that if you have such a camera, you will share your work on the website.

A final, and important, note about memory cards. You should get in the practice of occasionally reformatting your memory cards, not just deleting the old shots from them after you've confirmed they are copied to your storage system. One day I was getting ready for a call with a trusty CF card I had been using for several years, and while it was empty, the camera was also showing that it had about half of the storage capacity I thought it had. On a whim, I reformatted the card, and suddenly regained a ton of space. I suspect that all that garbage on the card may have contributed to a few files that were corrupted on some previous shows. Use your camera to reformat the card, instead of your computer, to ensure that the card's file structure is truly compatible with the camera's operating system. Your computer will be far more flexible about reading slight variations in file structures.

File-Formats Practice Session

1. Before you are shooting for real, read up on all the options your camera may have in terms of file types, qualities, and sizes.
 a. Figure out how to set those various options, and then take the same photo with all the different options available to you.
 b. Download and view them, and compare the quality with respect to your needs.
2. If you plan to use other point & shoot cameras, or your camera phone to take process shots, then take a few test shots with those cameras as well. Then figure out the process of downloading and saving the pictures from those devices. What is the resultant file type from those cameras? How big can you enlarge them? The smartphone is very convenient for process shots today, since the quality has gone up so much in the past few years, but is it good enough for what you need? If not, consider keeping a slightly higher-quality point & shoot available if process shots are something that you will need often.
3. If you do plan to use your smartphone, try this: I have set up my Dropbox account with my Droid so that any pictures I take are automatically uploaded to a special Dropbox folder. This makes utilizing the pictures very easy, and back-up is effortless. Here's the link to the Dropbox Help article: www.dropbox.com/en/help/307
4. If you are interested in looking at generational degradation, try this:
 a. Make a duplicate of an image file and rename it so you don't ruin a good file.

b. Open the file in an image-editing program, and make a small edit. It can be a resize, a crop, adding a watermark or text, just something quick.

c. Resave the file and close it.

d. Repeat about 10 times, making different slight edits each time, but staying clear of the main part of the image in the file.

e. Once you are done, print a quality copy of this file and compare to a quality print of the original file you made the duplicate of. How far off is the quality of the edited duplicate? If it is acceptably close, then the combination of your original file size, type, and quality, coupled with whatever image editing you are doing, isn't contributing much to any loss of quality of the final image. If, however, you can tell the difference after this many edits, then you know you need to do one of three things:

 i Move to a higher-quality start file.
 ii Try using a different image editor.
 iii Avoid reopening, editing, and resaving your files quite as much.

chapter fifteen

practices for documenting process versus product

documenting process versus product 145

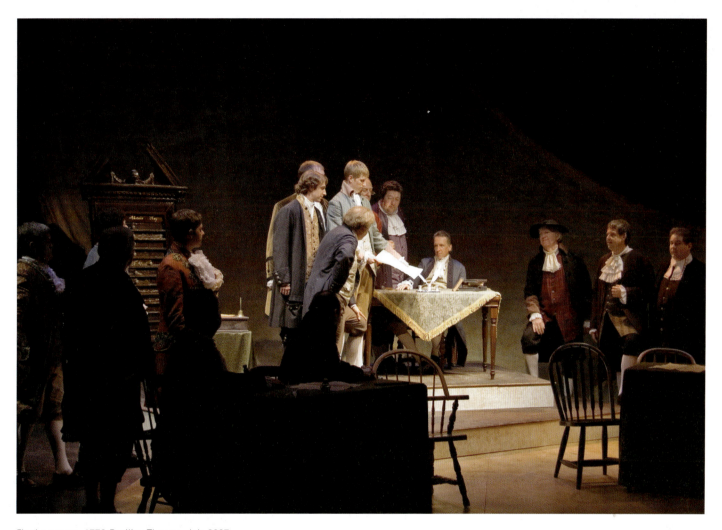

Final moment, *1776*, Pavilion Theatre, July 2007.

So far, we have been discussing what is necessary to accurately capture a true representation of the final product on stage. This is often the most important goal for younger designers who are building a portfolio, but not the only goal. A truly successful portfolio not only shows the end product, but also demonstrates different stages of the creative process.

It's great to be able to show a director that you are able to create some great end looks with your designs, but it is also very important to be able to illustrate that those looks are what you were going for in the beginning. You may have heard the phrase, "Even a blind squirrel finds a nut sometimes," so being able to successfully document your design process will

appease any concerns that a director or production manager might have about your abilities to bring your initial ideas to fruition.

Some of the design areas of theatre lend themselves to this effort a bit better than others. Mainly, this applies to technical direction, scenic design, and costume design, and all of their related fields. I have seen many young designers include pictures of the lighting control board or the sound equipment racks, but I have always felt that these are using up space that could have been better spent on pictures of the actual production. These pictures of gear are usually not very attractive, and it's hard to make cable bundles look interesting. The process of building a costume, prop, or scenic element, however, can accurately illustrate how a designer's or technician's mind works, and demonstrate various skills that may not be evident in the final product. Younger designers tend to be far more involved in the day-to-day construction or creation of their designs, as opposed to more established designers, who may delegate much of the construction process to others.

While I hope that I can cover the needs of everyone in this very diverse field, I'm sure I've missed a few worthy areas. Visit the website for more tips about these areas and any I've left out as more of you are able to join the conversation.

Scenic Design, Projections, and Scenic Art

Scene design begins with research, and then evolves into sketches, models, paint elevations, and drafting, before it is turned over to the technical director. So many of these steps already occur digitally now, with the (sometimes) exception of sketches, models, and paint elevations. You could use a copy stand to photograph the sketches and paint elevations, but you will get better results with a high-end scanner. This leaves us with models. It is important to document the model early in the process so that you can communicate effectively with members of the design team who may not be present and available all the time. If you are doing a show with multiple scenes, you can shoot pictures of the various arrangements for the director and other designers. Models are also fragile, and easily damaged, so it's good to have them "backed up." Years ago, I had a student who made very nice models, and then put them each on a shelf when the show was over for storage. When it came time for him to put together his exit portfolio, he took the models down to photograph them, only to discover that his cat had been using them as a hiding spot and sleeping in them. Many were wrecked, which was a shame. So, photograph them early!

Models may be shot from many angles, although you should try to shoot them from the viewpoint of the audience. This model in Figure 15.1 is shot from the viewpoint of the front row, which is okay, but the venue is huge, and most of the audience sits higher up in the seating, which is actually carved into the side of a small mountain. You can better appreciate the scope of the space in the production shot in Figure 15.2.

You will notice that there are some sources of side lighting that help define the model and give it some depth. This particular model is not inside your standard black model box, so it's a little easier to light. This is more accurate, since this particular venue does not have a typical proscenium arch, and is just framed by the trees and the sky. The next model seen in Figure 15.3 is for a production of *1776* in our Pavilion Theatre, which is a 3/4-thrust space. When you place a model in this model box you are forced to view it and photograph it from a higher angle than is typically experienced by the audience.

You might recognize the balcony from the production shot in Figure 9.20, and the final scene of the production is featured on the first page of this chapter. I've included it, along with Figure 15.4, to segue into scenic projections.

The shot on the cover of this chapter is a production shot that features the performers pretty well, so it's a reasonable shot for costumes as well as scenery, but it misses the entirety of the projections, which were a significant part of the

documenting process versus product | 147

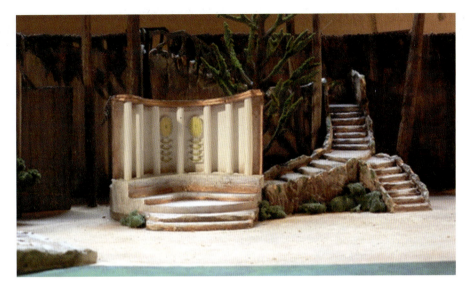

Figure 15.1: Model for *Unto These Hills*, Cherokee Historical Society, 2006.

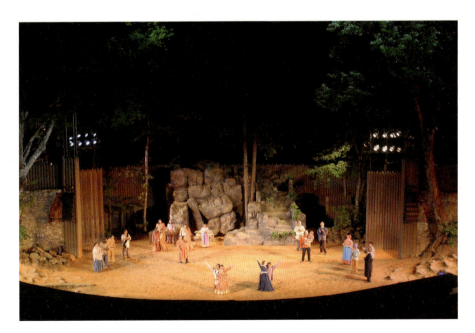

Figure 15.2: Production shot, *Unto These Hills*, Cherokee Historical Society, 2007.

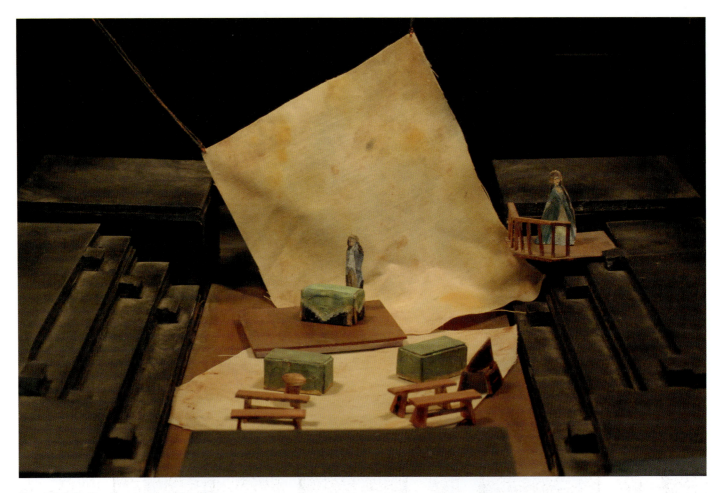

Figure 15.3: Pavilion Theatre, model for *1776*.

scene. By pulling back out, and staying at the same level, I was able to capture the projections on the floor, which were copies of the signatures of the original signers of the Declaration of Independence while also keeping the performers in the shot, who were moving into position to recreate the famous painting by Trumbull.

In both Figures 15.5 and 15.6, projections are featured prominently. In both cases, it was important to choose a light cue that was dark enough to allow the projections to be clear and not washed out. In Figure 15.5, there was a good deal of haze used to accent the lighting, but the shot works very well to show off projections because the haze has cleared at center stage, allowing you to see the up-center projection screen clearly. Figure 15.6 was harder to capture, due to the close proximity of the performers to the various scrim panels that served as the projection surfaces.

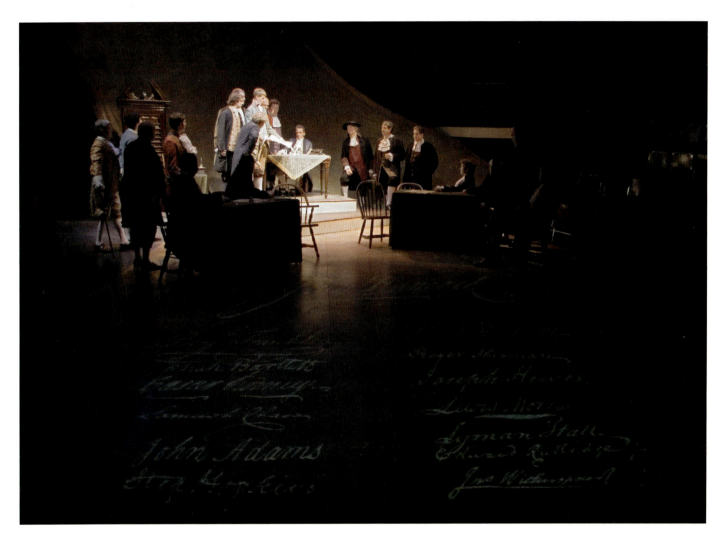

Figure 15.4: Final moment with projections, *1776*, Pavilion Theatre, July 2007.

I usually don't take photographs of empty sets, but in this case, I wanted to make sure that I caught a moment that really just featured the integration of the scenic design, the scenic art, and the lighting design, due to the complex interplay of colors. If you note the date, you will realize that this was shot on Ektachrome film, and is a scan of the Cibachrome print of that slide. It was necessary to push the exposure just a little bit to give the apartment the washed-out feel that we were trying to evoke, set against the vibrant colors of the rest of the world.

There are also times when a quick snapshot is useful for communicating with the other designers, and again, the cell phone might be a great way to do this. In the fall production

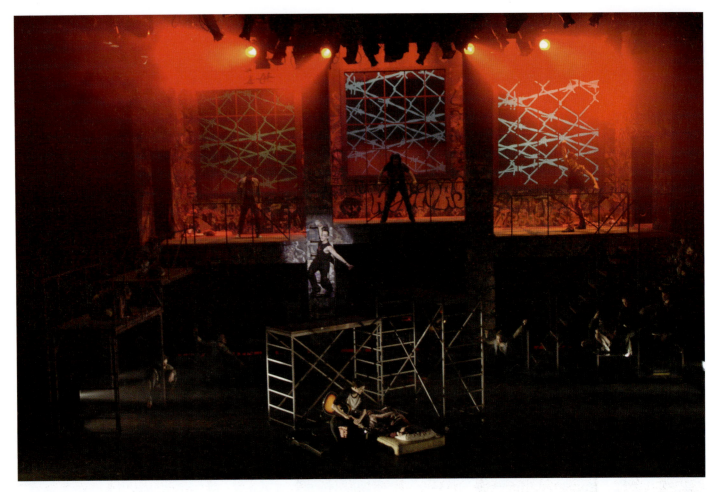

Figure 15.5: Projections moment, *American Idiot,* Penn State University, Feb. 2017.

of *Carousel* that I've shared, the scenic designer had to leave early, and didn't get to see the new scrim that had been ordered for the production (and was delayed in shipping). During the final dress, she texted me to ask how it looked, and rather than describing it, I texted back this photo. Will either of us use it in our portfolios? No, but it was a fast and efficient communication tool that didn't really exist for us 10 years ago, and I was impressed at my smartphone's ability to capture this image

(Figure 15.8), which I haven't adjusted in any way. Despite the serious lack of controls on it, the camera was able to get a pretty good exposure that was also color accurate, and it was able to meter and focus from about 100 feet away.

Scenic art, on the other hand, is an aspect of scenic process that is still done by hand, and has many process steps that can be cataloged. In this extensive series of shots, Scenic Artist Paige Eisenlohr was able to capture the major steps

documenting process versus product | 151

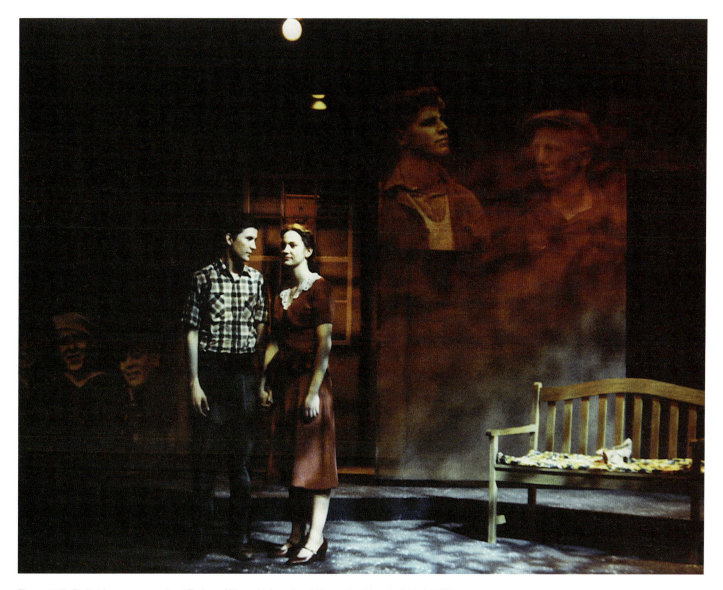

Figure 15.6: Projections moment, *Last Train to Nibroc*, University of Nebraska–Lincoln, March 2001.

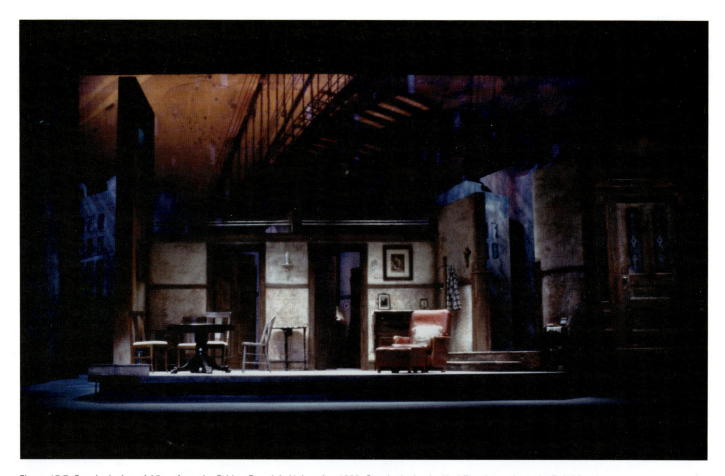

Figure 15.7: Scenic design, *A View from the Bridge,* Brandeis University, 1993. Scenic design by Karl Eigsti, scenic art by Bob Moody.

of the process of painting this complex pattern on the stage for our fall 2016 production of *Twelfth Night*. The process shots in the paint shop and on stage under the work lights were captured with her Apple iPhone 6s, and then I captured several shots during the photo-call that provide the viewer with context for the design. This is a very important step in the process of documenting your design work. It's great to see all the steps along the way in the shops, but critical to show that item, whether it's a prop, a costume, the makeup, or a paint treatment. Large or small, everything that goes into a show must fit within the world, and if you can show that your work can integrate into the collective work of the overall design team, then you will do well.

I feel that the final shot really helps to tie things together when you add people for scale and the last color elements of the costumes that haven't been present yet. But the earlier shots all have their value. What's important to note is what's there and not there. The floor in-process shots are not cluttered up with a ton of junk; you can very clearly see the floor all the way to the edges. Ms. Eisenlohr has attempted to take

documenting process versus product 153

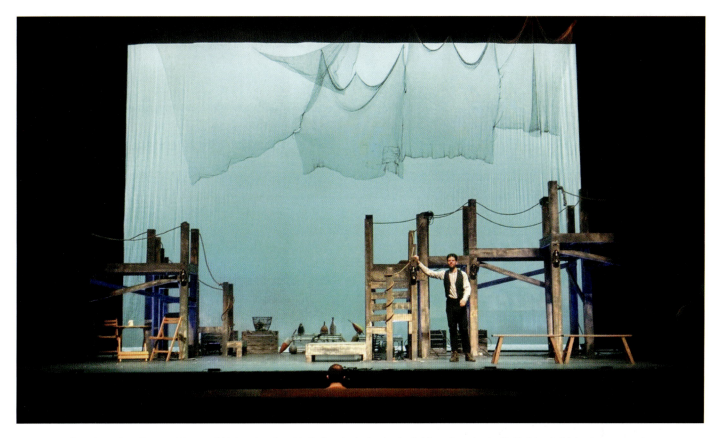

Figure 15.8: Scenic design, *Carousel*, Bucknell University, Oct. 2016. Scenic design by Andy Nice, direction by Emily Martin-Moberly.

the shots from the same viewpoint, which is also very useful in maintaining a visual continuity through the process. If there was one rule to follow in this part of the process, it would be this:

> Eliminate all the other variables in the world of the item you are trying to show so that the focus is on that item and how it changes from shot to shot.

This means maintain a consistent shooting location, make sure there aren't a ton of extra people milling about, and make sure that the shot is as "clean" as you can make it. The only thing I would do to improve this sequence is take the paint sample from Figure 15.9 and put it on a neutral background so that the visual noise of the other paint on the actual floor of the shop doesn't influence our impression of the work.

Now, let's take a look at a few bracketed shots you might recognize. These are from *La Voix Humaine*, for which I designed the lighting, and my wife designed the costumes and scenery. I took this bracketed set of photos for both of us

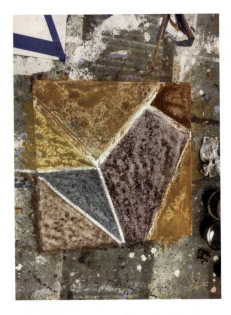

Figure 15.9: *Twelfth Night*, floor paint sample in paint shop.

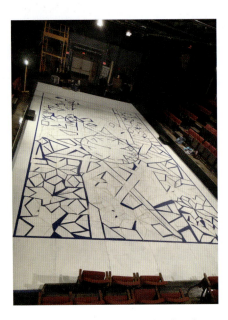

Figure 15.10: *Twelfth Night*, floor basecoat with painter's tape.

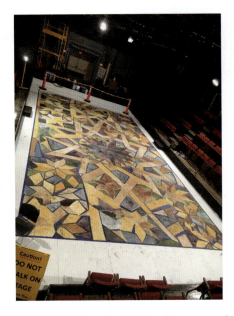

Figure 15.11: *Twelfth Night*, floor painted before tape removed.

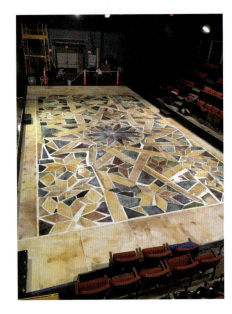

Figure 15.12: *Twelfth Night*, floor after tape removed under work light.

documenting process versus product **155**

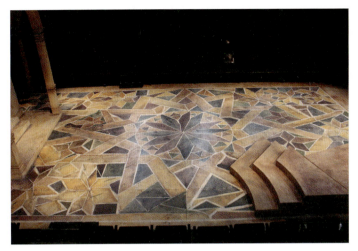

Figure 15.13: *Twelfth Night*, floor side view under show light.

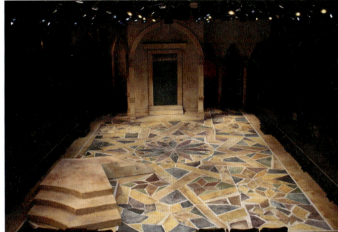

Figure 15.14: *Twelfth Night*, floor long view under show light.

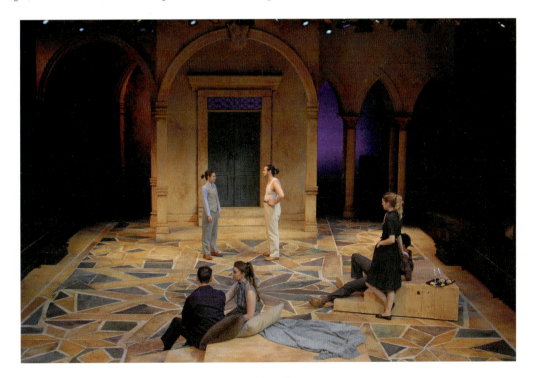

Figure 15.15: *Twelfth Night*, floor under show light with performers.

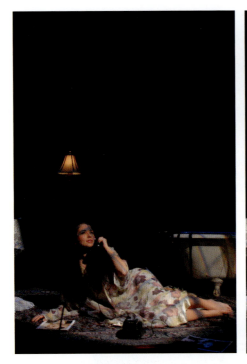 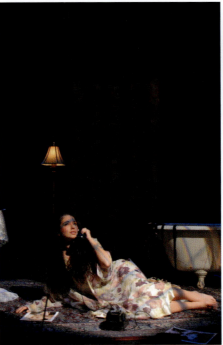 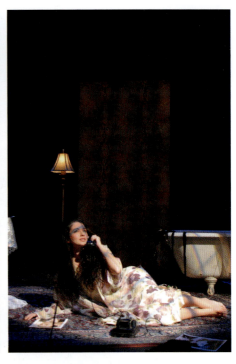

Figure 15.16: Moment from *La Voix Humaine*, Penn State School of Music, Oct. 2015. Shot at an aperture of f/2.8 and a shutter speed of 1/125th.

Figure 15.17: Moment from *La Voix Humaine*, Penn State School of Music, Oct. 2015. Shot at an aperture of f/2.8 and a shutter speed of 1/80th.

Figure 15.18: Moment from *La Voix Humaine*, Penn State School of Music, Oct. 2015. Shot at an aperture of f/2.8 and a shutter speed of 1/45th.

to use in any of our three portfolios, but here's where bracketing can be even more useful. Which of these three is the best for lighting? Which is the best for costumes? Scenic? It doesn't have to be the same exposure that satisfies all three demands. Incidentally, this was a situation where I tightened up the bracketing, and you will notice that the shots are separated by 2/3 of a stop rather than a full stop.

Personally, I like the middle exposure and the darker exposure as options for my lighting portfolio; I think the middle or the brighter exposures are good for props, costumes, and makeup; and the brightest one works well for scenery, since you can get a better sense of the treatment on the single flat, and have a good sense of depth.

Costumes, Makeup, Hair/Wigs, Millinery, Fabric Dyeing and Modification, and Prosthetics

Capturing the process of applying makeup can be particularly challenging. Often it occurs in very small rooms that are strangely lit with incorrect color temperature sources overhead, and bright, omnidirectional incandescent light bulbs around a mirror. The next sequence of photos was taken in the early 1990s to document the process of applying old-age

makeup to an actor playing the character of Firs in a Brandeis University production of *The Cherry Orchard*. The actor, Mark Enright, had to go through a complex and time-consuming process to transform from a young man into the 87-year-old character.

My wife, Jenny, was responsible for creating this transformation, and asked me to document the process. If I only knew then what I know now about taking process shots! The real challenge was that we were crammed into a tiny dressing room, really only meant for one person, and it took two people to apply the makeup, in addition to Mark and myself in the room. If I were to do this over, I'd create a temporary dressing-room space in a much larger room, and have the actor step away from the mirror for shots in front of a neutral background every so often. The other issue here, though, is that the latex dries fast, so you don't have much time to mess around. On the next two pages are 12 shots selected from the collection I took of every step along the way. This selection of shots tells the broad story of the application of the latex through the creation of the wrinkles, and finally the application of the facial hair and wig. Luckily, the final shot has some reasonable exposure, but I can tell from the grain that the film speed was probably set very fast in order to get the shots needed.

These shots were done with daylight-balanced print film instead of Ektachrome 320, mainly due to the costs of having so many prints made, if I recall correctly. The color temperature settings of the film used to dictate your output medium (prints or slides) but not anymore. As an experiment, I shot many of these pictures using the mirror reflection rather than a direct shot of the person. This allowed for some distance from the others in the room, but not much. Depending on the architecture of your dressing rooms, this may be a useful technique, but it's difficult to stay out of the shot and keep the framing and focus correct.

And what's missing here? I don't have a production shot of this character on stage. Which rules did I break? Framing and exposure could be better. Like I said...if I knew then what I know now. I'm sure I took production shots, but I must have given the slides away to the designers of this show. The next time one of these rare makeup opportunities comes around, I'll reshoot it and put it on the website to share!

In terms of full costumes, you can also take pictures along the way, as you craft the pattern, build the muslin, cut and stitch the actual fabric, and finish the garment. These steps can all be completed and photographed in the costume shop, but take a moment and hang a neutral background of cloth behind the mannequin displaying your work so that the focus is just on that one item. Costume shops tend to be a riot of patterns, colors, and surfaces, which are very distracting as backgrounds.

As I mentioned previously, it is great to have production shots of the actual dancers in the actual costumes on stage under the lights. Sometimes, however, the costume designer needs a still shot, and in the case with Figure 15.31 Jenny also wanted a close-up of all the beading, sequins, lace, and rhinestones that had been applied. This shot was easy for the dancers to hold, and was taken after the curtain call one night...no photo-call required. Staging them in a bright, well-lit spot in front of a drop that was lit with muted versions of the costume colors allowed them to stand out and sparkle.

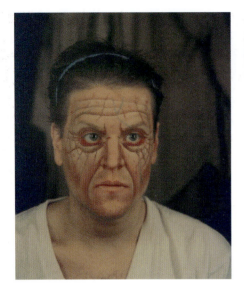

Figure 15.19: Base makeup completed.

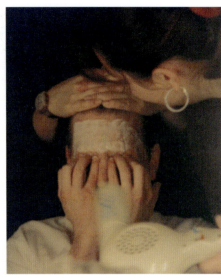

Figure 15.20: Adding first layer of latex to forehead.

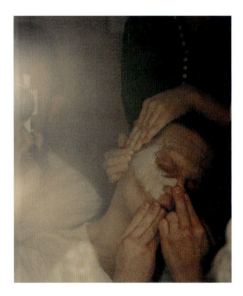

Figure 15.21: Adding layer of latex to cheek.

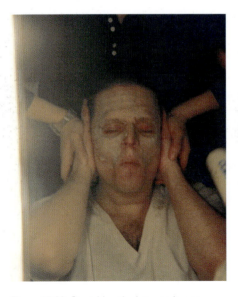

Figure 15.22: Stretching the latex as it sets.

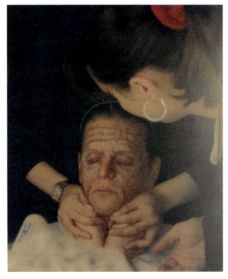

Figure 15.23: Drying the latex to create the wrinkles.

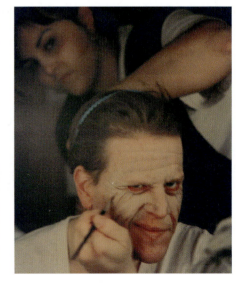

Figure 15.24: Line work on the latex appliques.

documenting process versus product | 159

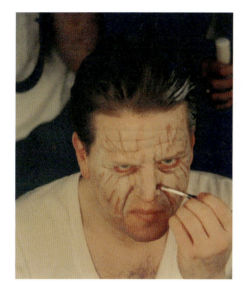 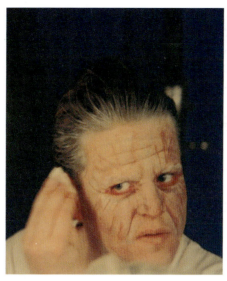 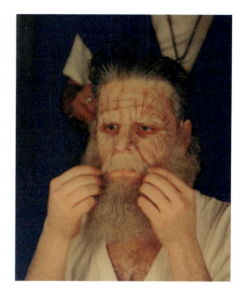

Figure 15.25: Additional line work on the appliques.

Figure 15.26: Adding powder over the line work.

Figure 15.27: Applying the facial hair.

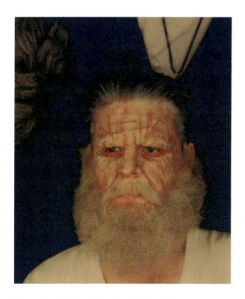 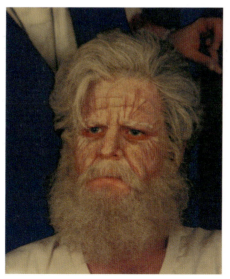 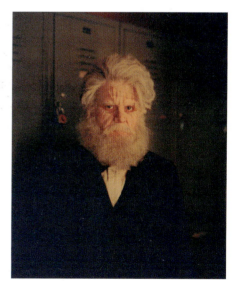

Figure 15.28: Final touches before the wig.

Figure 15.29: Final look with the wig.

Figure 15.30: Final look with costume suit coat.

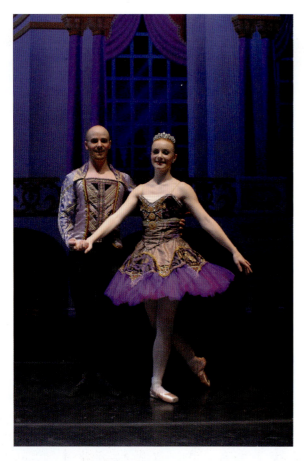

Figure 15.31: Doublet and tutu for *The Nutcracker*, Eisenhower Auditorium, Dec. 2009.

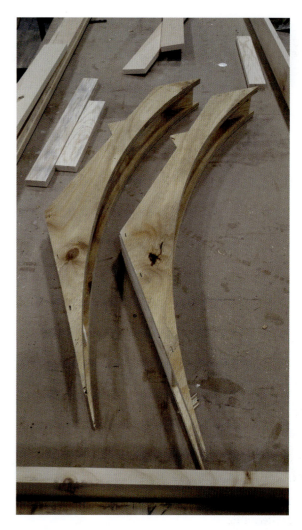

Figure 15.32: Church wall build process Step 1 – Arch framing, *First Noel*, Dec. 2016.

Technical Direction, Properties, and Electrified Props

Large or small, soft or hard, we build a great deal of items that go on stage, either from scratch, or by modifying something we already have. Tracking that process from start to finish can be a challenge, especially when you get into the exciting and often messy process of building and painting something. Still, take the time, and grab some snapshots as you go along. This is a selection of photos taken by TD Matt Lewis as he built this scenic element.

documenting process versus product | 161

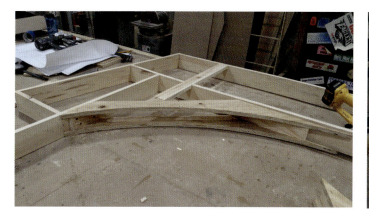

Figure 15.33: Church wall build process Step 2 – Arch frame installed, *First Noel*, Dec. 2016.

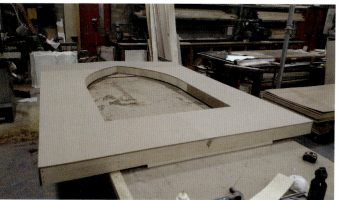

Figure 15.35: Church wall build process Step 4 – Front skin on flat, *First Noel*, Dec. 2016.

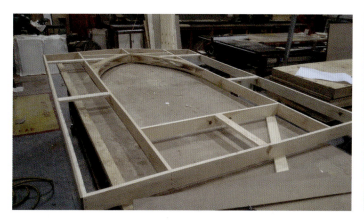

Figure 15.34: Church wall build process Step 3 – Full frame of flat, *First Noel*, Dec. 2016.

Figure 15.36: Church wall build process Step 5 – Inset window backing installed, *First Noel*, Dec. 2016.

This set of pictures are the highlights, but Matt has many more that he could add to show more detail of certain parts of the process. This is a fine example of how somebody might document any build involving scenery, furniture, props, or even wigs, hats, costumes, and other accessories. The theory is the same across the different design disciplines:

- Catch a shot at every major step.
- Try to keep the background as clear as you can.
- Try to maintain a similar viewpoint for your shots, where possible.

The previous shots were all covering the process of building something large. If, instead, you are working on something

Figure 15.37: Church wall build process Step 6 – Back of detail element, *First Noel*, Dec. 2016.

Figure 15.39: Church wall build process Step 8 – Detail element and cross attached, *First Noel*, Dec. 2016.

Figure 15.38: Church wall build process Step 7 – Front of detail element, *First Noel*, Dec. 2016.

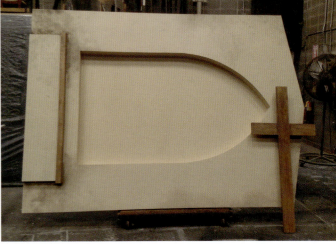

Figure 15.40: Church wall build process Step 9 – Full flat in paint shop, *First Noel*, Dec. 2016.

small, it will be easier to set up a little photo spot with some neutral fabric or similar material so that you have control over the background. I know I previously decried the use of flash in photo-calls, but there are useful applications when capturing process shots. The flash that comes built into your camera might not be the best choice, although the price is right since you already own it. Another relatively inexpensive option is a ring flash or ring light. This is an accessory (some cost from $50 to $100) that uses an adapter ring, which screws onto the front of most regular lenses, and provides a soft quality of light from the direction you are shooting. This particular unit comes

documenting process versus product 163

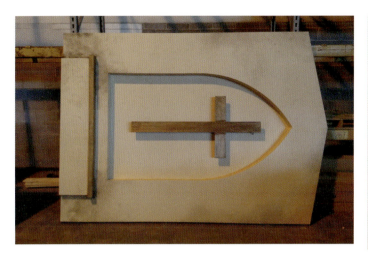

Figure 15.41: Church wall build process Step 10 – Finished flat, *First Noel*, Dec. 2016.

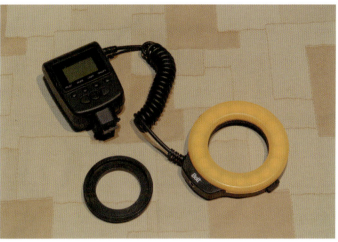

Figure 15.43: Ring flash unit with adapter for mounting and amber ring lens installed.

Figure 15.42: Church wall build process Step 11 – Flat installed in venue, *First Noel*, Dec. 2016.

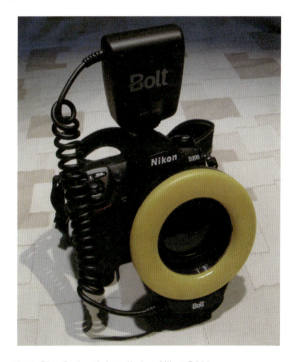

Figure 15.44: Ring flash unit installed on Nikon D200.

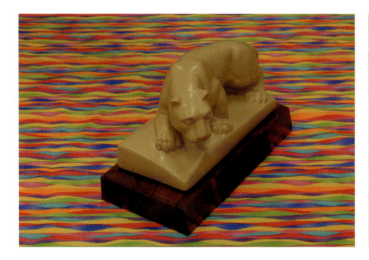

Figure 15.45: Shot of statuette using only top-light.

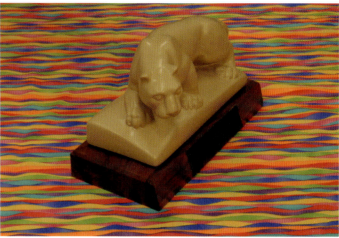

Figure 15.47: Shot of statuette using top light and ring flash manually held to right side.

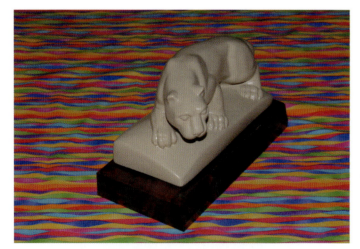

Figure 15.46: Shot of statuette using only built-in flash.

Figure 15.48: Shot of statuette using top-light and ring flash installed on front of lens.

with lenses that are either cool or warm, and also with a diffuser for a softer look. I chose the amber lens to fit with the color temperature of the Leko.

The first shot in Figure 15.45 shows the statuette in a single beam of light from overhead. The second shot in Figure 15.46 uses just the built-in flash. Note how cold and flat the object now appears. The top-light gets blown out by the flash, and the look is not very attractive. In

Figure 15.47, I have the ring flash control head on the camera, and the top-light is visible. I'm holding the ring flash off to the right side so that it provides fill-light. In Figure 15.48, the ring flash is attached to the front of the camera using the adapter ring. The third and fourth shots are subtly different from each other, and both provide more depth and dimension to the object than the first shot. All are superior to the pop-up flash shot.

Lighting and Sound Design

As I mentioned previously, pictures of lighting and sound consoles don't really do much to help document the process of lighting or sound design, but there are a few interesting points to make with these areas. Mic placements are a complex issue for many shows with live reinforcement, so close-up shots of these tiny mics being affixed to the performers could be very useful. The choices surrounding microphone placement within a pit or around a particular instrument might also be worth documenting. Remember to try to keep the visual background clean and uncluttered if possible. With mic placements, get some close-ups of attachments to costumes or hair and wigs, and then get a show shot with the mics in use to demonstrate how they looked in the end.

Another useful photographic trick that might help with many areas is the practice of getting shots of the interior of the venue with the house and work-lights on. I recently was hired on to do a show in a venue that I'd never seen before (not uncommon), and I had a plan and section of the space, but there were some lighting positions that I wasn't quite clear about just from the drawings. I asked my on-site assistant lighting designer to go stand center stage and take pictures of all the positions in the venue. By having her stand at a specific and measurable point, I could lay out the photos and have a much clearer idea of how the various lighting positions related to the acting areas onstage. While not a perfect practice for acquiring accurate photometric data, it answered a lot of general questions about the layout of the space. While this isn't a shot that demonstrates my process, it was a different use of photography that was critical to the success of my process.

Pyro and Special Effects

Back when we were talking about shutter speed, you might recall that there is an option for extended exposures. Often it was marked on older cameras as B for bulb, referring to the days of the old powder-flash that the photographer would hold up while opening the shutter. Later, these open conflagrations were replaced with one-time-use flashbulbs, which were used even in daylight to supplement the very slow film of the time. Using this setting allows you to hold the shutter open as long as you like, which is great for fireworks, pyro, lasers, and other effects that happen in otherwise dark situations. As long as it's dark, the shutter can remain open as long as you like, since there isn't any light passing through to the image-capture device. Once a pyro charge does go off, that light is captured. In fact, if you leave the shutter open for long enough and fire multiple charges, you'll get an image that layers all the different pyrotechnic effects on top of each other, which can be quite interesting. This is a great technique to experiment with the next time Fourth of July rolls around, or perhaps on New Year's Eve if there's a big fireworks show near you.

The counterpoint to this long-exposure technique would be interval photography, otherwise known as time-lapse photography. This is a fun and interesting way to capture the process of painting the stage floor or a drop, loading in the set, hanging or focusing lights, or other labor-intensive projects in the space. This allows you to capture some elements of the design and technical process that may go otherwise unnoticed, such as the careful planning that goes into a load-in, or the sheer number of people that must be marshaled and organized to effectively accomplish some of these larger tasks. If you visit my website, there is a time-lapse video of the painting of

166 documenting process versus product

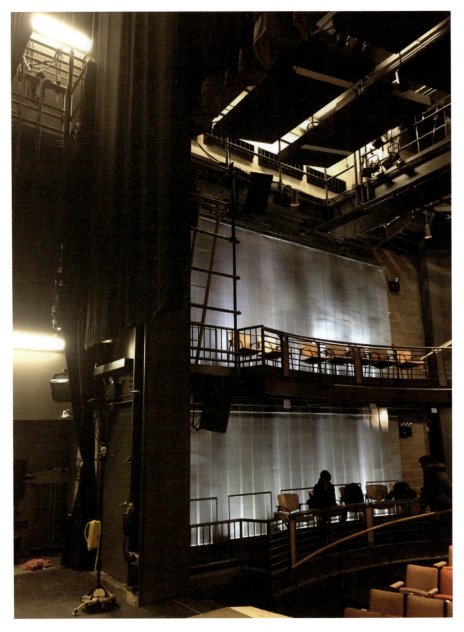

Figure 15.49: Stage left proscenium arch, house left lighting ladder, balcony rail, catwalk, and acoustical clouds, Gladys Mullenix Black Theatre, Allegheny College.

the *Twelfth Night* stage deck featured in Figures 15.9 through 15.15, and several other interesting process videos.

Remember Figure 5.20 and the depth-of-field trick it demonstrates? This technique might be very useful for anyone who wants to isolate an object from the rest of the background, whether it is a costume, prop, or other element. You can do this in the shops, but it is harder to do when you are taking production shots, so you need to plan out your settings to take the best advantage of the depth-of-field issue in your photography.

I look forward to seeing how other people have chosen to document their process, and invite you to share those shots on my website. Just remember to be vigilant about capturing the various stages of your build or process!

chapter sixteen

practices for running a photo-call

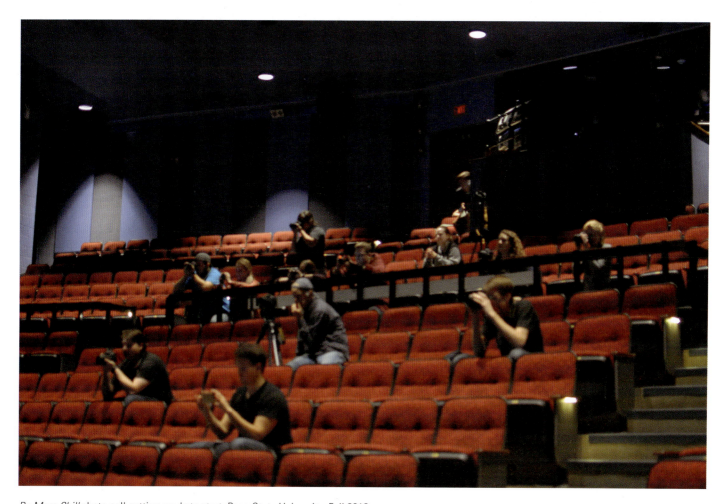

Be More Chill photo-call getting ready to start, Penn State University, Fall 2016.

The tradition of a photo-call goes back quite a while, and stories abound concerning directors-turned-dictators and three- to four-hour calls lasting well into the small hours or until an already-exhausted cast finally collapses. These stories have resulted in a pervasive fear of photo-calls, often leading the producers to insist on one of several less-than-satisfactory options. I have had directors and producers make ALL of the following suggestions related to the documentation of my or my spouse's design work. I offer them up to you now with the rational arguments I have made against such suggestions:

1. Can you just take pictures during the tech?
 a. No, because it takes me away from the tech table, and my work isn't really finished yet until Opening Night.

b. I can't stop the performers and stage a setup in the middle of a run because it's too disruptive for the performers who are still getting used to the integration of the technical elements.
 c. The producer has hired me to work on the design right now, and that comes first.
 d. I don't think the other design areas would like pictures of their work under lighting that isn't finished yet. Many people forget the fact that the sets, props, costumes, paints, and projections are often in a far more advanced stage of completion than the lighting during the early stages of tech.
2. Can you take pictures during the run of the show?
 a. No, because the box-office people don't want me standing in the middle of the seats, blocking patrons' views of the performance.
 b. Back in the film days, my 1969-era motor drive sounded like a small chainsaw. Even today, modern DSLRs often still have a shutter that must move and make noise. My DSLR on five-shot autobracket mode makes a very noticeable racket, which would also distract the patrons.
3. Can you take pictures without the performers?
 a. No, and this goes for all the design areas. A production is a synthesis of many diverse elements, and if you remove one, the entire look is now substantially different from what the audience experienced.
 b. Without people on stage, there is no energy, scale, or balance to the shot.
4. Can you take pictures of the costumes on mannequins instead of the performers?
 a. Again, no, because now the costumes aren't draped properly, and you don't get the intensity of performers' faces and body lines.
5. Can you take pictures of the costumes on the performers in the basement hallway?
 a. No, for all the same reasons as I cited in 3a.
 b. The lighting in most backstage areas is often overhead fluorescent, which casts unattractive shadows and does awful things to the colors of fabrics and makeup.
6. And, finally, in a last-ditch effort to avoid a full photo-call for costumes for a ballet my wife had designed, the producer asked if we could just have *the stagehands* wear the costumes for the photo-call! Other than the obvious problem of convincing a tall, muscular stagehand to attempt to wear a tutu designed for a 105-pound, 5'6"-tall prima ballerina, I felt that it would be asking too much to try and get the stagehands to recreate the final poses of each of the dance numbers. Without a doubt, this was the most absurd thing I've ever heard from a producer.

As a designer or technician involved in the creation of a theatrical event, you have every right to document your process and the end result for use in your portfolio. There are other legal considerations concerning the use of these photographs beyond "archival" purposes, but this rarely is an issue when it comes to a designer photo-call. Many theatre companies will also do a "media day," which is a short photo-call designed to capture an image or two for use in the media, usually to accompany announcements about the run of the show, or for posters and programs. Broadway productions, which enjoy long technical rehearsal periods and even longer preview runs, are able to take these media pictures at a time when far more of the design elements are nearing completion. For most other production situations, this is usually done in a way that allows for the fact that much of the design isn't yet complete. There may be a few characters in more of a close-up shot, wearing costumes that are nearly complete, and sometimes in front of some available scenic elements. More often than not, however, these are done under work light, and not in a finished "light cue." They are fine for what they are used for, and necessary for the promotion of the production, but usually

they are not of much use to the designers who are looking for portfolio-quality images.

So, at the risk of angering producers and other theatre administrators, let me reinforce the most important point here. You, as an individual who has poured time, effort, heart, and soul into some aspect of a production, have the right to take actual, staged pictures of the real actors, in the real costumes with correct hair and makeup, in front of the real set and in the right light cue. It is a recognized right, although some producers are more willing than others to make this happen. Surprisingly, I find that many colleges and universities seem to be the most reluctant to allow photo-calls to happen, which is a disservice to all the students who need good-quality photographs for their portfolios. In the non-professional world, there are actually less rules to abide by, since there are less professionals involved. Most professional theatre does tend to involve performers and backstage personnel who are members of the various unions that oversee theatre work. Actors' Equity, which governs performers and stage managers, has the clearest set of rules for their members when they are involved, found in the *Actors' Equity Association: Agreement and Rules Governing Employment in Small Professional Theatres*. I've provided a web-link in the Appendix if you would like to review the full text of Section 42, which governs photo-calls. To sum up the more important points, Equity requires the

- Call not to exceed 90 minutes.
- Call to occur right before or after rehearsal or show.
- Photos only to be used for advertising the show.
- Notice of call given a day in advance of the call.

It is important to be aware of these rules, even if you are in an educational situation, since many colleges hire guest performers and designers, and their union regulations follow them. If you are in high school, or another situation where there are no union contract concerns, it's still a good idea to use these parameters so that everyone gets used to the idea of a carefully organized and time-limited photo-call. The following list of items is a good starting point for setting up a photo-call:

1. Several days in advance, the stage manager should request a list of desired shots from the director, the various designers, and other production personnel.
2. The stage manager should then compile the list, eliminating duplicates and combining similar shots to get down to a list of 12 to 16 "setups." In the old days of film, we would shoot three bracketed shots of a single setup, and could then do a total of 12 setups before running out of film. You wouldn't want to waste film, so you would try to stick right to that number so that you used up the whole roll. Going over wasn't an option, because then you would have to change to another roll, taking time, and then the second roll might be partially wasted. Now, you are only constrained by the size of the memory card, but don't let this trick you into thinking you can take as many shots as you want. There is a law of diminishing returns here, given the fact that most photo-calls are scheduled after a performance, and your performers are justifiably tired. Keeping them longer than the usual Equity-mandated hour is generally a waste of everyone's time. They are too tired to give you the energy you need, and your pictures will show this. If, on the other hand, the photo-call is scheduled for a time prior to a performance, or even more rarely between a matinee and an evening performance, you need to be sensitive to the fact that the performers need time to get into character and complete their usual pre-show routine. In the region of 12 to 16 setups are usually possible within an hour, and if well-organized, can be accomplished with little to no rush or panic.
3. Once the list is compiled, the lighting designer can attach the appropriate cue numbers to each shot, and the stage manager can plan the shot order. It's easy to jump around in the cue stack, so the order is least important to the lighting and/or projection designers. Depending on the

show, however, the order may have a very distinct impact on costumes or scenery. Quite often, when the photo-call begins after the show, the call will be run in reverse show order. The set is already in the last scene, and the actors in their final costumes. Work backwards through the show, and you will end up with the set in the first scene, ready to go for tomorrow. While this is how many photo-calls go, there are times when you may choose to go completely out of order. If you are doing *Noises Off*, for example, Act I and Act III are the same set, but Act II is the other side of the revolve, and takes a bit of time to get to, whereas the costumes are mostly the same in all three acts. Here, you might shoot all of Act III and Act I, and then change once to Act II. Alternately, you might have a set that gets totally trashed through the show, requiring a great deal of clean-up. This might require a split photo-call. Shoot for 30 minutes on the clean set before the show, and then 30 minutes after the show. Changes in makeup or major props usage/breakage might drive the need to alter the order. One year we were working on a production of *The Nutcracker*, which calls for a large cast of young children, almost all of whom are only used in Act I and are dismissed at Intermission. We didn't want to ask the parents to keep the kids through the entire second Act, and then wait even longer as we shot the second Act, so we did Act II after a Friday evening show, and then Act I before the Saturday matinee. Splitting this call over two days also allowed us to fold the set restore back to Act I into the end of the Friday call without going overtime for the union stagehands, which also kept the producer happy.

4. If there are scenes where the lights are not static, for example, F/X chases, strobes, or other moving effects, then the lighting designer should capture a static snapshot of the dynamic cue, and record it specially for the photo-call. If my cue stack runs from Cue 1 to Cue 173, but Cue 52 is a chase effect, I might "freeze" the chase at a point that is visually attractive and appropriate for the planned photo, and record that as Cue 952. I then just note that as the cue to go to for that shot on the photo-call sheet.

5. If you are doing a show where there are props or costumes that get destroyed or altered during the run, you will need to have doubles arranged for. This is important to think about very early in the production planning process, to allow for extra purchases to be made, or other logistics to be sorted out. Several years ago, we did a production of *Sweeney Todd*, which involved quite a number of costumes getting soaked in stage blood. In order to accomplish the planned photo-call, we had to have an extra set of the white shirts worn by some of the characters, and also organized the call to take pictures of the costumes that were bloody right away, so that the wardrobe crew could get the bloody white shirts in the laundry, and clean the rest of the jackets and pants so they could have them ready for the shots from the start of the show.

6. Once noted with cues and organized as efficiently as possible, the stage manager should distribute the list to all involved, and post copies backstage.

7. Before the show, the stage manager should remind the cast that there will be a photo-call afterwards, and make sure everyone knows not to leave until dismissed. More than one carefully planned and scheduled photo-call has been derailed because one major character forgot, left the venue, and was unreachable for the rest of the night.

8. In my world, the stage manager has always been the one empowered to run the photo-call. They are best prepared to recall the blocking associated with the moment you want to capture, or the line that defines the moment you are looking for. They will tell the cast when the call will start (usually giving them some time to meet and greet after the show, take a short break, and otherwise prepare for the shoot). I have always, however, reserved the right to talk to the cast before we get started, in order to lay out some ground rules. I explain that this is my one chance to document the work that I've done on the

show, and the quality of my portfolio depends on good pictures. I ask them to please listen closely to the stage manager, and be prompt in making costume changes or finding props. I make every effort to get them on my side, so that they understand how important it is that they don't goof off, make funny faces, or try to get each other to laugh while holding a pose. If you demonstrate to them that you respect the fact that they are tired and that you are very organized and ready to work hard to get them out as quickly as possible, then you will find that they are very willing to participate in a positive way. If you are disorganized, or your equipment isn't set up, or if you don't project an air of professionalism, who can blame the performers for not doing the same?

9. Often friends and family want to join in the call. As much as I am happy to accommodate these requests, I always tell them three things:
 a. No flash may be used.
 b. Shoot what you want within the listing of shots that we are doing, but we aren't going to add shots or wait on you. (Often family can squeeze in quick shots of performers while we are waiting on a set or costume change, and this is fine, as long as it doesn't delay the overall call.)
 c. Feel free to stand wherever you like, as long as it's not in the field of view of the "official" photographers.

10. Once the call has started, the stage manager will announce each shot, and everyone involved should get their props and find their place on stage. Everyone else should be nearby, and not wandering off, unless the stage manager tells them they should go change costumes (if needed) for the next shot. Once everyone is in place, I will tell the performers to "find your pose and hold it." Often, people want to run lines or try to run the scene blocking, but this doesn't work for bracketing. You need to be able to take multiple still images of the same moment with different exposures to give yourself the flexibility to choose an appropriate image for your portfolio. If the moment is very difficult to hold, as is often the case in dance, you may need to stage several attempts. Big lifts in ballet are often candidates for this, or the pose shown here from a dance moment in *Carousel*:

Figure 16.1: *Carousel* dance moment – Shot #1 in the auto-bracket series.

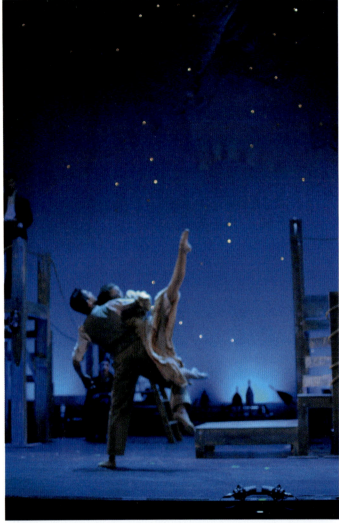
Figure 16.2: *Carousel* dance moment – Shot #2 in the auto-bracket series.

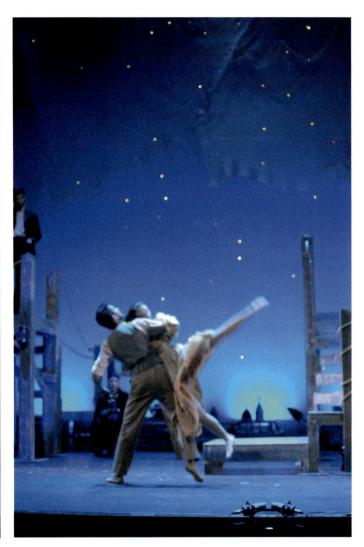
Figure 16.3: *Carousel* dance moment – Shot #3 in the auto-bracket series.

Ultimately, I didn't get what I was hoping for with this shot, but I did get a great version of these two in a different moment later on (you may have noticed it elsewhere in this book). It's important, though, that most of the time, everyone is holding that moment. This is where your practice and preparation are critical to the success of the call. You need to be quick about capturing the moment, as it is fresh, before people begin to falter and sway. I generally take about three seconds to capture all I need with my new DSLR because of the availability of

auto-bracketing. Those without that feature might take longer, and if you see people starting to sway and move, give them a break. I tell them to "relax for a moment," let everyone take a few breaths, and then ask them to "find their pose again." Performers will appreciate your attention to their physical situation, and will make a better effort to hold the pose when they know it won't be for long. It is important, though, if you are giving them a break, that you are clear that you aren't done, otherwise people drift away very quickly, which leads to longer calls while you get everyone back into place.

11. Sometimes I have to be the "bad guy" at photo-calls, when people suddenly want to add all sorts of additional shots to the list. If it's just one quick variation on a shot already planned for and is easy to accommodate, that's one thing, but when the director comes in and wants six other shots, then we run the risk of destroying the well-made plan for the call. Depending on your situation, based on the ease or difficulty in fitting the extras in, and who is asking to take more shots, you will have to make a call on the fly about adjusting the list. One way to mitigate this issue is to get extra shots while waiting for a costume change. Often the costume designer or props master wants a close-up of one or two characters with a specific item they made, and this can often be done while other things are getting into place.

12. Plan your shots out in advance. You should carefully evaluate your list, and determine what row (or rows) you plan to stand in, and if you are staying in one place for the whole call or moving around. Once you have sorted this out, you can determine which lenses you might want to use. This is especially critical in thrust and in-the-round spaces, where you need to look beyond the shot and possibly deal with empty seats in the background. Many of the shots may need to be taken from different positions around the venue, depending on the dynamic nature of staging in the round. Proscenium staging often allows for the photographer to stay in one place, since the director is often staging the piece within the framework of the proscenium arch.

13. Once you know where you are shooting from, and if you are moving or static, you can make the call on using a tripod, a monopod, or just handholding the camera, as demonstrated in Chapter 6.

14. It's a good idea to be aware of who is shooting with you at the call, and from where. I try to talk to the other photographers before the call starts, and find out what their plans are. We have a regular photographer on retainer for close-up publicity shots, and he often needs to be closer (and hence, in my shots), but we've worked out a method where he will shoot his stuff quickly, then sit down on the floor in the aisle, and I can take my shots over top of him without any issues. This of course depends on him being fast and there being some professional and open communication between us. During the shoot for our recent production of *Twelfth Night*, one of the other photographers got in my shot (Figure 16.4). You will also notice that his presence threw off my camera, which autofocused on him instead of the performers. I could have cropped him out of the shot if the focus was okay, but I had to wait and take another run at this with the focus on the right people. Photo-calls are very active times, and people get tunnel vision about getting the shot they want, and quite often will wander into your field of view. Sometimes they are still in the dark part of the house, and you don't notice them until it's too late.

15. Do you need multiple cameras? If you are not using a zoom lens, but need to get some long shots and some close-ups, you might need to bring multiple cameras, and maybe a friend to help shoot or at least hold. This is another situation where one on a tripod and one in the hand can work very well for you.

16. You must be prepared with all your equipment ready to go.
 a. Charge your batteries, and make sure you have more than one just in case.

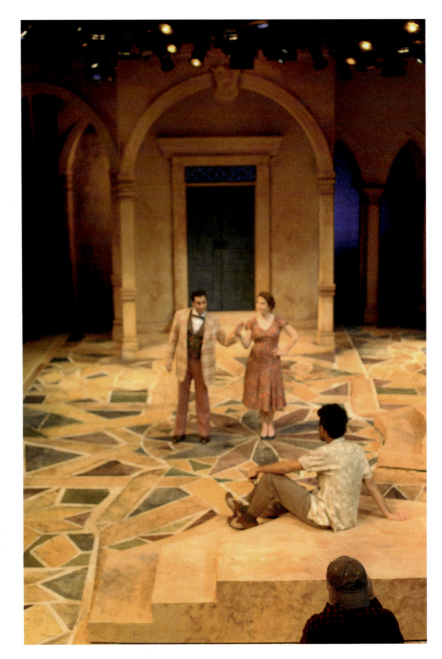

Figure 16.4: Unexpected "cast member" in my shot from *Twelfth Night*, Penn State University, Nov. 2016.

b. Clean your memory card out so you don't run out of space, or suddenly have to start deleting things to make room.

c. Reset your shot counter, if you like, as we discussed in Chapter 14. Just be careful and organized about keeping each show in a separate folder, or batch-renaming them right away once you download them from the card.

d. Ensure that your camera's time and date are accurate so that you have a valid time/date stamp on the files. Very helpful when you are looking back through years of files. You can also get units that will location-stamp your photos using Global Positioning System (GPS) coordinates. I know this is very useful in some professions, but probably not a priority for us.

17. I really like to keep the house at a glow during a photo-call. It won't affect your photos if it's down around 20 percent or so, since you aren't taking pictures of the seats usually, and it's great for making sure everyone doesn't trip over each other, knock over tripods, or dump a camera bag over. You can always dowse it for really dark shots in smaller spaces if you find it is leaking on stage. Smaller spaces or non-proscenium spaces may be just fine with the house lights off, since the stage light may very well light up the seating areas.

18. If you are shooting in the round, it is important to keep all the actors who aren't being used for the current shot out of the seating, but somewhere close by. I also walk around and clean up anything else that might be lying around in the seating if that section is going to end up in my shots. As you saw in Chapter 9, framing and planning out your shoot will alert you to unwanted things like exit signs, coats left in the seats, and extra coffee cups lying around. Sure, you can fix some of this in Photoshop, but why cause yourself the extra trouble?

19. I don't take much to a photo-call, but there are some essentials:

a. Spare batteries
b. Spare memory cards
c. Sync and power cables
d. Specialty lenses needed for the shoot
e. Lens hoods
f. Lens cleaner and paper
g. Canned air (be careful with canned air and DSLRs, check your manual)
h. Small flashlight
i. Shot list and Sharpie
j. Small coil of Paracord for lashing tripods

Figure 16.6 is the shot list from the photo-call for *Trouble in Tahiti*, Penn State School of Music, Oct. 2016. Note that the specific light cue needed for each scene is noted, along with the characters needed, and what line or moment is being captured. This is a very clean and clear example. It was circulated by email in advance to all the artistic team, and posted backstage for the actors to reference as the night progressed.

I know that it seems like there is a great deal that goes into this, and all of these suggestions are the result of

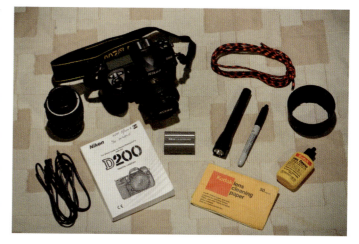

Figure 16.5: The usual equipment and supplies found in my "go" bag for photo-calls.

Tahiti Photo Call Schedule (10/28)
Starting at 9:35 PM

Scene VII (Finale)
Newspaper
Pg. 116 - LX 164 - When doors are closed
Pg. 109 -LX 156- "Waiting in time somewhere?", w/ Dinah DL
Pg. 108- LX 152- "…something about Tahiti…", w/ Trio on Platform
Pg. 107- LX 150- "Telling of intimate matters…
Pg. 097- LX 140- "What a terrible, awful movie!"

Scene VI (Salon)
Salon wall, salon chair, stool, scissors, martini glass
Pg. 090-LX 133- "As the natives sing Ah!"
Pg. 090-LX 132.5- "Running wild with lances…"
Pg. 084-LX 124-"There she is in her inch or two…"

Scene V (Shower)
Shower, bench, mirror, trophy, clothes rack
Pg. 072-LX 104- Sam standing DS of the bench
Pg. 076-LX 106- "…fish who are trim in the fin."
Pg. 078-LX 109- "…never, never, never be thin!" w/ Sam facing US
Pg. 080-LX 114- "Men are created unequal!"

Interlude
Plates, roast, silver ware, napkins
Pg. 069-LX 98- "Family picture second to none"
Pg. 066-LX 93- "Six days of work…", Eating

Scene IV (Rain)
Umbrellas
Pg. 059-LX 82- "Can't we find the way back…"
Pg. 053-LX 74-"Why?" Sam and Dinah back to back

Scene II (Offices)
Desk, desk chair, stool, phone, psyc chair, psyc chair, umbrellas

Figure 16.6: Photo-call shot list for *Trouble in Tahiti*, prepared by Stage Manager Jojo Sugg.

situations that could have run more efficiently. Also, I don't want anyone to walk away from this chapter thinking that candid photographs aren't good to take. Certainly, if you aren't tied to the tech table, or maybe the show is ready to open but you still have a dress rehearsal, by all means walk around and shoot. Knowing the moments that you are interested in capturing in advance will allow you to be ready and waiting when they come about. I was actually in this situation during *Luna Gale*, in that I had a photo-call set for Tuesday night after the dress rehearsal, but was able to get up and roam during the tech and also try to capture some moments. The case can easily be made that you may catch some emotional energy from the performers during a candid that can't be recreated during a setup shot. Hopefully a combination of those shots and a carefully planned call will capture everything you need for your portfolio.

chapter seventeen

photography of other types of performances

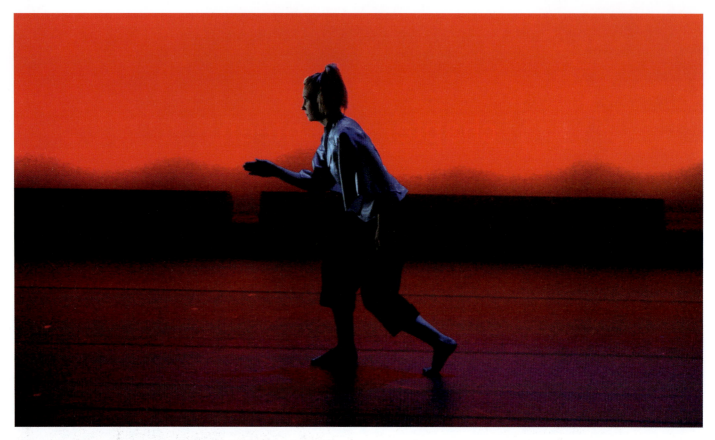

Penn State Spring Dance Concert, Playhouse Theatre, 2006.

Thrust and In-the-Round Spaces

When shooting in thrust and in-the-round spaces, quite often you find the best composition of performers is framed against the seating, or worse, against part of the seating and part of the set. You may recall my thoughts on this from Chapter 9. These considerations also apply to other situations, but especially with these types of venues. This is a situation that all designers on the show should accept as part of the cost of doing business in these venues, but you can mitigate the damage done by seeing your nice period costumes against old orange folding theatre seats. Remember the depth-of-field trade-offs, and take advantage of the opportunity to blur the background out. You might need to do some lens math in advance, in order to see how far away you need to be from the subject for various aperture settings. Or, if you have access, go to the venue in advance and try shooting some test shots at different aperture settings, allowing you to get a better sense of your camera's specific depth-of-field capabilities. You also need to keep a close eye out, usually between when the audience files out and when the actors

are back from taking a rest break, for leftover programs, hats, coats, and other audience flotsam and jetsam. I also make sure all the seats are in a uniform position if they will be in the shot, either all folded down or all folded up. It's a small consideration, but the disarray in the background could distract the viewer's eye from your more important subject matter. Through the call, you need to continue to keep a lookout for other loose objects the performers might bring back in with them and leave lying about, including props and costumes for other shots, and my personal favorite, the lone water bottle that suddenly appears in your frame.

Ballet and Dance

Dance, in all its forms, is a very active type of performance, and far more difficult to stage moments from. As you've seen in other chapters, I have been successful in capturing dance movement by careful observation, planning, and timing, as opposed to staged photo-call moments, although I still try to do those when possible.

Instead of just getting the dancers to hold a moment, I feel it's more successful to have them run the 20 to 30 seconds before the moment, and then shoot a flurry of shots with a fast shutter speed as they get to the pose you want. Sometimes it's a pose they can hold, in which case you can bracket it, but if not, you may have to have them run it a few times. Modern dance (and other forms) may often feature a single dancer on a large stage, so I often get closer to the action than I normally would, just to catch more detail of the dancer's movement. I lose the overall feel of the whole stage, but find that big empty stages don't often make for strong and interesting photographs. It's not to say that solo dances in big spaces aren't interesting, it's just that we are freezing a moment in time that is different than the audience experience, since they wouldn't have seen that moment for so long. The cover shot for this chapter is a good example of this idea. From Row J, the one performer wouldn't fill the stage with energy, even though she did as she went through the dance.

Opera and Musical Theatre

Opera is very much like theatre or musical theatre, in that it is usually staged in a typical theatre space, so the only thing you have to consider that may be a bit different is the band. If the band is in the pit, and not visible, by all means send them home before you shoot the photo-call. If the band is a visible part of the show, then you need to decide between including them or not. Figure 17.1 shows a student production of *Trouble in Tahiti*, and the band was on an upper platform behind the house on stage. You will also perceive that the angle I shot from is fairly high. This is a very intimate theatre, and even though I was shooting with a 35mm lens, I had to be back a fair distance from the stage to get the whole set in. The house has a very steep rake to it, so I was stuck with the choice of less of the set or less angle. After looking at these shots on the screen, I could have been down one or two rows, and lost the columns without losing the sense of the space, and the angle to the performers' faces would have been much better. This is also the point where I have talked myself into buying a 24mm wide-angle lens for the next time I shoot in that space.

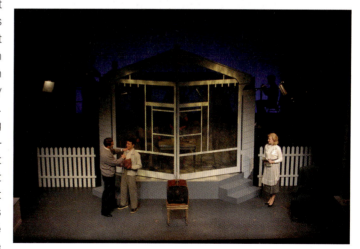

Figure 17.1: Prologue from *Trouble in Tahiti*, Oct. 2016.

Back to the question of the band. I feel that since they were there in the show, they should be there in the shot, with music stand lights on and everything. That's what the audience saw so that is the most truthful representation. Sometimes I might adjust a music stand a little bit to eliminate glare that is coming right at me, which I did to the stand light on the stage left side of the shot. We didn't have the musicians playing, just posing as if they were playing, so that there wasn't any movement to deal with. Do take some extra time to talk with the musicians and explain what you are doing and why you need them. I actually haven't had much trouble with the members of the band, but conductors and musical directors seem to have a hard time sitting still, which means that I tend to shoot two runs of every bracket instead of one. That certainly helped me with this photo-call, since the musical director kept on messing around despite several requests to hold still. If you run into that issue, with a musical director, or any performer that doesn't want to participate for some reason, just hold your tongue and have them set up and do the shot a few more times.

Rock Tours

Rock shows and other musical acts are similar to musicals like *American Idiot* (which is actually a musical based on the rock band Green Day), in that they are very dynamic, constantly

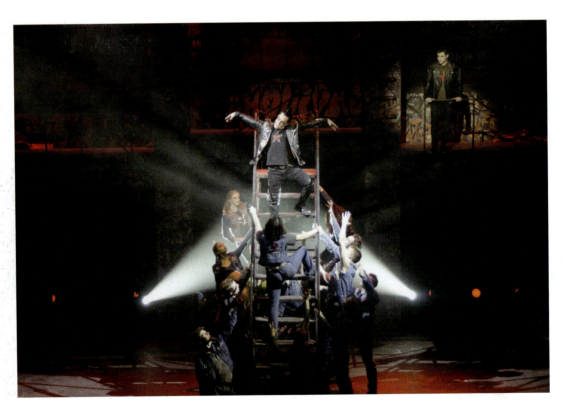

Figure 17.2: Production moment from *American Idiot*, Penn State School of Theatre, Feb. 2017.

changing, and usually feature lots of motion effects and atmospherics. This is a situation where you need to follow the suggestion I made to "freeze" cues with lots of movement, and use them for the call so that the lights are held in a dynamic composition that works for the shot. You don't want to have to rely on blind luck if you can do this in advance.

Outdoor Dramas

I had the good fortune to work for several years in a massive outdoor space in Cherokee, North Carolina. You've seen a shot or two already for that production, but I wanted to revisit it to talk about the sun. Our show actually started before sunset, and we tied the design of the piece into the setting of the sun during the first act. Each year, we would do a photo-call, but it was difficult to plan one out so that the shots we took were occurring at the right times of day, dusk, sunset, or night. In Figure 17.3, I actually tried to replicate some sunlight for this shot, which happened in the first act, so that we could capture the moment, even though it wasn't an accurate depiction of the actual moment in the show. The other shots you've seen from this production are from the second act, which happened after sunset, so they are all far more accurate and didn't require any extra cueing. They are the more dramatic and portfolio-worthy moments anyway, so I'm not too sad about the first act not being true to form.

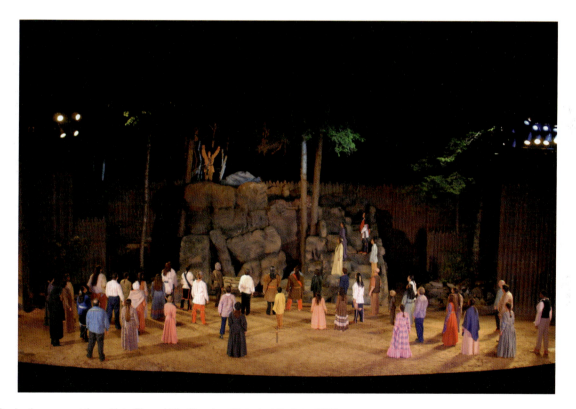

Figure 17.3: Production moment from *Unto These Hills*, Cherokee Historical Society, 2007.

Specialty Events

I have been involved in a number of productions that are more like one-time events. Often these are things that may have been carefully planned, but due to the nature of the event, are impossible to stage more than the one time they actually happen. One example is shown in Figure 17.4, which is a moment from a special fundraising event that our theatre department was asked to produce for the university. Due to the vast number of involved entities, and the very narrow window we had to produce this event, it just wasn't possible to fit in a photo-call. We never did a full dress rehearsal with every person involved until the actual show. I was programming with my students right up until the moment we opened the house, and had only a few moments to shoot some pictures as the event was happening. I set up to bracket and just shot as much as I could when I had a moment to grab my camera. This entire project was complicated by the massive video screen upstage, which backlit everything, all the time. Many of the choice shots are actually 2 stops under-exposed from being "on the meter," but at least I have a lot of shots to choose from.

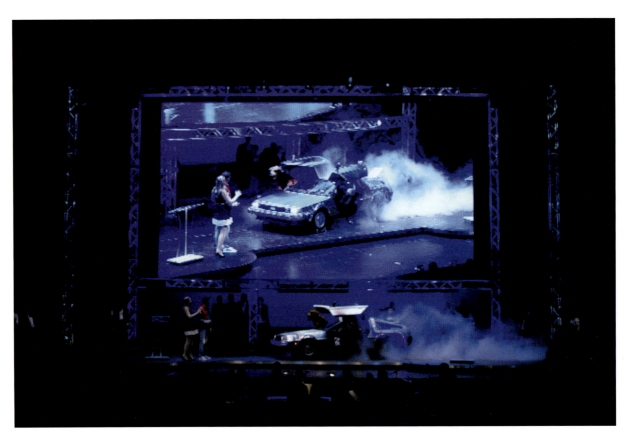

Figure 17.4: Production moment from *For the Future – PSU Capital Campaign Closing Event*, April 2014.

TV and Film

TV and film lighting is often a different color temperature, as we discussed in Chapter 8. So that's the first thing you need to be aware of. The second issue is backlight. In order for backlight, cyclight, and other lighting angles upstage of the performers to be perceived by the camera, the levels are usually set very high. My usual reaction, when I've set the levels of the scene so they look good on the monitor, is one of slight shock when I look at what the set looks like in real life. Things often appear way out of balance in terms of relative levels, with the background being too distracting and bright. But if it looks good on the video camera, that's what's most important. This may translate to your camera as looking okay, or out of balance, so make sure you are bracketing with a wide offset of exposures so that you have some latitude to play with. Lastly, I have included this moment from a broadcast we filmed where some musical theatre students performed a cabaret-style musical event for a live studio audience. I tried shooting a few shots from the light board, but this was again a situation where a photo-call just couldn't happen. Notice the camera boom that swung into the shot! I didn't really notice it

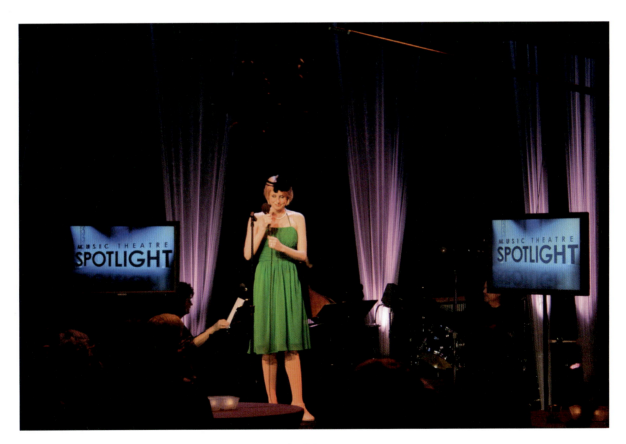

Figure 17.5: Production moment from *Spotlight on Musical Theatre*, WPSU-TV, 2006.

at the time, since I was trying to do three things at once, and it's not in the other bracketed shots from this series, so it must have just dipped in for a moment. Unfortunately, this is the best exposure of the three.

Everything here should apply at least in part to other situations, but there are so many other types of performances out there. I hope that those of you who may shoot these other performances will share lessons learned on the website over the next few years. Take the best parts of what I have shared here, and apply them to your specific situation, and I hope that you will enjoy success with your efforts.

chapter eighteen

digital photo manipulation and presentation

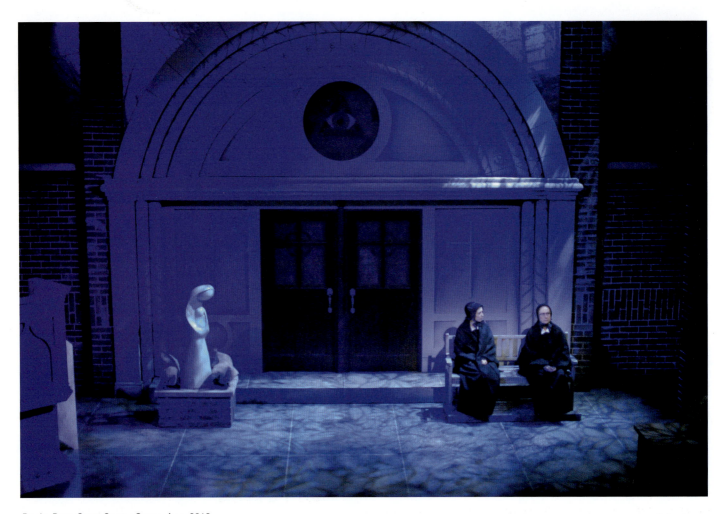

Doubt, Penn State Centre Stage, Aug. 2013.

When you select photos from your collection, it is important to pay close attention to a number of factors that will influence the colors and your perceptions of the exposure balance. The small screen on the back of your camera is fine for what it does, but it isn't as high a quality or as color-accurate as your computer monitor. Even if you have a great monitor or computer screen, you might still not be seeing the best representation of your files. This is one of the real pitfalls of digital photography. With slides and prints, you were always seeing the finished product with no filters other than your own eyes and the light in the room. With digital photography, your perception of the image is influenced by the various monitors you use to view the image, the light in the room where you are working, and the quality and ink levels of any printer you

choose to use to print out the photo. Even if you take your images to a professional printer, you may experience some differences in color and contrast levels. For this reason, it is important to eliminate as many variables as you can. For a quick example of how disparate various reproductions of a digital image can be, do a Google image search for the Mona Lisa: (www.google.com – image:Mona Lisa). Aside from the various spoofs on the painting, you will see images of more than a dozen versions of the actual painting, with wildly divergent color profiles and contrast ratios. If you are creating a web page, then you have to accept the fact that your viewers may have monitors that are different from yours, and that is out of your control. All you can do is supply the most color-accurate picture to begin with.

To begin, there are side-by-side comparisons you can make, or you can calibrate your monitor. First, take a look at an image with a lot of color in it. How close is it to what you remember from the stage? Can you take your laptop into the theatre and compare directly? Do you have any programs that are otherwise influencing the color output of your screen? What external lighting is affecting that screen? I run a program called f.lux, which takes into account time of day, location, and surrounding lighting conditions, and adjusts the color of the screen on my laptop to a warmer tone at night or when I'm in the dark. This is very useful if I have my laptop open during technical rehearsals because I can have the screen color-keyed to tungsten light, and it doesn't throw off my color sense. It's a great little program, but I do need to turn it off when I'm using my laptop for image editing. If you are using such a program, and have disabled it, the most basic place to start is by adjusting the screen's brightness and contrast.

Once you've done that, hook your laptop to an external monitor, and put the same image up on both…are they close or wildly divergent? If one looks right on, then congratulations, you can move on to viewing and editing your work, but if not, it's time to dig a bit deeper into the calibration world. There are several techniques for adjusting your laptop screen or monitor, ranging in cost and ease. There are some basic calibration tools built into most stand-alone monitors, allowing you access to several adjustments, such as brightness or tint. You may be able to adjust these by eye to find the settings that are fairly accurate, but it is very difficult to quantify these settings, or verify that they are, in fact, accurate. Current computer operating systems also have some built-in options for calibration, but much like those on stand-alone monitors, you are still dealing with very broad adjustments.

The Mac has a calibration feature that is pretty effective, built into its System Preferences. If you run its calibration, you will end up with a profile that can be stored again for use in similar lighting conditions. Windows has a similar system that relies a bit more on user input, but might also be enough.

You may also want or need to resort to a more external method for doing this, if the built-in calibration options result in strange colors or just don't feel right. There are a number of calibration devices out there, with a wide range of prices, depending on how much help your computer needs. I admit that this might be getting pretty far afield for most people, but if you work with a number of other colleagues or students, maybe having one of these devices for your group might be

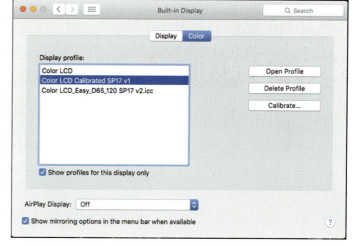

Figure 18.1: Mac monitor calibration window.

useful. The way they work is that you take the calibration device, and plug it into the computer via Universal Serial Bus (USB), and then run the software. The software will help you position the device on the screen so that it can read the screen output and adjust it accordingly.

Once this has finished, the software will create a monitor profile that you can switch to with just a few clicks. This allows you to enable and disable your various screen and external monitor profiles as your needs dictate. Many of these sensors are set up to respond to and adjust the screen to compensate for changes in external lighting.

Once you are satisfied with your screen output, you can do a quick test to see how things are between your monitor and your printer. All you need to do is print out a nice, high-quality print of a selected colorful image, and then compare it to the image you still see on the screen. The screen image will have a bit more **luminosity** to it, since it's on the screen instead of paper, but the things we are also looking at are color, contrast, and exposure. How close is that printout? If they are different, which one looks more accurate to you?

Figure 18.3: Color Munki calibration tool installed and in position for calibration.

If it's the monitor still, then take your image file and have it printed professionally, and see how much it differs from the output from your printer. You may need to resort to professional printing or upgrade your printer if you are otherwise unsatisfied with the results.

Photo Editing and Manipulation

If you are satisfied that your monitor and printer are both displaying the images correctly for your needs, then you can accurately sort through your images and cull what you don't need to keep. I try to identify 12–24 files that represent the best of the lot, and might pull them into a sub-folder as a starting place if I want to feature a shot from that production or project.

Figure 18.2: Color Munki screen calibration device.

As part of this process, you may identify files that are in need of some help, or you realize that you don't have a perfect shot of a pivotal moment, and need to do some image editing. I must pause here and restate my position on digital photo manipulation. I've been presenting workshops across the country for 15 years on the topic of theatrical photography, and maintain that it is critical to get the best shot possible in the camera so that it isn't necessary to do much in the way of manipulation or adjustment later on. For all of you who heard me before, I am not abandoning my soapbox on this particular topic, but felt that I still needed to address the possibilities available to young photographers. Sometimes you just don't get a good shot of something that is particularly important to your portfolio, and you need to go back and "save" the shot from one of the "less-than-perfect" images you did capture. The skill to capture what you need will come with time and practice, so until then, I offer some suggestions on editing.

I am not, however, a Photoshop expert, and there are far better how-to books out there about Photoshop and similar programs. If you plan to get into this area of things seriously, get a good guide to the photo-manipulation program of your choice. Often, all I need to use is the Mac Preview application to rotate shots around and maybe do some simple cropping. I have, on occasion, needed to work with Photoshop to do some more delicate adjustments, but not for my portfolio use. In that sense, I will stay a purist, and will use the editing programs to create images for teaching purposes and such. So, let's discuss a few things you might want to do to help present your photos as best you can.

Borders and Cropping

This is probably the most basic level of editing, other than making sure the photo is turned the right way up. In fact, in the days of slide film, a crop was required. A 35mm slide was a slightly different aspect ratio (2:3) than an 8 x 10 print would be (4:5). So, if you wanted to print the entire slide, you would end up with black bars top and bottom, or you would have to choose to lose a little of the image off one or both sides. This assumes that you are doing a "full-bleed" print. A full-bleed print means that there is no white border around the edge of the image. This has always been my preference, simply because there isn't a white border around most proscenium arches. The colors surrounding a print always influence your perception of the print. Even in this book, where the pages are white, your perception of the images I've chosen is different than if you saw them on the otherwise black pages of my portfolio. Compare your perception of Figures 18.4 and 18.5, which are the same exact photo image, but against different screen backgrounds. Even this will have an effect on how you view the pictures. Are you looking at them in a brightly lit office or a dimly lit theatre? Again, the surroundings will influence your view of the image.

As with most all of the manipulations mentioned in this chapter, you need to think about your end use. How will the image be displayed – physical print or digital? In what context will it be shown – website, portfolio, emailed image, PowerPoint presentation? For example, is it essential that you have the picture viewed against a black background? If you are putting it on your website, you can set the background on the webpage to ensure this, but if you are sending some images to someone, maybe you need to edit them to add a thick black border around the image.

As far as actual cropping goes, if you are cropping down a number of photos that will be displayed together, try to ensure that they are the same size and aspect ratio when cropped, if appropriate. I tried to keep most all full-stage production shots in this book in the same aspect ratio for continuity, but they won't be 8 x 10s anymore when the book goes to print. Most of the other demo and example photos have been cropped to best show the item or concept being shared. In the examples shown in Figures 18.6 and 18.7, I was distracted by the shadows of the floor mics, so I just trimmed the bottom so that the mics are gone without cutting Julie's skirt off at the hemline. It's a minor change, but I feel that it makes a big difference in the end.

photo manipulation and presentation

Figure 18.4: Photo-call picture against a white background of Word files.

Figure 18.5: Photo-call picture against a dark desktop background.

photo manipulation and presentation | 193

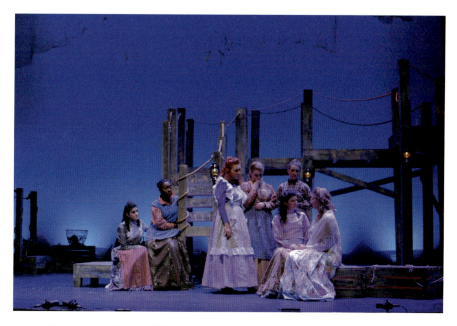

Figure 18.6: Julie and female chorus from *Carousel*, Bucknell University, Nov. 2016.

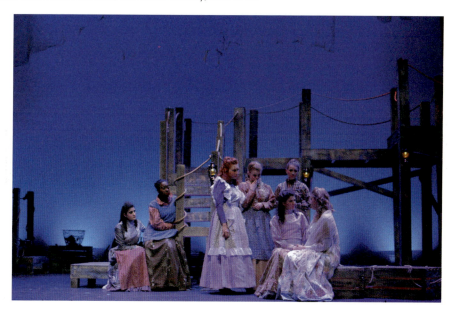

Figure 18.7: Cropped version of Julie and female chorus from *Carousel*, Bucknell University, Nov. 2016.

Another framing and cropping decision that you may need to make concerns all the lights in the shot when you are in a smaller space. We looked earlier at a shot where a few lights were present, but not a big deal. In this shot, the entire light plot is visible, since the venue has a low grid. I would need to resize and crop this shot much like a wide-screen movie to include the characters but eliminate all the fixtures. I've decided to leave it as is, since this is what the audience saw. This is the last production I shot on film before briefly experimenting with a digital point & shoot Nikon E995 for a few months, and then finally committing to the full-bore DSLR that I now use.

Focus

There isn't much you can do if your shot is out of focus. Some programs have a "Sharpen" feature, but that will only help you out so much. This is an area where you've got to get it right the first time. If, on the other hand, you want to soften some edges on the background items to help create focus, that is possible in the software. If you can do it by careful depth-of-field planning, all the better.

Exposure

Hopefully your experience after working through all the suggestions I've made will help you get great exposures every time, but when you run into a shot that isn't properly exposed, this is certainly an area where you can tweak the brightness or contrast. If you have a choice, it's better to brighten up a shot that is too dark, since there may still be detail available to you in the shadows. Often things that are over-exposed are just too blown out to have any detail left. At this point they can't be rescued. As with any filter for adjustment that can be made using photo-manipulation software, the further you have to push an adjustment, the less believable the photo becomes. Little tweaks are easily made, but it's hard to apply a filter to fix one aspect of the photo without possibly shifting other aspects of the photo in a way you don't want. With adjustments like this, it's advisable to save multiple copies so that you can step your way back through the process if you decide you need to start part of the way over. Remember to always work from a copy so that your untouched original is still available if you have to go back all the way to the start.

Color Balance

This is another area where you can salvage the photos that maybe are slightly off. You will have trouble making sweeping changes to the delicate color balances in your photos without running the risk of some of the colors becoming skewed or unbelievable. The problem with the filters and adjustment sliders found in most photo-manipulation software is the fact that it's often difficult to apply these filters or changes proportionally across the photo. You have to do a lot of work to isolate certain problem areas using masking layers, and then

Figure 18.8: Production moment from *Rimers of Eldritch*, Penn State University, Fall 2005.

figure out how to blend the filtered layers and the unfiltered layers back together in a believable fashion. I'm not saying it's not possible, but it does take a good bit of time, effort, and skill. Often, it's more time and skill than I have available. If you are just tweaking the color balance, you may be able to get solid results by experimenting with the wide range of adjustment tools. If you are doing some of this finer detail work, you should probably start with a RAW file first, rather than the JPEG if you can. As we know, the RAW file has a great deal more data in it, so it should be a far better starting point for this kind of work. Eventually you will need to save the RAW file as an output file, with JPEG being the most common and easiest to print from if you are visiting a printer or office store.

When you decide on your end use, you might actually want to prepare different versions of a photograph for multiple uses. In my classes, I still teach my students to build a "hard" portfolio to bring with them to interviews, in addition to creating a portfolio website. You'll need a high-resolution version of the file for printing. If you are only ever intending that a picture be viewed on a typical computer monitor, then you don't need a high-resolution version, which will take a while to download and view. The same goes for the actual printed versions. If you are preparing something that you are mailing off for an interview, you need it to look good, but only last a week. Maybe you can get away with regular inks and paper. If you are putting the work on display, or want to keep the hard copy for a long time, spend the money on the archival-level paper and quality inks. This might also mean it's time to investigate the professional-grade printing available to you. A digital image printed on a glossy or semi-glossy photo paper has so much more depth and luminosity to it than plain paper.

If you have a local option for professional printing, it's a great idea to go there and get to know the people working there. You will ultimately have better results from folks who understand your needs and are willing to work with you to retain some repeat business. While many of the office supply stores are more convenient in terms of hours, we find that it's never the same people twice, and we often have to have things redone multiple times before they are right. Don't be afraid to stand your ground and refuse to pay for things that are printed incorrectly. I've often been told I should just settle for whatever the printer spits out, but I won't. Many of my students have also had run-ins with the local Walmart, which has a copy center as part of the photo-finishing center. They've been told that Walmart won't print the digital images because they are concerned about copyright issues. This happens even when the students tell them that there isn't an issue *because they took the photo, and hence have the copyright on the image!* If it was just one time, I wouldn't mention it, but this is an issue that is apparently tied to corporate policy, and has occurred many times over a span of years. If that is your only choice, just give yourself the time to deal with this as a potential issue, and go during the day when you can talk to a manager if a concern is raised.

When it comes time to show your work, remember that the people you are sharing with will never know what you left out if you don't point it out. Celebrate the successes in your presentation, and don't belabor the things that didn't turn out the way you had hoped. We all wish we had a bit more time in the theatre to fine-tune things, but sometimes it is just not possible. Be selective and edit with your head, not your heart. You will need your heart later when you develop a presentation to go with the pictures, but for now, when you are "culling the herd," ask yourself if you are attached to a particular image because it is a great example of a moment in the show, or because it has some personal meaning that won't be apparent to the reviewer. I've seen this happen many times, where a young designer has put an otherwise mediocre shot in their presentation because it was their favorite dance number. While it may evoke some fond memories, it has now tarnished your whole presentation a little bit.

chapter nineteen

best practices for photographers

best practices for photographers | 197

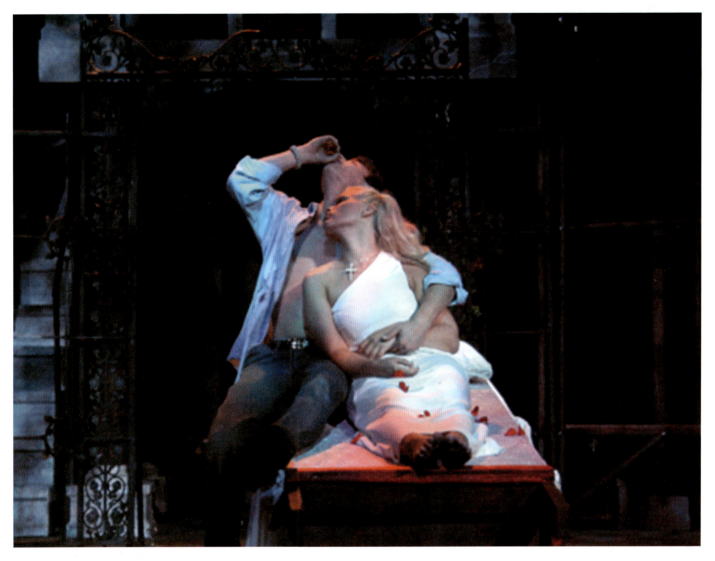

Crypt scene, *Romeo and Juliet*, University of Nebraska–Lincoln, Oct. 2003.

As I mentioned previously, Ektachrome slide film is coming back, and soon a true tungsten slide film may again be available to stage photographers. That said, I'm not sure I could or would ever go back to the old days now that I've become enamored of some of my DSLR's features, such as auto-bracketing and white balance. Ten years ago, digital photography wasn't *nearly* as advanced as it is now, and I look forward to seeing where it goes in the next 10 years. I'm sure there will

be great strides in terms of pixel count, ISO sensitivity, and maybe even the reduction of depth-of-field concerns. Focus and metering will certainly become more flexible and adept, and all of these wonderful new things will come with appropriate price tags attached. Until that time, we have some amazing technology available to us, and the potential to create exciting and vibrant images.

As I said, I don't attribute my success to anything beyond a determination to work hard at gaining the skills needed to be fast, efficient, and competent during a photo-call. There are three things that you can do to rapidly improve your abilities and portfolio.

- Practice often.
- Immediately sort and evaluate your photos.
- Back up everything.

I've already mentioned several times the costs and timelines associated with slide film. Often, I would be thrilled if I ended up with six or seven slides worth saving, maybe one to two of which were worth turning into 8 x 10 prints. With modern DSLRs, you can "preview" the shot on the back of the camera and reshoot if needed. The preview screen may not be totally accurate when it comes to color, but I can easily tell if I have committed some of the cardinal sins of photography, including bad framing, over-exposure, or blurry focus. With auto-bracketing, you can take quite a number of images all at once. All of this is just costing you storage space, which is quite cheap and plentiful. So, I suggest that you shoot as often as you can, even if it's not your design. Shoot for friends or volunteer for other local theatres. Once you have the equipment, it is now essentially free to practice, so there is no reason not to get out there as often as you can. This will allow you to become very familiar with your camera and all its settings. It will allow you to anticipate what settings you might want for an upcoming shot, giving you a chance to change those settings without holding up the photo-call. You should become so familiar with your camera's major settings (the ones mainly accessed by dials and buttons, not buried in software menus) that you can make changes on the fly, in the dark, without having to look at the settings. While still in school, I often shot photo-calls for friends as long as they covered my film/processing costs, and I let them have unrestricted rights to use the results for their portfolios, as long as I could use the photos in my photography portfolio as well. On many occasions, I shot for more than one area, requiring me to work with two different cameras. This also involved a lot of running up and down the aisles. A fast, high-quality zoom lens might have done me some good there, but at the time the costs associated with that kind of glass were just too high. Regardless, the practice has paid off in spades, and now that the costs to do so are measured only in time and storage, there is far less of a barrier to you than there was for me. Even if you are working with borrowed equipment, you are training your eye and brain to pay closer attention to framing and composition. The relationship between all the variables that govern exposure are the same from camera to camera; you just need to learn which buttons and dials do what you need. Lastly, the more you shoot, the more confident you will become in your anticipated results, and the easier it will be for you to plan out what you need to do to get the best shots possible.

When it comes to backing up, you need to become a bit obsessive. Back up your shots immediately. Even if you don't have time to label and sort them all, at least ensure that you have a secure and reliable backup of the files right away. I recommend a two-tier system. You should have a reliable, stable, hardware backup, and a reputable cloud backup. In the slide age, I kept my slides in a safety deposit box, so they were safe from anything, but as I shot more and more, I ran out of space in the box, so I bought a fire-proof file cabinet. This won't protect against every possible situation, but it was a good start. At least there was a chance they would survive if the apartment building I was in went up in flames. Not happy to think about, but I know more than one person who has lost their portfolio or photographs to a house fire. Now that we are in a digital age, it's easy and free to make copies of the file – in fact the photos in this book are all digital copies of the original files.

By having a physical copy and a virtual copy, you are protecting yourself from local disasters, such as fire, flood, tornado, or theft. If any of those things happen, you still have the virtual copy, which should remain on the servers of your backup company of choice for years to come. Depending on your situation, the physical or virtual copy might be easier to access, but you now know that they are identical files, so it shouldn't matter which one you use. Many people choose to use services like Dropbox, Carbonite, iCloud, Mozy, or Symantec, to name a few. I have Dropbox set up on mine to automatically back up any photo device I connect to my laptop, without having to think about it. Even my phone is set up to do this, and it will back up automatically over Wi-Fi without having to remember to connect it. This is an exceedingly useful feature if you end up using your phone to capture in-process images of your work. Choose one with excellent reviews and a solid reputation. Hopefully the cost will be within your reach, but keep in mind that if you lose these files, you can't ever recreate them, so consider this part of your job security. The same goes for the physical media that you use for your hard backup. If you are solely relying on the tired, old hard drive in your laptop, then you are really running the risk of losing everything. Laptops can get stolen; hard drives can crash and eat all the data. Use a high-quality external storage device that can be unplugged and locked up somewhere safe. This keeps the data physically secure, but also separates the data from your computer, so that it can't get corrupted by a virus or locked down with ransom-ware. You might be able to use a USB key to start with, as they are available in high-capacity models that are quite reasonable now. If you shoot a lot, however, you will eventually need to move to some sort of external hard drive that can be plugged into your computer, or perhaps a network-attached storage device (NAS) plugged into your router. Seagate, Crucial, and SanDisk have proven to be pretty reliable, but check the reviews to see if this changes from model to model. If you have a Mac, you can take advantage of its built-in Time Machine for local backups to an external hard drive, or better yet, link to a Time Capsule and have your router and NAS bundled together in one device.

No matter which way you go, be sure to go home and download your photos right away. Here are a few things that have tripped me up in the past:

- If you are downloading directly from the camera to the laptop, make sure your batteries are recharged, or plug your camera into a wall outlet to keep it on. I've had my battery die in the middle of a download that ended up taking far longer than I thought, which caused the memory card to get corrupted, since it turned off in the middle of the download and wasn't "ejected" properly from the computer.
- Download right away, and at least put them all in a labeled folder with show and date. One time, I didn't do this, and it bit me. I needed a shot immediately for someone doing publicity on the show, so I just downloaded the one shot I needed, and figured I'd go back and take care of the rest later. I forgot that I hadn't ever downloaded the rest of the shots, and the next time I used the camera I reformatted the card at the start of the call. As I hit the "OK" button, I suddenly realized what I'd done, but it was too late. So, all I have from that entire show is one shot, which is a shame.
- Once your photos are all copied over to your laptop, eject the chip from your computer or otherwise properly disconnect your camera. Once it is disconnected, double check that *all* the photos are present in the new folder you created. One time I got ahead of myself and thought that the computer was done, popped out the chip, and didn't check on this. It turned out that half of the photos were still uploading, and I almost lost them. Luckily, I was able to go back and re-download the missing files.

Even if you have taken care to do this right away, sometimes things happen and a file gets corrupted. I have no idea

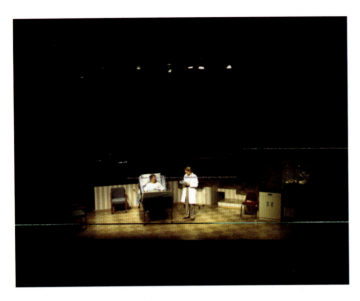

Figure 19.1: Corrupted file. This was the JPEG version of the shot.

what happened to this particular shot, which I found had been damaged at some point when I was sorting through everything to label them. Luckily, the RAW version of the file was still intact, and I had other bracketed versions of the exposure, so I was covered.

Preferably you should sort, label, and evaluate your shots right away, but if you have to wait, don't wait too long. One of the great things about digital photography is the ease with which you can generate 200 or 300 photo files in a night. If you are generating both JPEG and RAW image files, with a five-shot bracket, that's 10 files per button press. Since it's so quick to do this, I will even take multiple bracket sets of one stage look, perhaps to cover myself with slightly different framing or composition. Or perhaps I saw an actor move a bit, and I gave them a pause and had them hold again, and then I reshot. Through all this, I could end up with 10 times as many files to look through compared to that single, 36-exposure roll of film I used to be limited by. This is all great news, but it means that you have a lot more to go through. When I got my box of slides back from the developer, I used to sit at my light table, sort through all of them, and discard the ones that were too over-exposed to be of any use. The under-exposed ones might be able to be used for a print, but the ones that were blown out were pointless to keep. You need to decide for yourself if it's worth keeping the files that are similarly over-exposed. You don't have to worry about storing and moving boxes and boxes of physical slides any more, but you do have to deal with storing them somewhere digitally. I haven't thrown out the files I don't see using yet, mainly due to time. I pick through and identify the ones I want to use in my portfolio, and mark them specially or keep them in a special "Use These!" subfolder. I don't want to have to wade through several hundred images again the next time I need a shot from my library of images.

Depending on your computer's operating system, your file system may not be able to preview the RAW versions of your files. If you are taking pairs of shots, then the file system will display them adjacent to each other, since they will be numbered the same with a different file extension.

In this case, the file in the screenshot is named DSC_0038.JPG, and the RAW version is right after it in the list, and labeled DSC_0038.NEF. The current MacBook OS is able to support the display of thumbnail images of both JPEG and RAW files versions, so it's easy to look at anything in the file folder. If you can't see a thumbnail of the RAW version, then having the JPEG version adjacent to it lets you quickly and easily cull through to decide which ones you might want to open up in Photoshop for a closer look, and which ones you can discard or archive. There are many ways to sort, especially on a Mac, including the thumbnails page or the cover-flow page. Use whatever method makes the work go quickly and efficiently for you, and that will help you stay on top of cataloging everything. Once you've identified what you plan to keep, you can rename all the files, or just the ones that are important if you like. I tend to leave them with their original numbering, just as they came out of the camera, but use carefully labeled folders to eliminate confusion.

Figure 19.2: Sorting photo files on a MacBook Pro.

I wrote in Chapter 16 about the rules and laws that may govern a photo-call. Generally speaking, if you are using the shots for your portfolio, and are not selling them, then you should be fine with taking them for "archival" purposes. If, however, you are planning on using them in a commercial situation, then you will likely need to obtain a waiver or release. I have found the stage management team to be very helpful in this respect. I give them enough copies for the entire cast several days in advance, and they are usually able to catch all the performers when they arrive for the rehearsal or show call the next day. Don't wait until after the call; it's too late to deal with any issues that might arise from the request at that point, and you might have a tough time tracking everyone down.

Several of the examples I've used, however, date back several decades, and whereas I've made a good-faith effort to locate and contact the individuals in the photographs, often I've run out of luck. Your legal situation, and projected use, may or may not require this, but you should make every effort to

RELEASE, WAIVER AND CONSENT

A work is being prepared concerning **Theatrical Photography**, to be published by Routledge (the "Publisher") under the tentative title **Stage & Theatre Photography** (the "Work") by **Professor William Kenyon** (the "Author"). In order that the Work may be a full and complete account, the Author has photographed you in connection with **your involvement in Penn State School of Theatre productions** which the Author intends to include in the Work. These photographs may include your appearance on stage, back stage, or during work calls, rehearsals, or other times associated with the creation of the production.

In consideration hereof, you have consented to allow photographs to be taken of you, and you agree to the use and publication of all or parts of these photographs, as part of the Work in any and all editions, versions, and media now known or hereafter developed, and you hereby release any and all claims relating to the Work, or any of the above uses, including copyright. This release, waiver, and consent is not revocable.

Please sign at the place provided below to indicate your agreement to this release, waiver and consent.

Signature: _____

Print Name: _____

Date: _____

Figure 19.3: This is an example of what a release might look like. This is what I used to obtain permissions for the photos in this book.

respect the right of all the artists involved. Generally, everyone I've worked with has been very cooperative and participatory, and usually the performers are happy if they can get a copy of their own of some of the shots.

Only one time in my career have I ever had a run-in with another photographer. I was working on a show, and my travel schedule just didn't allow for a photo-call to happen outside of the technical rehearsals I was available for. I thought maybe I would step aside during a few cues and take a few shots from the tech table so that I at least had a bit of a record of the show, even if it wasn't what I had hoped to get. A commercial photographer, hired by the venue, was also there shooting the final dress, and came by to angrily inform me that only he had rights to take pictures during the show, and that I wasn't allowed to take any pictures. I pointed out that the producers were aware that I was taking pictures, I was only taking archival shots for my portfolio, and that I hadn't been able to arrange a separate photo-call to satisfy those needs. The other photographer stood his ground, stating that I was interfering with his rights to be the sole person documenting the show for the company. I tried to be as polite as possible, but didn't have time to debate this issue with a dress rehearsal going on. I pointed out to him that as one of the visual artists involved in the creation of the stage looks he was capturing, he was in turn violating my rights as an artist by not asking my permission to document the lighting design work I had created. Suddenly he realized the extent of the situation, and we parted friends with the verbal agreement that he could take all the pictures he wanted of my lighting design, as long as he shared a copy of the shots he took so that I could use them in my portfolio. Everyone walked away happy, and I got more shots of the show than I would have otherwise. Be clear about your intended uses, and polite when you ask for permissions, and everything should work out fine.

When you use another photographer's work in your portfolio, you need to cite their work. When you get permission from the photographer to use the work, ask how they would prefer to be cited. Usually a discrete label on or near the photograph is sufficient. I usually ask my students to cite my work this way:

Photo by William C. Kenyon.

If you are using several photos from the same photographer on the same set of portfolio or web pages, you could instead say:

All photographs by William C. Kenyon.

What's important is that the credit is clearly connected visually to the photo. A semi-transparent watermark is a great way to go, and is something fairly easy to do in Photoshop.

I just added a layer to the image, added a text box, and set the text box to a layer opacity of 50 percent. You can then copy this layer and add it to other files as needed.

Purchasing and maintaining your camera and lens collection can be a stressful and time-consuming task, not to mention the potentially significant costs involved with photography. Cameras are available at many different levels of quality, ability,

best practices for photographers

Figure 19.5: Close-up of Photoshop – adding layer with text for photo credit.

gear you can afford, and squeezing the most value out of that gear.

There are three broad categories of camera and estimates of costs:

- Consumer Grade (under $1,000)
- Prosumer Grade (from $1,000 to $2,500)
- Professional Grade (over $2,500)

Many, but not all of the Consumer Grade cameras will be good for this type of photography – you will have to look very closely at all the options available, and determine which ones you can live without if they aren't all there. Don't forget to look at how easy it is to change settings…are they easy-access buttons and dials, or are they buried in a multi-layer software menu? Be wary of cameras that are all auto-everything. This is especially true for cameras that only do auto white balance. You will recall from Chapter 8 how important it is to be able to have some control over this setting, and how the "auto" part may not function as needed. Most of the Prosumer Grade cameras are going to do everything you need, and do it quite nicely, but they are a commitment. If you can afford a Professional Grade camera, or otherwise know where to borrow one, that's great, but I imagine this is probably out of the reach of most theatre practitioners.

All I can say is do your research, ask around, borrow or rent if you want to try before you buy, and you should come

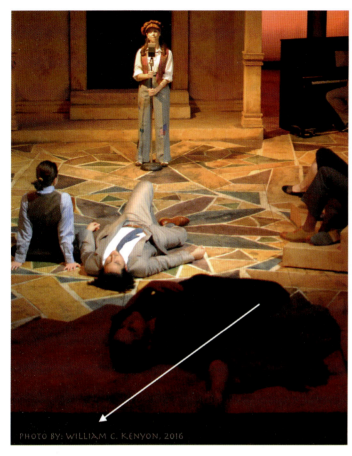

Figure 19.4: Note the watermarked photo credit in the lower left corner. *Twelfth Night*, Penn State University, Nov. 2016.

and feature-sets. What you can afford as a student or freelance professional may limit the options available to you. I chose to invest a larger amount of my available income in cameras than most, partly because it is something that I really enjoy, in addition to something that I needed to get very good at in order to promote my abilities as a designer. You will have to make the decision for yourself as to how much money you put toward this endeavor, but I truly hope that what you have learned from this book will go a long way toward helping you get the best

out just fine. There are some great resources in the back of this book that should help you in your search. Once you have decided on a platform (brand and camera sensor size), then you can delve into the world of lenses. I bought my Nikon D200 camera body as a "kit," which paired it with an extra battery, some accessories, and a Sigma-brand lens with a Nikon mount. The kit with the Sigma lens was less expensive than buying the equivalent Nikon lens by a good bit, but I was ultimately very disappointed in the lens, which broke after about two years of fairly easy use. If going this route gets you into a better camera, then great, but just be sure to plan for replacing the lens with something more suited to your needs in the nearer future. These inexpensive "kit" lenses tend to be slow lenses with a medium-zoom range, so they are okay for most things, but not great at anything. As I mentioned before, I stayed in the Nikon family in order to be able to continue to use my older Nikon lenses, although they don't have the same level of options, especially autofocus, that the newer ones do. I have started to collect a few newer lenses built for the DSLR market, but like the ability to still employ some of my favorite glass from the earlier generations.

Once you start to invest in some good gear, it is important to take good care of it. Here are a few things you can do to prolong your gear's useful life:

1. Don't leave batteries in the camera during long-term storage. Especially alkaline and "button" or "coin" batteries…they can rupture and leak over time, ruining your camera. If you plan to put the camera on the shelf for a few months, pop the batteries out, put them in a Ziploc bag, and secure the bag to the camera with a rubber band or just keep it nearby.
2. Your camera should come with a "body" cap that covers the mirror if you have the lens off. Most theatres are really dusty environments, so even if you are just taking the lens off for a few minutes, the body cap is essential.
3. Lenses come with caps for both ends, and any time you have the lens off the camera, you should cap the body end of the lens. Don't just put it in the box or bag it came with, as it can also get dusty, and then you will transfer that dust right into the body of the camera if you aren't careful. Of course, always use the front lens cap whenever you aren't using the camera.
4. You should also protect your awesome new favorite lens with an inexpensive ultraviolet (UV) filter. Since we don't tend to need to use filters for anything else in our world, you can obtain a plain UV filter, which is essentially clear glass with a UV coating, and put it on your lens. It won't affect your shots at all, and is an excellent bit of extra insurance to help keep your nice lens from getting dirty or scratched and broken. If the filter takes a hit, replace it for less than $20, which is cheap insurance compared to repairing or replacing a good lens.

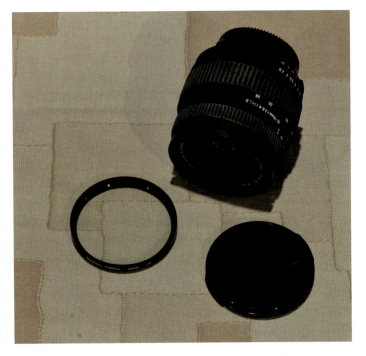

Figure 19.6: Nikon camera lens with UV filter and lens cap. Note that the UV filter has no effect on the color or sharpness of the fabric it sits on.

5. Hot weather is very bad for quality electronics, as I'm sure you know. Be very careful to never leave your camera in a hot car, where the temperatures can rise to well over 130° on a hot day. Even if it's only 70° outside, interior car temperatures can easily hit the 100° mark. This can have a permanent and damaging effect on the life of the battery, the small motors in the camera and lens, and the image-sensing chip. Your owner's manual will most likely give you more specific details about your particular camera and what temperature extremes it can handle.
6. Extreme cold weather can be equally bad, especially if you don't let your camera warm slowly back up to room temperature. Parts can become brittle in extreme cold, and glass can crack. Rubber seals can fail, and your battery may prematurely drain. The other major concern is condensation. If you bring a cold camera into a warmer and more humid environment, it will exhibit the same tendency for condensation that you see when you take a can of soda out of the refrigerator. If I'm in a situation where I know this is possible, I try to keep my camera zipped up in its bag for a while so that it can warm up slowly, and the bag helps to keep the moisture in check.
7. Most manuals suggest that you avoid pointing your camera directly into the sun. While this is useful advice, you might be thinking this doesn't matter, since we are indoors for what we do. This is true, but you should also avoid looking directly into the beam of any arc lights that might be in the rig. Some of the higher-wattage moving lights out there are quite powerful, and can potentially damage your image sensor, not to mention hurt your eyes if you look directly at them.
8. There are many camera bags out there, but you should try to invest in one that has some thick foam padding protecting the contents. Make sure the bottom and exterior sides are good and solid, and that you have some thick, padded interior dividers. Many bags are lined with Velcro so that you can move the dividers around to customize the bag to your preference. You may even end up with several sizes, for different travel situations.
9. I talked a good bit about tripods in Chapter 6, but I just want to revisit this briefly. Quality tripods feel solid; cheap ones feel flimsy. This isn't the be-all, end-all of advice I can offer, but it certainly is a reasonable start. You might also want to look for adjustable feet. Many tripods have a spike at the end of the leg that can be used in softer surfaces, but the good ones also have a rubber foot that covers over the spike, which is better for smooth surfaces like tile.
10. If your camera takes regular batteries, like AAs or AAAs, check and see if you can use the newer rechargeable ones, or the super-long-life lithium batteries. Your owner's manual will tell you what is permissible for your particular camera. If you can use the lithium batteries, that can be a real bonus at photo-call for two reasons: weight and lifespan. They are so much lighter weight that it makes a noticeable difference in the weight of the camera over the course of an hour. They also last far longer, which is great if you are using the camera constantly over the course of the hour. Just be aware that most of the newer battery types run at full charge until they drop off completely, as opposed to the older alkaline batteries that fade over time, giving you a heads-up that they are nearing the end of their charge. No matter what, ensure that you have spares in your bag, already cut out of the blister packaging, so they are ready to toss in and get you back to shooting.
11. If your camera takes a rechargeable battery pack, be sure you have a spare, and be obsessive about making sure yours is charged. The main battery in my Nikon is now about 10 years old, but it still holds a full charge when I charge it. It loses that charge when you store it over time, though, and now over less time than when new. I always plug it in to recharge in the morning of the day of a shoot, and it has proven to be very reliable and has the

ability to last a full and busy shoot. I do keep the charger with me in the bag, though, in case I need to toss one on the charger while I use a backup. If you can plug your camera into a wall outlet, it would be good to have that cable with you, and know where an extension cable is so that you can run power into the seats. This is certainly a clunky solution, but might be the only thing that keeps you shooting.

12. Cleaning supplies are essential, and should include lens-cleaning solution, lens paper, a small can of pressurized air, and a lens brush. The paper and lens solution is essential for getting oils off your lens, such as a fingerprint, whereas the air or brush do a great job with dust and lint, and require less scrubbing of delicate coated lenses. If you are using the UV filter I mentioned, and are careful with the body caps, this will significantly limit any cleaning you have to do to the surface of the filter, which again is a more "disposable" item if it gets damaged or can't be cleaned. Microfiber cleaning cloths are also very popular and useful now, but must also be cleaned every so often if used a lot. Keep your cleaning cloth stored in a pouch or Ziploc, so it doesn't pick up grit from the inside of your bag or pack, which can then transfer to the lens and possibly scratch it. Avoid the temptation to use your shirt sleeve or other clothing article to wipe down a lens...some fabrics, especially organic ones, can be more abrasive to a coated lens than you might realize. Additionally, you might also have dirt on your sleeve that gets transferred over to the lens surface. Specialized soft lens brushes are great for getting at dust or lint, especially if it's stuck on for some reason. You might even find one that has a little pad on it that you can wet down with lens-cleaning solution. Check your owner's manual for additional information about your particular camera and lens.

13. The canned air I mentioned is great, but comes with some cautions. If you are blowing lint off a lens, that's one thing, but if you have gotten dust on the internal mirror or image sensor, that can be another issue entirely. Canned air, especially at close range, can damage some of the tiny springs in the mirror/shutter curtain mechanism. The air is blowing the dust around, and could make things worse instead of better. Finally, if you've used canned air often, you may have had an experience where you get some propellant that shoots out as well, either due to major temperature differences between the can and the surrounding air, or due to a depleted amount of air left in the can. Lastly, if you accidently turn the can sideways, you might also get some propellant instead of air. This material is very cold, and can permanently stain or damage your image sensor. A safer alternate is a blower brush, which has a little rubber squeeze bulb that gives you a puff of air, and you can control the pressure. This is often the preferred method if you have to clean the image sensor. Avoid wiping the sensor with anything, as it is extremely delicate.

14. Some cameras are equipped with a self-cleaning image sensor, which can "shake" the dust off. This only moves the dust off the sensor to a "trap" in the camera, which eventually needs to be cleaned professionally. Nonetheless, this can be a very useful solution if you have the option available to you. In the end, you may need to have your camera professionally cleaned at some point. Overall, if you are careful to begin with, all the cleaning issues should be pretty minor. I've never had to deal with anything more than a little bit of dust and occasional fingerprint on the UV filter.

15. Make sure you have an extra memory card handy, formatted, empty, and ready to go in case your card dies on you or gets full. Cards are cheap now, so it's easy to pick up an extra one after the pain of buying the initial camera rig has passed.

In addition to buying gear new, there is a vibrant market for used camera gear out there. Depending on where you live, you might even still have access to a camera shop, but these

are getting rare. If you are in a large city, though, check around and you might find some resellers that offer used equipment. You really need to be careful though, with any used equipment, since there are things that are obvious, such as dents and dings on the outside of a lens or camera body, but it's very hard to determine the state of the internals. This is much like buying a used car, so go somewhere with a good reputation, make sure there is a return policy or warranty, and as soon as you buy it, go put the gear through its paces and make sure it performs as expected.

Deals may be found locally on Craigslist.org or other local social-media sites, and of course there are many deals on eBay and other auction sites. Local auctions are also often good places for finding deals on used gear. Again, go into this with your eyes wide open. You might get a real steal, but you need to know what you are looking for, and be sure that whatever you are buying is compatible with your other equipment (if that is a concern). Especially with online sellers, do your homework, especially with companies that are "click-thru" sellers on otherwise reputable sites like Amazon.

Visit my website for discussions and questions and I invite you to share your work there as well. As the world of digital photography is changing at an ever-increasing rate, there is no way for me to predict what equipment will be out by the time this book is published. This is a topic that I have found many people to be passionate about, and I look forward to hosting a vigorous conversation on the art of theatre photography there.

Best of luck, and I truly hope that this book has helped you to be successful with your photographic endeavors.

glossary of terms

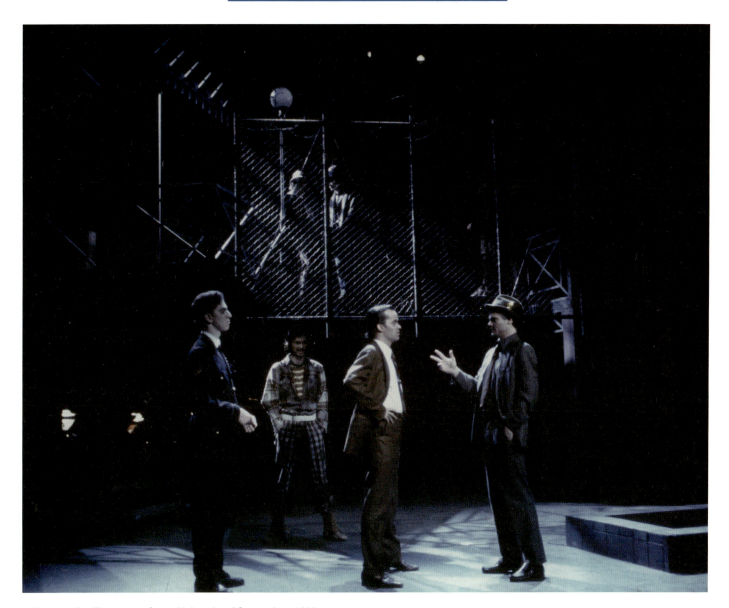

Jail scene, *The Threepenny Opera*, University of Connecticut, 1993.

4K ultraHD – The next video standard beyond 1080p HD video, with a resolution of 3840 x 2160, which is twice the resolution of 1080p, and is a 16:9 aspect ratio.

Additive Mixing – The practice of overlapping different colors of light to achieve a new color. The most common example is to overlap red, blue, and green light, which additively mixes to white.

Amber Drift – The tendency of incandescent theatre lamps to become warmer as they fade down on a dimmer. This is in direct correlation with the Kelvin color temperature scale found in Figure 8.2. Many designers use this to their advantage when creating cues, but it can also result in major changes in the color temperature of people and things on stage as cues change. LED and arc sources are not subjected to this phenomenon, as LEDs dim in a different way, and arc sources do not dim, but have their intensity reduced or cut by a mechanical shutter.

Aperture – The variable-size opening in a camera lens that controls the amount of light that passes through the lens.

Aperture Priority – A camera metering mode that allows you to choose the aperture, and then allows the camera to choose the appropriate shutter speed required for optimal exposure of the shot.

APS-C (Advanced Photo System Type C) – Smaller sized image sensor found in most non-professional-grade DSLR cameras.

ASA (American Standards Association) – This organization set many standards for various industries, including setting a standard for film speed, which became synonymous with its initials. Film speeds are often expressed as 100 ASA or 400 ASA. The American Standards Association later became the American National Standards Institute, or ANSI. ASA 100 is equivalent to ISO 100.

Aspect Ratio – A mathematical ratio that expresses the relationship between the length and height of an image. Common ratios are 3:2, 4:3, and 16:9. A square would have an aspect ratio of 1:1.

Available-Light Photography – The practice of taking photographs, often in the theatre, at night, or in other darker situations, where you rely solely on the available light. No supplemental fill light, bounce light, or flashes are used.

Blocking – This refers to the carefully planned movements of the actors around the stage by the production's director.

Bokeh – Refers to the quality (or lack thereof) of the out-of-focus portion of an image. This quality is usually a function of the particular lens that you may be using.

Bracketing – This is the practice of taking multiple exposures of the same image with slightly different settings, allowing the photographer the chance to capture a range of exposures to choose from when picking images to use. Some modern DSLR cameras have the ability to bracket automatically, which is a huge benefit in a photo-call situation.

Candela – One of several ways to measure light intensity. www.dictionary.com/browse/candela?s=t

Capture Medium – The material responsible for capturing the light passing through the lens and shutter assemblies, and fixing that light as a permanent image. In analog cameras, this would be the film in the camera, and in modern digital cameras, this would be a **CMOS** sensor.

Cibachrome – This is a type of photographic paper, later known as Ilfochrome, that was used for making color prints of color positive transparencies (slides). This process, while costly, was infinitely superior in quality to the other option of having

an inter-negative made from the slide, and then printing a positive color print from the inter-negative.

Color Rendering Index (CRI) – This is a measurement from 0 to 100 that indicates how well a given source renders light compared to a perfect reference source. The higher the number, the better and more accurate the colors will appear under that particular source.

Color Temperature – Measured in degrees Kelvin, this is a quantification of how warm or cold white light appears.

CMOS Sensor (Complementary Metal-Oxide-Semiconductor) – A digital computer chip designed specifically to capture visible light energy and transmit it to other computer chips that ultimately save the data as an image file.

Cropping – The practice of trimming a photo down by physically or digitally cutting off one or more sides to create a smaller version of the previous image.

Depth-of-Field – Refers to the camera's ability to render a sharp or soft focus of objects at different distances from the lens. This function is affected by the distance of the camera to the object as well as the chosen aperture. A shallow depth-of-field means that only some of the objects are in focus at a given time.

DSLR (Digital Single-Lens Reflex) – A digital version of the standard SLR (Single-Lens Reflex) camera that replaces the film with an electronic image-capture device. The camera still allows the photographer to view the image to be captured through the actual lens, utilizing the same mirror and prism construction of a typical SLR.

Digital Zoom – Some cameras allow the image being captured to be digitally enlarged beyond what is possible with the optical zoom of the camera, although quality is often lost.

EI (Exposure Index) – Another, less common, term for film speed or ISO sensitivity.

Film Speed – In film photography, film is rated at different speeds, with faster speeds having greater light sensitivity. The concept of film speed continues to exist in digital photography, and refers to the sensitivity of the image-capturing device used to record the image.

Fixed-Focus Lens – Otherwise known as a prime lens, this is a lens with a fixed focal length, as opposed to a zoom lens that can change its focal length.

Foot-Candle – One of several ways to measure light intensity. www.dictionary.com/browse/foot-candle

Full Bleed – If a photograph is printed without a border, it is referred to this way. Essentially, the photographic image covers the print all the way to all four edges.

Full-Frame Lens – This is a lens that is designed to work with a full-frame DSLR CMOS sensor, as opposed to a cropped sensor such as the APS-C sensor.

Full Spectrum – Refers to lighting sources that emit light across the entire visible portion of the electromagnetic spectrum. This includes the sun, incandescent light bulbs, and incandescent theatre lights. The relative power of each wavelength may vary across the spectrum, which gives each source its distinct luminous quality.

Golden Ratio – Another term for the Golden Rectangle.

Golden Rectangle – A mathematical ratio of 1:1.618, which governs the proportions of many areas of art, including architecture, painting, drawing, and photography.

glossary of terms

GIF (Graphics Interchange Format) – One of several common digital image formats.

Grain – Film and digital images that are of poor quality due to poor exposure, enlargement, or higher film speeds are often referred to as "grainy," in reference to the lower quality of the image. Digital images might also be referred to as **pixelated**.

HDR (High Dynamic Range Photography) – A type of digital photography and image manipulation that involves the layering of multiple varying exposures of a single image to create more depth and dramatic contrasts in the light and shadows.

Hue – In color mixing, this refers to the actual color, regardless of value or saturation.

Inverse Square Law – Light intensity decreases over distance and is governed by the equation: $\Delta I = 1/\Delta D^2$, which means that the Change in Intensity = 1/Change in Distance2.

ISO (International Organization for Standardization) – This is the international version of the ASA (American Standards Association). This organization set many standards for various industries, including setting a standard for film speed, which became synonymous with its initials. Film speeds are often expressed as ISO 100 or ISO 400. ISO 100 is equivalent to ASA 100.

JPEG (Joint Photographic Experts Group) – Also written as JPG, this is the most common digital image format.

Kelvin – Temperature scale that begins at absolute zero, and is used to measure the color temperature of light.

Lumen – One of several ways to measure light intensity. www.dictionary.com/browse/lumen?s=t

Luminous Quality – Refers to the feel and appearance of the light emitted by different sources before it is altered by gels, dichroic glass filters, or other **subtractive** or **additive color-mixing** methods. This refers to the overall difference that you may perceive when viewing sunlight versus candlelight.

Lux – One of several ways to measure light intensity. www.dictionary.com/browse/lux?s=t

Megapixels – A measurement for the resolution of an image sensor in a camera, which is equivalent to 1,048,576 pixels.

Metadata – This is the data that refers to all the various camera settings associated with a digital image, and is stored as part of the image file.

Mirrorless Camera – Also known as a Mirrorless Interchangeable Lens Camera (MILC), is a new form of digital camera that eliminates the entire mirror and pentagonal prism that has defined the design of typical **TTL** film and DSLR cameras.

NEF (Nikon Encapsulated Format) – A brand-specific version of the RAW format for storing digital images.

Noise Reduction (NR) – A digital filter that can be applied in-camera to reduce pixilation or grain in high-ISO images.

Optical Zoom – A camera with an optical zoom has a lens with multiple adjustable glass elements that allows the user to zoom in or out, changing the effective focal length of the lens, and thus the size or magnification of the image.

Paracord – A lightweight synthetic cord originally used by the military for rigging parachutes. Similar in diameter to theatrical tie-line, available in many colors, and very strong for its size and weight.

Pixel – The smallest element of a digital image that is individually addressable in terms of hue and saturation.

Pixelated – Refers to an image that is of lower quality. Often interchangeably used with the term "grainy."

Prime Lens – Another term for a fixed-focus lens, this is a lens that cannot zoom, and has a fixed angle of view.

Prosumer – Refers to equipment that falls between the levels of features expected by your average amateur versus those expected by professionals working on a daily basis in the industry. Prosumer equipment is usually more feature-rich, with price tags to match.

Push – A method of shooting film at a higher ASA rating, and then processing the film in a slightly different way, allowing the photographer to gain extra light sensitivity from the film.

Push Processing – The processing portion of the technique of "pushing" film.

Rangefinder Camera – A camera without TTL focusing. The user views the image through a secondary viewfinder and not the actual lens used for the shot.

RAW – This is an image format that allows for the most information about the image to be captured and stored. In addition to a much greater pixel count for the image, the format can store a great amount of the image's metadata.

Rule of Thirds – This is a common rule that is applied to the composition of an image. Divide the image into thirds vertically and horizontally to find the intersections that create dynamic interest and focus.

Saturation – In color mixing, this refers to the amount of color present in a particular hue, as opposed to its actual hue or value. Lighter saturations are referred to as tints, and heavier saturations are referred to as shades of a particular hue.

Shutter Priority – A camera metering mode that allows you to choose the shutter speed, and then allows the camera to choose the appropriate aperture required for optimal exposure of the shot.

Shutter Release – Either the button on the camera that causes the shutter curtain to retract, exposing the film or image sensor to the light, or that otherwise causes the camera to capture the image.

Shutter Speed – Refers to the duration of time that the shutter will remain open, exposing the capture media to light.

SLR (Single-Lens Reflex) – A common type of film camera that utilizes a prism and a moveable mirror to allow the photographer to view the image to be captured through the actual lens. When the shutter release button is pressed, the mirror flips up out of the way, and the shutter curtain moves aside to allow the light from the image to pass directly through the lens to the film.

Spectral Power Distribution (SPD) – This is a graphical representation of the radiant power emitted by a specific lighting source as measured across the visible spectrum. This provides the viewer with a clear idea of the color composition of the light source by showing the relative intensities of the light at each of the different wavelengths.

Stop – A relative measurement of light that is either half as much light or twice as much light as an adjacent setting.

Subtractive Mixing – The practice of using multiple color filters in the same lighting fixture to remove certain wavelengths of light in order to mix a new color. This is often done with the secondary colors, cyan, magenta, and yellow.

TIFF (Tagged Image File Format) – One of several common digital image formats.

TTL (Through-the-Lens) – This acronym refers to the design of typical SLR and DSLR cameras, where the user is viewing the shot they will be taking through the actual camera lens, courtesy of an arrangement including a five-sided prism and a moveable mirror that lives in front of the shutter curtain.

Value – In color mixing, this refers to the lightness or darkness of a particular color, as opposed to its hue or saturation.

Vibration Reduction (VR) – A system commonly found in longer prime and zoom lenses that helps to reduce vibration in the recorded image.

Vignette – A darkening of the image found at the corners and possibly all edges of a shot. Usually caused by the incorrect lens hood, or a stack of multiple filters on the end of the lens.

White Balance – A setting in your camera that allows you to determine the proper color temperature for a photograph.

appendix

List of Print and Internet Reference Materials

In addition to all the websites and other reference materials here, one of the best places you might be able to also go for tips, gear, and other guidance is a local camera store, if you live somewhere that such a place still exists. In my youth, I spent many hours at Lincoln Camera in Wilmington, Delaware. They have since been bought out by a chain, and subsequently closed down. The guys behind the counter were always a wealth of knowledge, and willing to bargain on used camera bodies, lenses, and other accessories. Not only did I learn a great deal from them, but I also picked up a lot of information by listening to the other professional photographers who came in to buy or sell gear and get film developed. Likewise, the local camera store here in State College, Pennsylvania, closed its doors a few years back, unable to compete with the digital revolution. I used to go there for high-quality prints of slides and digital files, but many of the office supply stores now offer print services at a fraction of the cost to make a photo print.

I'm sure that over the next few years, some of these will come and go, so please consider this a jumping-off point rather than a definitive list. I also haven't done business with every one of these sites, so I can't vouch for every experience that you may have. I can only say that, at this point in time, these are the ones that have risen to the top in my opinion.

(I am a particular fan of dpreview.com and B&H Photo, however…)

Companion Website to this book:

- www.stagephoto.org

Camera Equipment Reviews and Info:

- www.dpreview.com

Camera Equipment Manufacturers:

- Nikon – www.nikon.com/
- Nikon D200 Manual – http://downloadcenter.nikonimglib.com/en/products/10/D200.html
 - In case you wanted to refer to the manual for my camera.
- Canon – http://shop.usa.canon.com/shop/en/catalog/cameras
- Sony – www.sony.com/electronics/cameras
- Pentax (Ricoh) – http://us.ricoh-imaging.com/
- Minolta (Konica Minolta) – http://ca.konicaminolta.com/
 - These are no longer made, but this links to support if you buy a used one.
- Leica – https://us.leica-camera.com/
- Sigma – www.sigmaphoto.com/
- Olympus – www.olympusamerica.com/

Camera and Camera Equipment Sales:

- B&H Photo – www.bhphotovideo.com/
- 42nd Street Photo – www.42photo.com/CategoryList/digital-cameras/111

- 47th Street Photo – www.47stphoto.com/photo.html
- Amazon – www.amazon.com/ – (camera gear and storage devices)
- Adorma – www.adorama.com/
- eBay – www.ebay.com
 - Good deals to be had, but approach with CAUTION; once you buy, usually sight unseen, you are stuck with what you get and no warranties.
- Craigslist – www.craigslist.org/about/sites
 - Be careful, since there usually aren't warranties here either, but at least you can go evaluate the equipment before purchasing.
- New Egg – www.newegg.com/
 - Great site for storage media, cards, hard drives, etc.

Camera and Lens Rentals:

- BorrowLenses.com – www.borrowlenses.com/
- LensRentals.com – www.lensrentals.com/

Other Equipment:

- Spectrometer – www.asensetek.com/lighting-passport/
- Gossen Light Meters – www.manfrotto.us/gossen
- Screen Calibration – www.colormunki.com/

Software:

- Photoshop – www.adobe.com/products/photoshop.html
- Mac Photos for OS X – https://support.apple.com/photos
- Lightroom – www.adobe.com/products/photoshop-lightroom.html
- f.lux Screen Color Control – https://justgetflux.com/
 - I use this program for most of the time on my machine, but disable it and invoke a calibrated color profile for my monitor when doing important color work. This is a great program for general laptop use in the theatre, and has some interesting writing about color temperature and light.

Photographers:

- Joan Marcus Photography – www.joanmarcusphotography.com/
- Ken Rockwell – www.kenrockwell.com/index.htm
 - Great gear reviews, lessons, and tips.
- Richard Finkelstein – www.rfdesigns.org/

Legal and Copyright:

- United Scenic Artists – www.usa829.org/Contracts/ContractsOverview.aspxIndex
- *Actors' Equity Association: Agreement and Rules Governing Employment in Small Professional Theatres* – www.actorsequity.org/docs/rulebooks/SPT_Rulebook_15-17.pdf (Refer to Section 42 specifically)

Books:

- Farrell, Ian. *Complete Guide to Digital Photography*. New York, NY: Metro Books, 2011.
 - ISBN: 978-1-4351-3549-9
 - One of the best references I've found for modern DSLR photography.
- Jaen, Rafael. *Show Case: Developing, Maintaining, and Presenting a Design-Tech Portfolio for Theatre and Allied Fields 2nd Ed.* Massachusetts: Focal Press, 2011.
 - ISBN: 978-0240819266
 - The industry-standard reference book for building theatrical portfolios.
- Browar, Ken, and Deborah Ory. *The Art of Movement*. New York, NY: Black Dog & Leventhal Publishers, 2016.
 - ISBN: 978-0-316-31858-7
 - Incredible collection of studio photographs of dancers in motion.

about the author

William C. Kenyon.

William C. Kenyon serves as head of the Lighting Design Program in the School of Theatre at Penn State University. An active professional designer, William has designed more than 150 plays, operas, and dances, along with over a dozen national and international tour seasons with several theatre and dance companies. William has been involved in Native American theatre and dance for more than 15 years, serving as resident lighting designer for the American Indian Dance Theatre, and was involved in the complete reimagining of *Unto These Hills*, a massive outdoor spectacle celebrating the history of the Cherokee. Prior to Penn State, William taught lighting and sound design at the University of Nebraska–Lincoln. William received his BFA from the University of Connecticut, and his MFA from Brandeis University in Massachussetts.

William is very involved with OISTAT's Education Commission (Organisation Internationale des Scénographes, Techniciens et Architectes de Théâtre), after having served two terms as Commissioner for Education for USITT (United States Institute for Theatre Technology). He is also a member of USITT, OISTAT, IALD (International Association of Lighting Designers), IESNA (Illuminating Engineering Society of North America), and USAA (United Scenic Artists of America) Local #829 in the areas of lighting and sound design. When not on tour or in tech, William is working on climbing the highest point in each US state. He lives in Pennsylvania with his wife, Jenny, a costume and scenic designer and forensic artist, and his daughter, Delaney, who is a designer, martial artist, and world traveler.

index

nb: Page numbers in **bold** refer to glossary definitions.

absolute zero 79
acoustical clouds 166
active autofocus 14–15
Actors' Equity 171
Adams, Ansel 23, 25
additional optical paths 8
additive mapping **210**
Advanced Photo System Type C *see* APS-C
all-black field 30
Amazon 141, 207
amber drift 94, **210**
amber ring lens 164
American Idiot 137, 150, 182
aperture **210**
aperture priority 115–18, 129, **210**
aperture setting 33, 37, 39–51, 180–1; practice session 50-1; *see also* f-stop
Apple iOS 10 142
APS-C 102–3, **210**
arc lights 80, 85, 87, 92
archiving 170, 195, 201–2
ASA (American Standards Association) **210**
ASA/ISO 32, 37, 72; *see also* film speed
aspect ratio 96–101, 110, **210**; *see also* framing shots
atmospherics 133
auto-bracketing 11, 112–13, 126–35, 175; practice session 134
auto-exposure settings 115
autofocus settings 13–20, 42, 62; practice session 20
automatic white balancing 80–1, 89–92; *see also* white balance
available-light photography 2, 49, **210**
avoiding camera shake 54–8, 60–2
AWB *see* automatic white balancing

backing up 198–9
backlight 184–5

ballet 181
basic photography 5–12
Be More Chill 169
best practices for photographers 196–207
Bit Map files *see* BMPs
black model box 18, 146
black-body sphere 79
blocking 104, 108, **210**
blower brush 206
blue cyclorama 15
blurring 35, 43, 46, 54, 116, 135, 180, 198
BMPs 138
body cap 204
bokeh 47, **210**
borders 191–4
bracing stance 68–9
bracketing 25, **210**; *see also* auto-bracketing
breathing techniques 54, 61–2, 132
Broadway productions 170
built-in flash 164–5

calibrating meter 24, 120, 189
camera focus settings 13–20
camera meter 21–30
camera mimicry processes 6–7, 34
camera shake 54–8, 60–2, 66–7, 132, 134
camera strap 62–6, 70, 132
candela **210**
canned air 206
Canon family 11
Canon PowerShot SX10 IS 10, 42, 116–17
capture medium **210**
capturing audio 10
capturing performance energy 1–4
Carbonite 199
Carousel 16, 53, 70, 98, 139, 150, 153, 173–4, 193
central processing unit 50–1
CF card *see* Compact Flash Card

change-out 127
changing "on the fly" 84, 117, 125, 129, 175, 198
Cherry Orchard 157
"chimping" 20, 118
Cibachrome 149, **210**
close-ups 30, 41, 56–7, 117
Closer Than Ever 2
CMOS sensor (Complementary Metal-Oxide-Semiconductor) **211**
color accuracy 37, 76, 188
color balance 78, 80, 94, 194–5
color calibration 94
Color Munki screen calibration device 190
Color Rendering Index 85, **211**
color temperature 28–9, 78, 84–7, 89–93, 157, 185, 189, **211**
color temperature settings 28–9, 78, 84–7, 89–93, 157, 185, 189
color values 36
color-changing effects 78
color-correcting gels 92
colored gels 78, 85, 87, 89, 92
Compact Flash Card 141–2
compactness 9
compensation 57
compression 137–40
cone of vision 102
continuity 153
Constrain Proportions 100
copyright 195, 198
costume design 156–61
CPU *see* central processing unit
Craigslist 207
CRI *see* Color Rendering Index
cropping 96–7, 99–103, 110, 143, 191–4, **211**
Crucial 141, 199
"culling the herd" 195
cyclight 185

dance 181
daylight-balanced film 157
Declaration of Independence 148
degrees Kelvin 78–80, 82, 84, 90–4, 129
densitometer 121
depth-of-field 36, 43–4, 47, 48–51, 76, 127, 131, 156, 165-7, 180, 194, **211**
designing scenes 146–56
detents 50
digital camera perception of light 21–30; practice session 30
digital file formats 136–43; practice session 142
digital noise reduction *see* noise reduction
digital photo manipulation 187–95; borders/cropping 191–4; color balance 194–5; exposure 194; focus 194; photo editing 190–1
digital zoom 50, **211**
digital-single-lens-reflex camera 8–16, 44–5, 49–54, 57, 74–6, 81–4, 121, 129–33, 170–4, 197–8, **211**
distance-and-rise situation 107–8
documenting process vs. product 144–67; costumes 156–61; lighting and sound 165–7; pyro and special effects 167; scenic design 146–56; technical direction 161–5
Don Quixote 48
Doubt 188
dress rehearsal 178, 184, 202
Dropbox 142, 199
DSLR *see* digital-single-lens-reflex camera
duplication 142–3
dynamic area 17; Dynamic Area – Closest Subject (camera setting) 17

eBay 207
editing photos 190–1
EI (Exposure Index) **211**
80A filter 83
Eisenlohr, Paige 150–3
Ektachrome 320T film 24, 73, 76, 83, 127, 149, 157, 197
electrified props 161–5
electromagnetic energy 23, 78, 85
Enright, Mark 156–60
entry-level cameras 10–11, 50
Equity *see* Actors' Equity
ETC Source Four Leko 85–6, 88–9, 91
EV *see* exposure value
EV compensation *see* exposure value compensation

EV correction 120
Exchangeable Image File Format *see* EXIF
EXIF 138
exposure 7, 194
exposure balance 188
exposure through-line 37
Exposure Triangle 35, 54, 76, 133
exposure value 120-1, 123, 125
exposure value compensation 27, 50, 113, 119–25, 129-30, 133-4; practice session 124-5
Exposure Zone System 23–5, 134–5
extended exposure 165
external shutter releases 54
extremes of weather 205

f-stop 32–3, 35–7, 40–1, 44; *see also* aperture
F/X chases 172
fabric dyeing 156–61
facial recognition algorithms 18
field-metering settings 27, 30
fill light 30, 164
film lighting 185
film speed 34–6, 71–6, **211**; practice session 76
finding the pose 175
fireworks 167
First Noel 161–3
fisheye 105
fixed-focus lenses 47, **211**
flash units 28–30, 79, 82, 161-2
flats 156, 161–3, 165
flattening effect 28
flaws 3
fluorescent light 79–80, 84–5, 87, 93
f.lux 189
focal distance 15–16
focal length 33, 41, 49, 103
focal plane 45
focus 194
focus sensor strip 15
foot-candle **211**
For the Future 184
foreground–background contrast 28
4K Ultra High Definition 9, 142, **210**
Fourth of July 167
framing shots 95–110; practice session 110
freeze-framing 53–4, 70, 172, 183
full bleed 191, **211**
full spectrum **211**
full-frame lens **211**

full-stop 54
fundraising 184

generational degradation 138, 142
GIF 138, **211**
Golden Ratio 101, **211**
Golden Rectangle 101, **211**
Google 189
Gossen Starlite 2 light meter 26
grain **212**
Graphics Interchange Format *see* GIF
Green Day 182
group dynamic 17
Guys and Dolls 134

hair/wig design 156–61
half-stop 54
hard portfolios 3, 9, 28, 83, 101–3, 145–6, 150, 170–3, 195, 202
Hasselblad 142
HDR **212**
high-contrast elements 15
how digital cameras perceive light 21–30
hue **212**
human eye 6–7, 78

iCloud 199
image composition 96, 100, 180; *see also* framing shots
image-sensor size 101–2
in-the-round spaces 180–1
incandescent light 79–81, 87–94, 156
incident-light meters 26
infrared light 87–8
interval photography 165
Inverse Square Law 29–30, **212**
involved shots 108–9
iPhone 6/7 142, 152
iris 7
ISO (International Organization for Standardization) **212**
ISO sensitivity 72, 74, 76, 198; *see also* film speed

Joint Photographic Experts Group *see* JPEGs
JPEG 2000 138
JPEGs 129, 137–41, 195, 200, **212**

Kelvin scale 78–80, 83, 84, 90–4, 129, **212**
Kenyon, Jenny i, xvii, xxi, 157, 160, 219

Kingston 141
Kodak 73, 83

La Voix Humaine 97–8, 129–32, 134, 153, 155–6, 192
Last Train to Nibroc 151
latex 157–60
latitude 185
LCD screen 8, 10
LED mixing 78, 80–1, 85, 87, 89, 93–4
Leko lamps 85–7, 89–90
lens of the eye 7
lens flare 18–19
lens hood 18–19
Lewis, Matt 161–3
Lexar 141
light meter 21–30
light values 120; *see also* exposure value compensation
light-sensing array 8
lighting design 165–7
location-stamping 177
loss of quality 50
lossless compression 137–8
lossy compression 137–8
lumen **212**
luminosity 190, **212**
Luna Gale 99–101, 178
Lustr+ 87–9
lux **212**

Mac OSX Preview Inspector 138, 191
MacBook 38, 189, 200–1
Macro aperture 41
makeup 156–61
making models 146–9
manipulating digital photos 187–95
masking layers 194–5
maximum aperture 41, 49
mechanical plunger cable 57
megapixel count 12
megapixels **212**
memory cards 141–2, 177, 199, 206–7
menu banks 117–18, 129
mercury-vapor lamps 80
metadata 37, 50–1, 74, 76, 133, **212**
meter priority 112–18; practice session 118
mic placements 165
microfiber cleaning cloths 206
microSD 141

millinery 156–61
miniaturized DSLR 10
mirrorless cameras 8–9, 41, 57, **212**
mirror–prism arrangement 7–8
mismatched colors 80
model-making 146–9
modifying fabric 156–61
Mona Lisa 189
monopods 54, 60–1, 132
motion blur 35, 54, 76, 132, 134
Motorola 142
Motorola Droid Maxx 9, 28, 43, 142
Mozy 199
musical theater 181–2

NAS *see* network-attached storage device
NEF 138–9, 141, **212**
network-attached storage device 199
Newegg 141
Nikon AF-S Nikkor 50mm f/1.4G lens 43, 49
Nikon D200 10–11, 15, 26–7, 140, 204–5
Nikon DSLR camera 62
Nikon E995 point & shoot 194
Nikon Encapsulated Format *see* NEF
Nikon F2 with 35mm f/2 lens 7
Nikon SLR camera 54, 62, 73
noise reduction 75–6, **212**
Noises Off 172
NR *see* noise reduction
Nutcracker 160, 172

"off the meter" 116
offsetting 128–30
Olympus 9
Olympus Stylus 790 SW point & shoot 9, 42, 141
"on the meter" 24–5, 35, 121–4, 127–8, 131–2, 184
open communication 175
opening up the lens 40, 43
opera 181–2
optical zoom 50, 142, **212**
optimum exposure 24–5, 30, 115–16, 129
other types of performance 179–86; ballet/dance 181; opera/musical theatre 181–2; outdoor dramas 183; rock tours 182–3; speciality events 184; thrust/in-the-round spaces 180–1; TV/film 185–6
Our Country's Good 22
outdoor dramas 183

over-exposure 27, 54, 112, 116, 121, 123–5, 127–8, 131–2, 194, 198
overview of photography 5–12

painting 146–50, 167
Paracord 58–9, 61, 177, **212**
passive autofocus 15–16
Pentecost 40
perception of light 21–30
period costumes 180
peripheral vision 102
photo manipulation 187–95; *see also* digital photo manipulation
photo-calls 3–4, 11, 17, 28, 37, 51–3, 57–65, 103, 168–78
photometric data 165
Photoshop 27, 50, 54–5, 75, 81, 85, 91, 97, 100–3, 134, 177, 191, 202
pinhole cameras 6
pixel **213**
pixelation 15, 73, 76, 198, **213**
PNGs 138
point & shoot cameras 8–10, 14, 41, 47–50, 81, 84, 112, 115, 142
pop-up flash shot 165
Portable Network Graphics *see* PNGs
powder flash 167
PowerPoint 191
PQI 141
practice sessions; aperture 50-1; auto-bracketing 134; autofocus settings 20; camera meter 30; EV compensation 124–5; file formats 142; film speed 76; framing shots 110; meter priority 118; shutter speed 70; white balance 93–4
practices for documenting product *see* documenting process vs. product
practices for running a photo-call *see* running a photo-call
presentation of photos 187–95
previewing 198
primary settings 31–8; aperture 33; film speed 34–6; shutter speed 33–4; white balance 36–7
prime lens 47–50, 131, **213**
professionalism 171–3, 175
projections 146–56
Proof 32
proper exposure 25, 27, 35–6, 46, 53, 73
properties 161–5

proportion 96, 100
proscenium arch 20, 29, 56, 96, 100, 146, 175, 191
prosthetics 156–61
prosumer range of cameras 10, 56, 102, 203, **213**
push processing 73, 76, 127, **213**
pyro effects 165

quick-release tripod base 56

Radio City Music Hall 28
rake 107, 181
rangefinder camera 8, **213**
RAW 37, 129, 138–40, 142, 195, 200, **213**
red shift 94
red-eye reduction 15
reflected-light meters 26
reformatting 142
remote shutter release 57–8
resizing 99–100, 102, 137–9, 143
retina 7
RGB color-sensing matrix 11
Rimers of Eldritch 194
ring flash 162–5
rock tours 182–3
Romeo and Juliet 197
Rosculux 68 87–92
Rule of Thirds 96–8, 100, **213**
rules governing photo-calls 171
running a photo-call 168–78
R.U.R. 72
Russian Ballet Theater of Delaware 46–8

Samsung 141–2
SanDisk 141, 199
saturated 87, 89, 90, 134
saturation **213**
scalloped lens hood 19
scenic art 146–56
scrim 148, 150
SD card *see* Secure Digital card
Seagate 199
secondary settings 111–13; auto-bracketing 113; EV compensation 113; meter priority 112–13
Secure Digital card 141–2
selector wheel 44
self-cleaning image sensor 206

selfies 14–15
sensitivity to light 34, 36
sepia toning 84
1776 108–9, 145–6, 148–9
shooting in the round 177
shooting mode 133–4
shortened leg tripod 58–9
shot framing *see* framing shots
shutter curtain 33–4, 53, 57, 206
shutter priority 115–16, 118, 129, 132, **213**
shutter release button 15–16, 133, **213**
shutter speed 33–4, 52–70, 134, **213**; practice session 70
side lighting 146–7
Sigma zoom 11, 204
Singin' the Moon Up 14, 115
single area 17–18
single-lens-reflex camera 7–8, **213**
skewing color 28, 37, 76, 82, 90–2, 194
SLR *see* single-lens-reflex camera
smartphone cameras 8–9, 14, 28, 41, 50, 80–1, 112, 115, 142, 149–50
sodium-vapor lamps 80
soft focus 194
sound design 165–7
SPD *see* Spectral Power Distribution
special effects 167
specialty events 184
Spectral Power Distribution 85–9, **213**
spectrophotometer 79
spot metering mode 25–6
spot meters 26
Spotlight on Musical Theater 185
stage managers 3, 171–3, 201
stand-alone handheld meters 26, 28
still life 125, 134
stop-action photography 53
stopping down 40, 43, 53–4, 76, 133
stops of light 23, 120–4, 127–30, 133–4, **213**
strobes 172
subtractive mixing **213**
Sweeney Todd 172
Symantec 199

Tagged Image File Format *see* TIFF
Tahiti photo-call schedule 178
technical direction 161–5
telephoto zoom 49

television 185
temperature sensitivity 84
three-dimensional sculpting 28
three-shot bracket 127–32, 140
thrust 104, 107, 146, 180–1
thumbwheel 54, 116
TIFF 138, **214**
time-lapse photography 167
top-light 164
tripods 54–8, 60–61, 65, 96, 103, 132, 205
Trouble in Tahiti 177–8, 181
TTL (Through-the-Lens) **214**
tungsten 73, 83–5, 93, 189, 197
tunnel vision 175
Twelfth Night 103–9, 152, 154–5, 167, 175–6, 203

ultraHD 9, 142
ultraviolet light 78, 204
under-exposure 27, 30, 35, 51, 112, 116, 122–5, 127–8, 130–2, 184
Unto These Hills 6, 18, 112, 127, 147, 183
Urinetown 78
useful reference materials 215–16
UV filter 204–6

value **214**
Vari*Lite VL3000 87
variable-aperture zoom lens 49–50
vibration reduction 49, 57, **214**
View from the Bridge 152
vignetting 102, **214**
visible spectrum 6, 78–9, 82, 85
visual noise 153
vomitory entrance 107–9
VR *see* vibration reduction

waivers 201–2
Walmart 195
waterproof cameras 9
Weaver stance 68–9
white balance 36–7, 77–94, 121, **214**; practice session 93–4
wide-angle zooms 49, 181
widescreen 99, 194
Wings 96

Ziploc 204, 206
zoom 7, 10–11, 42, 47–9, 103, 110